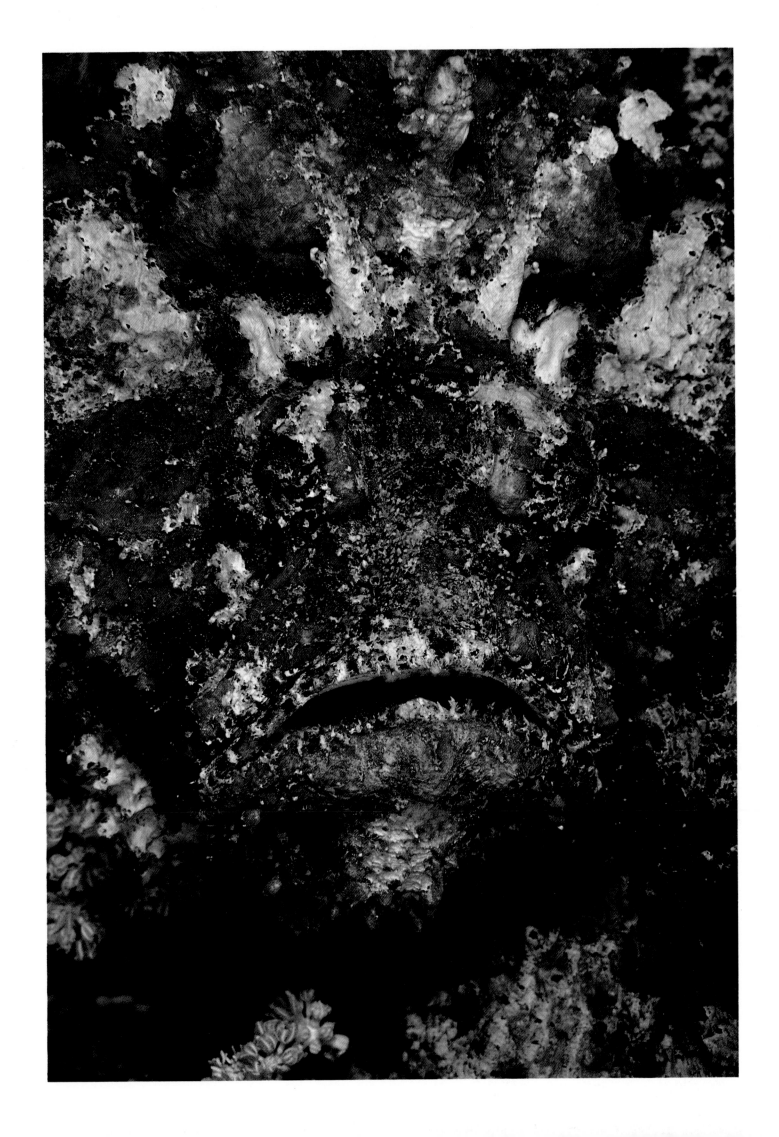

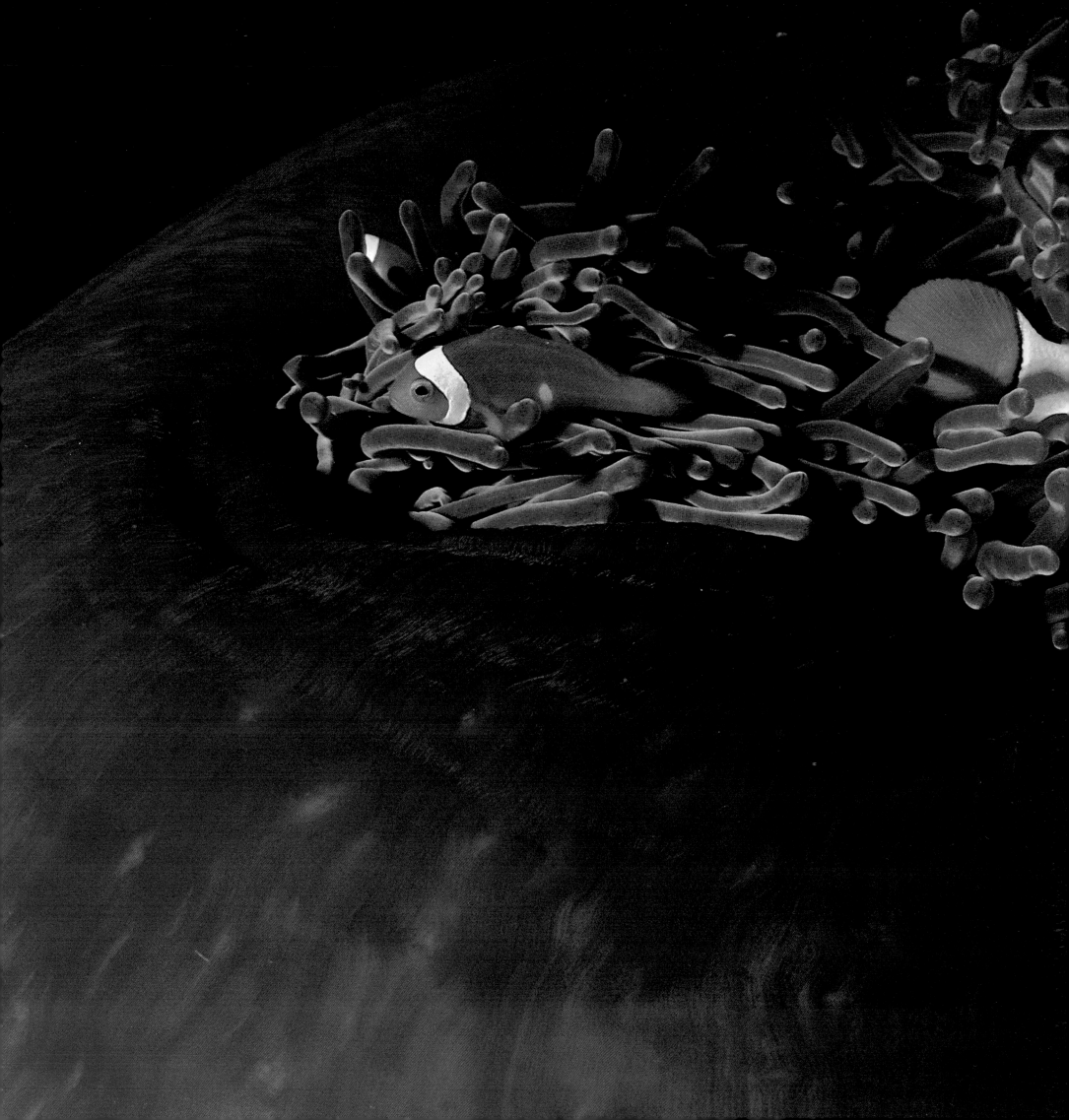

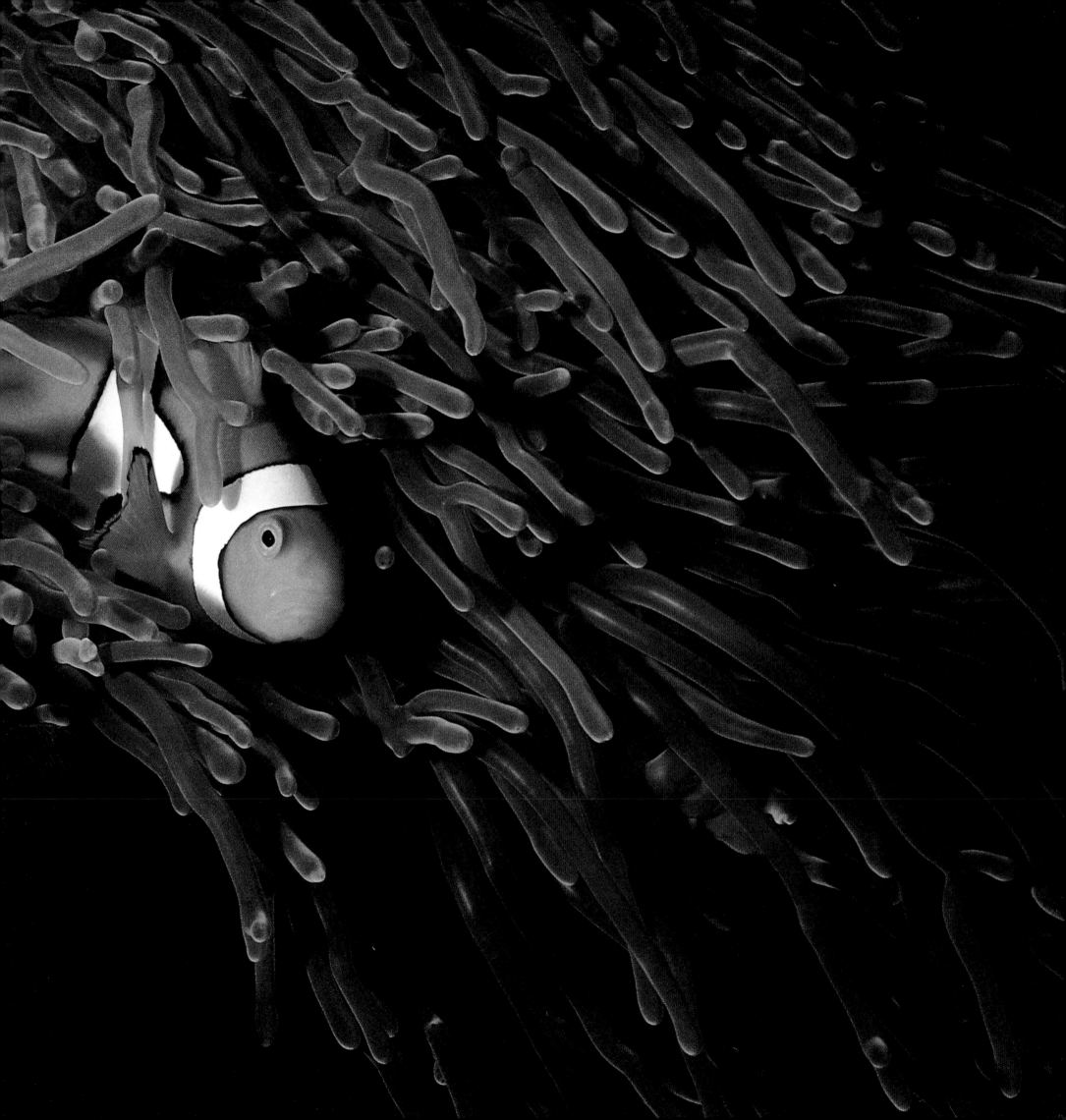

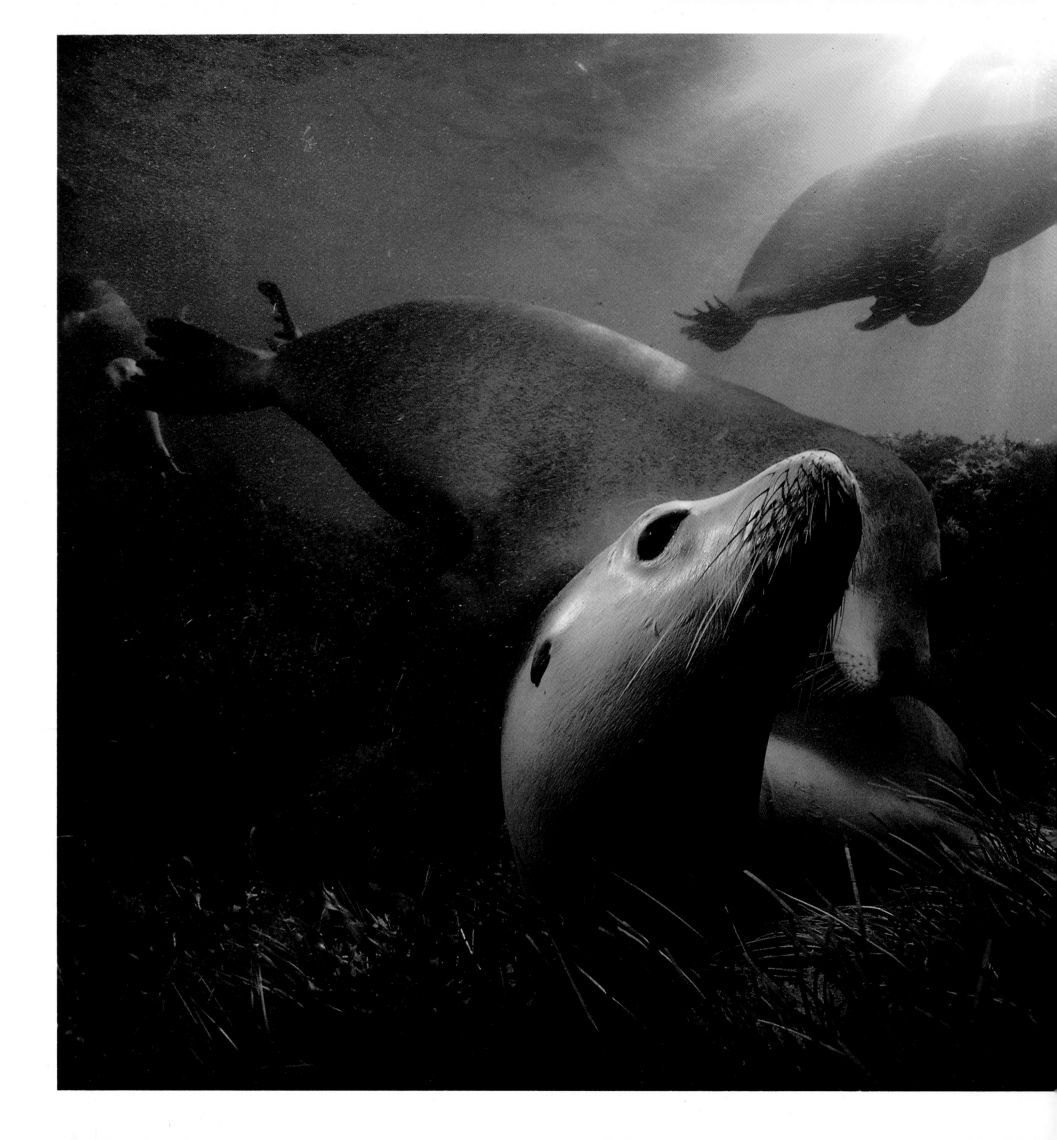

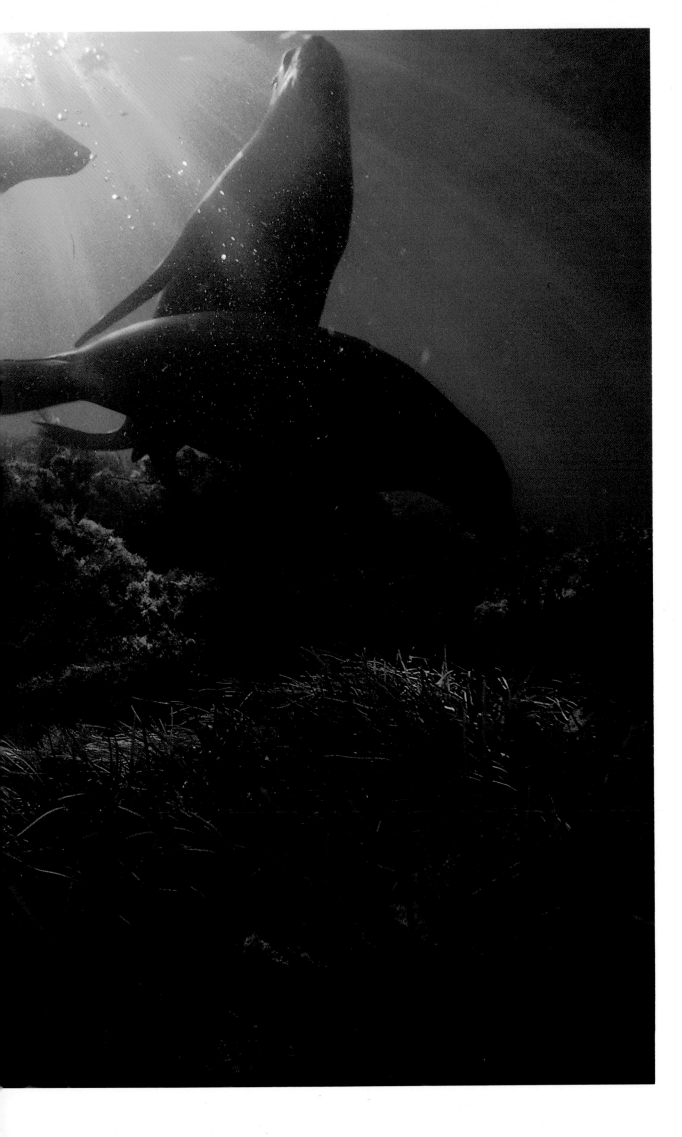

(Page 1) Stonefish,
Ras Muhammad, Egypt.
SYNANCEIA VERRUCOSA

(Pages 2-3) Clownfish burrow in
sea anemone's tentacles as it closes
up for night, near Kavieng,
New Ireland Island,
Papua New Guinea.
AMPHIPRION PERCULA

(Facing) Australian sea lions,
Hopkins Island, South Australia.
NEOPHOCA CINEREA

(Overleaf) Undersea desert,
Marsa el Muqabelah, Egypt.

LIGHT IN THE SEA

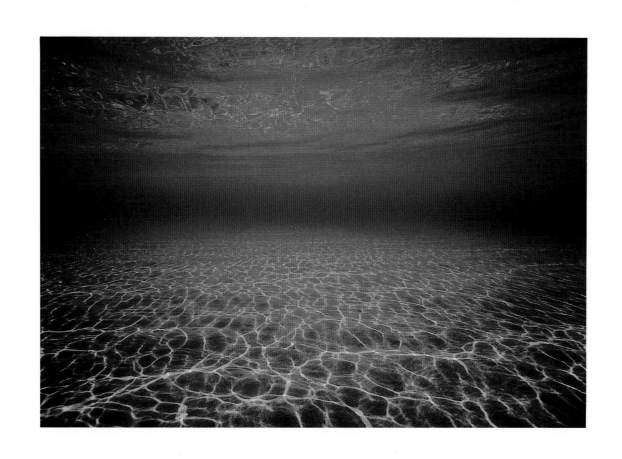

DAVID DOUBILET

SWAN·HILL
PRESS

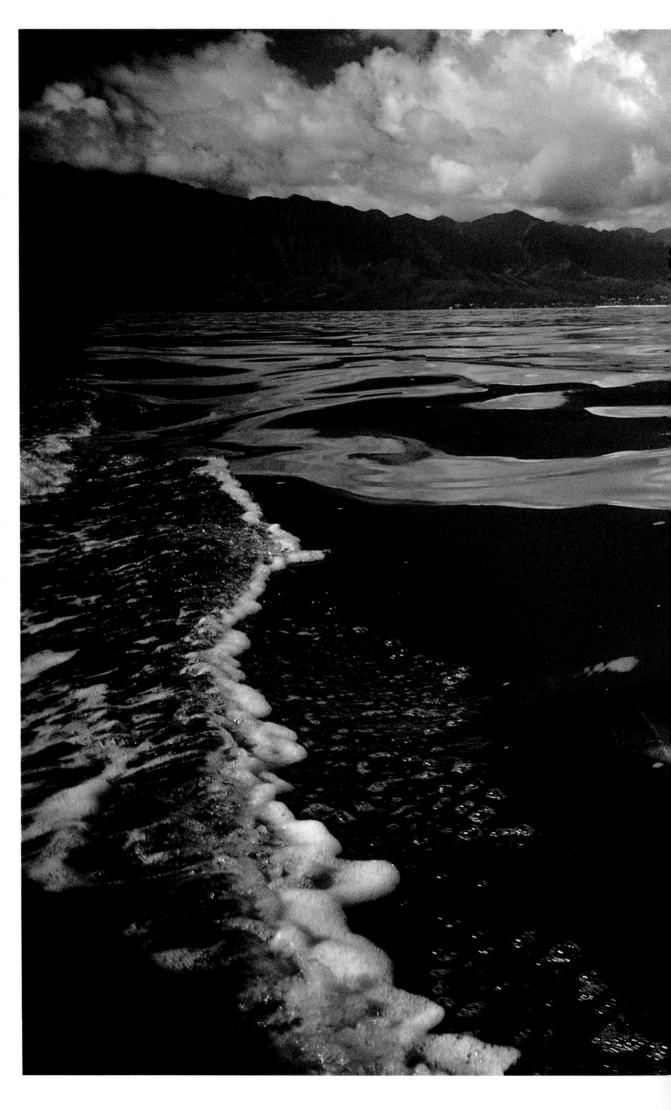

Photographs pages 4-5, 12, 30, 30-31, 38, 41 (top), 52, 64, 66-67, 71, 72-73, 74-75, 78-79, 80-81, 85, 89, 90-91, 94-95, 96, 98-99, 100, 101, 102-3, 103, 112-13, 116-17, 125, 140, 140-41, 142, 144, 148, 159, 161, 162-63, 164-65 copyright © National Geographic Society.

Excerpt from *The Silent World* by Captain J. Y. Cousteau copyright © 1953 Harper Brothers. Reprinted by permission of Harper & Row, Inc.

First published in the USA in 1989 by Thomasson-Grant, Inc.

This edition published in the UK in 1990 by Swan Hill Press, an imprint of Airlife Publishing Ltd.

British Library Cataloguing in Publication Data available.

ISBN 1 85310 181 8

Printed in Japan by Dai Nippon Printing Co., Ltd.

For Anne, for Emily

Swan Hill Press
An imprint of Airlife Publishing Ltd.
101 Longden Road, Shrewsbury, SY3 9EB, England

(Facing) Bottle-nosed dolphin,

Kaneohe Bay, Oahu, Hawaii.

TURSIOPS TRUNCATUS

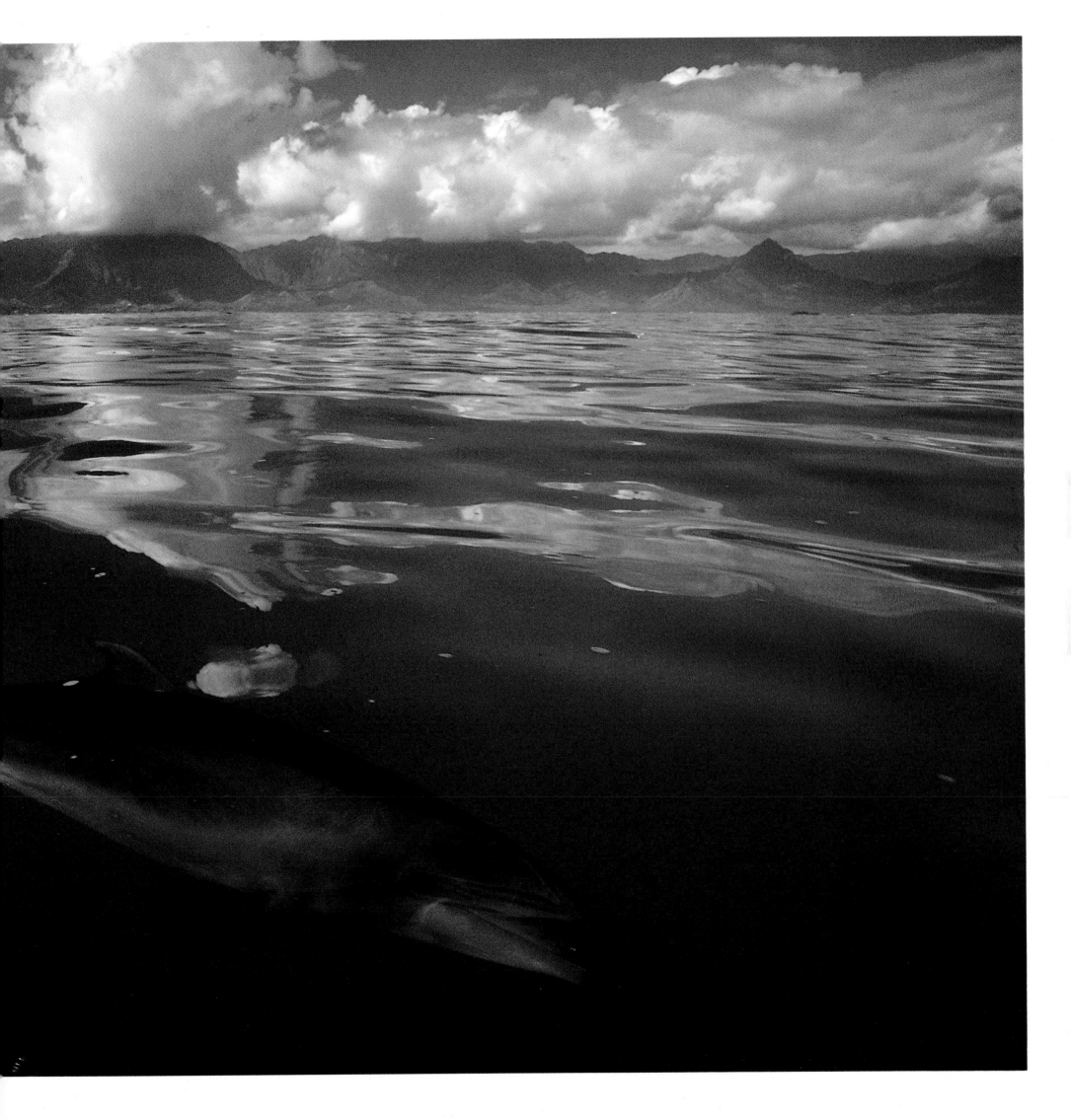

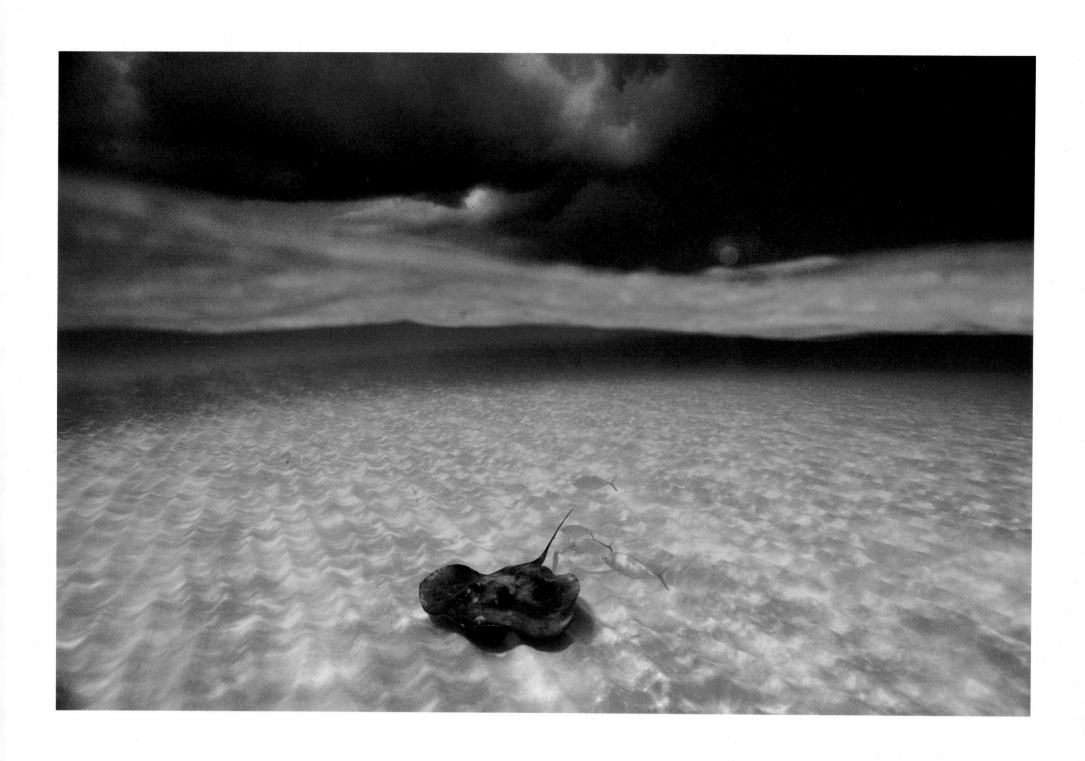

Southern stingray, North Sound,

Grand Cayman, Cayman Islands.

DASYATIS AMERICANA

One Sunday morning in 1936 at Le Mourillon, near Toulon,

I waded into the Mediterranean and looked into it through Fernez goggles.

I was a regular Navy gunner, a good swimmer interested only in perfecting

my crawl style. The sea was merely a salty obstacle that burned my eyes.

I was astounded by what I saw in the shallow shingle at Le Mourillon, rocks

covered with green, brown and silver forests of algae and fishes unknown

to me, swimming in crystalline water. Standing up to breathe I saw a trolley

car, people, electric-light poles. I put my eyes under again and civilization

vanished with one last bow. I was in a jungle never seen by those who floated

on the opaque roof.

Jacques Cousteau
The Silent World

INTRODUCTION

The rocks were upholstered with tiny brown and yellow mussels. Under the surface, foam bathed the rocky masses like clouds around mountain peaks. Silver menidia fish swam through the clouds, and blackfish crept around the mountain bases. Emerald bits of seaweed danced in the surge.

I swam in Italian flippers, a French mask, and an American snorkel with a ping pong ball valve and a mouthpiece made of synthetic rubber as pliable as cast iron. The valve was supposed to keep the snorkel dry. It never worked. The mouthpiece made me gag.

I poked my head above water. It was like breaking a spell. I was beyond a T-jetty in Elberon, New Jersey; the August sky was impossibly bright, and I sloshed back and forth in an easy swell. A west wind carried sound from land: beach club conversation, lifeguards' whistles, and children's shouts. I even heard, or maybe just imagine I heard, the mah-jongg ladies, a wonderful species of 1950s human with huge red lips and teeth and voices like tank transmissions, smoking cigarettes with ashes that defied gravity. Earlier I had flapped past their

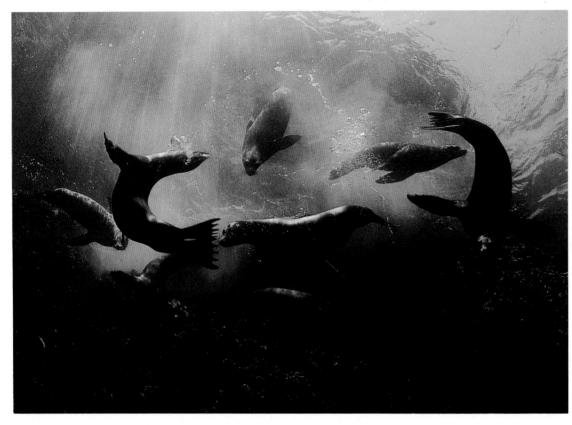

Galapagos sea lions, Galapagos Islands, Ecuador.

ZALOPHUS CALIFORNIANUS
WOLLEBAEKI

tables in my yellow flippers, and the mah-jongg ladies called to me.

"David, you look like a space man."

I was.

"David, be careful. There's shawks out there."

There were.

It was years before I realized that there was no *w* in "sharks."

I put my head back underwater and swam toward the beach. Across the shallows, people's feet advanced, huge white Moldavian tree slugs attached to ankles and legs that rose like baobab trees toward the surface. I saw a wonderful secret thing. Tan crabs with maroon claws fled before the feet. Sometimes they would fold their claws shyly in front of their faces and bury themselves backward in the sand. Sometimes they would raise their claws above their carapaces, preparing to die with an ultimate act of defiance.

As the Moldavian tree slugs descended, the crabs attacked. Breathing through my snorkel, I floated on my stomach, my ears above water, and heard the howls of pain. I smiled; water seeped around the mouthpiece. I was nine years old and it was 1955.

S unlight is transformed when it enters the sea. Shallow water separates it; the brightest shafts dance across the sandy bottoms. Deeper water makes light a glowing presence, diffused from above. In this blue, blanketing glow, colors change. Red becomes black, blue veins look green. Some yellows become mustardy, others stay bright.

If you carry light into the sea in a flashlight or electronic flash—in essence, sunlight in a bottle— you restore the surface spectrum. "Restore" is a mild word for what happens; the change is truly magical. Along the flanks and canyons of the deep reefs, a hidden palette of colors flourishes. Nothing on the surface can compete, except perhaps a South American parrot. While photographing, I never see these colors; when I touch the camera's trigger, the electronic flash blooms and dies in less than 1/2,500th of a second. I never know the true color of a photograph until I get the yellow boxes back from Kodak. And then, for all the travail of diving and photographing, the sea delivers incredible rewards.

Pink alcyonarian coral, Red Sea.
(Anne L. Doubilet)

W hen I was 12, I began to photograph under water in earnest. First I used a Brownie Hawkeye in a rubber bag attached to a mask. It leaked. Soon I graduated to an Argus C-3, the world's most difficult camera, in a Seahawk housing. It leaked. Then I bought a prewar Leica and housed it in a cast aluminum beast called a Lewis Photo Marine. To seal its vague gasket, you inflated the housing with a bicycle pump. With this housing, you could control the camera's aperture or focus, but not both. This triggered vicious cycles of decision making. Did I want to shoot close-ups or distance pictures? Would the sun stay out or be gobbled up by that sailing cloud? Invariably, I made the wrong decision. When I was 17, I bought a Rolliemarin camera housing. It was wonderful. I could focus and change f-stops, shutter speeds, and filters.

For four years, I shot in black and white and watched the way light entered the sea.

I was 12, too, when my father took me to the Bahamas and I saw my first coral reef. Accustomed to the Jersey shore's green murk, I leapt from the boat and found myself looking through brilliant water at a castle filled with life: red and green parrotfish, groupers like camouflaged British bombers, sickly green moray eels, a fat, sinuous nurse shark, an orthodontic barracuda, sea fans, a huge loggerhead turtle. I grabbed the turtle and rode it to the surface. It breathed horrible turtle breath into my face. I was in heaven. No, I was poleaxed.

At that time, there was a contest for kids with an extraordinary first prize: 10 minutes of supersonic shopping at the F. A. O. Schwarz toy store in New York. When the bell rang, you had 10 minutes to grab anything, everything, and nothing you had always wanted. I had a dream. Actually, it was a nightmare. I won. The bell went off, but I couldn't move. My feet were encased in lead deep-sea diver shoes. I was swimming through jello. The clock ticked rapidly. I wanted everything, yet everything was beyond my grasp. In the sea, 30 years later, I still have that feeling. No place on earth has more visual richness than a coral reef. Each moment there is priceless; it can never be recovered and spent again.

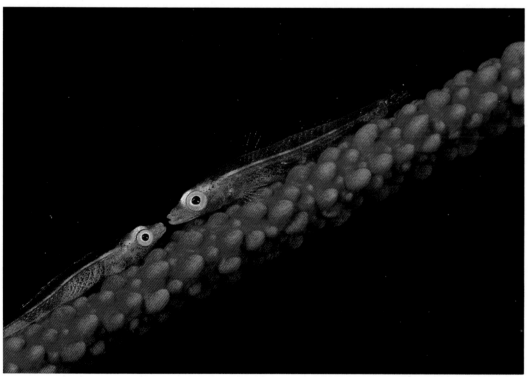

Seafan gobies on whip coral, Coral Sea, Papua New Guinea.
BRYANINOPS LOKI

In 1968, two wondrous changes happened in my life. At Boston University, I met Anne Levine, who was to become my wife. That year the astronauts' first images of Earth from space were published. Few photographs have had more impact than these first portraits of humankind's home, with its spiraling clouds and intense blue surface — a blue to which a distant sun brings life. This blue is the sea. For Anne and me, this blue, this sea, became our lives' central theme.

That year I went to the National Geographic Society to show my work to the director of the photography department, Robert Gilka. Gilka was fearsome, tough. He looked through my sweaty pictures and said with a voice as dark as a monsoon, "There's nothing new here."

"Can I come back?"

"The door is open."

He handed my pictures back. I took them in boneless, meatless fingers, and promptly dropped them. Gathering them as I left, I literally crawled from his office.

Fortunately, Bates Littlehales, one of the Geographic's hero-photographers, was nearby. He picked me up. We went into the editing room. He looked through my pictures:

"There's nothing new here."

He then sat down and told me about photography. A successful picture is an intimate picture, reaching across time and distance, through the lens, onto a strip of film, and into your eye. Whether you photograph fish or children, wild geese or butterflies, you must put yourself on their level and look directly into their eyes.

Bates told me about his work with the OceanEye underwater camera housing. With its cyclopean dome, it could shoot everything from wide-angle seascapes to portraits of shrimp. Bates' vision and the OceanEye revolutionized the making of undersea images.

A year later, I returned with new pictures and got my first assignment. The next year, on another assignment, as I crouched in an underwater blind with Professor Eugenie Clark 30 feet down in the Gulf of Aqaba, garden eels rose from the sandy seabed and danced. In the yellow and blue light of early morning, I made my first picture for *National Geographic*.

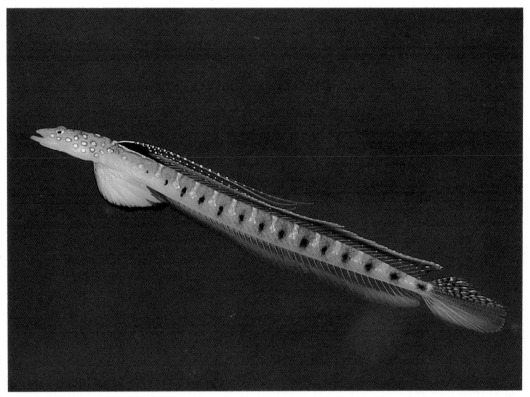

Sand diver fish,
Marsa el Muqabelah, Egypt.
TRICHONOTUS NIKII

Bob Gilka became my mentor. Occasionally he appeared in my dreams like the fearsome face of the Wizard of Oz, sending me tumbling with his dangerously accurate observations. Behind the Wizard of Oz face, Gilka had real understanding for each photograph. He pushed me, prodded me, asking the classic journalist's questions with a force that changed the way I took pictures.

Facing Gilka and *National Geographic* Editor Wilbur Garrett at a projection session felt like undergoing surgery in public—without anesthetics. But time after time, looking through new work, Garrett has shown a rare ability to instantly choose the most radical, dreamlike image, the one that will pull readers from their comfy lives and put them in the sea.

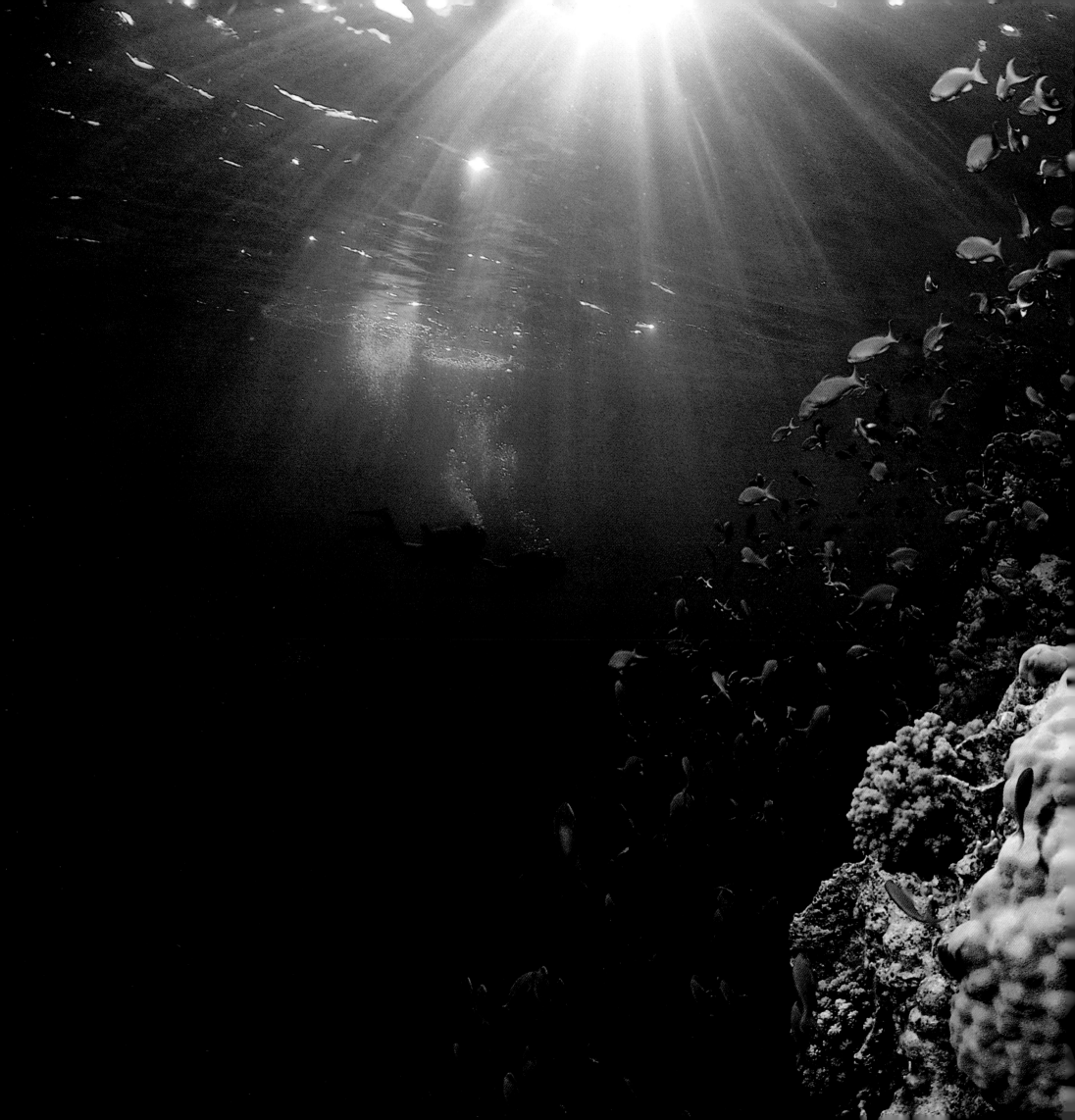

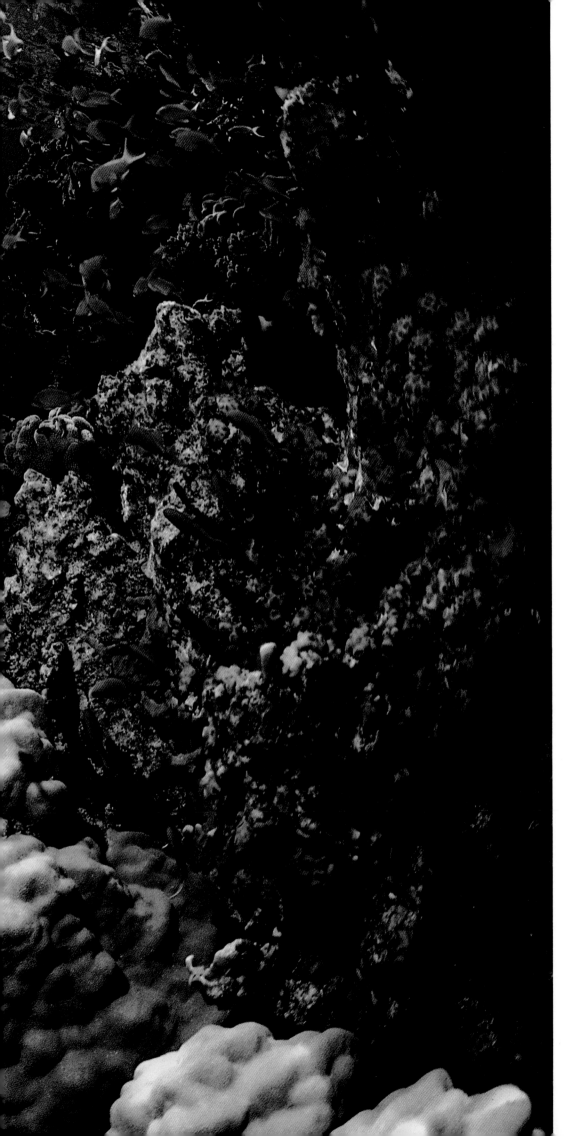

This book is a journey across the earth's waters, a journey Anne and I have made together. Back to back, we have watched mating sharks in the Red Sea, swum in a broth of jellyfish in Palau, felt cuttlefish arms and seal whiskers in the mid-Pacific, looked down the garbage-disposal throats of great white sharks, and witnessed the dance of clownfish against velvet curtains of anemones. After each dive, we have swum up together to the surface light.

Last year, our daughter Emily learned to put her head in the water and made her first crossing into the world below. We had just completed an assignment on the Great Barrier Reef and were back on land at a small motel in Port Douglas, Queensland. Anne had bought Emily a tiny mask, and she would paddle contentedly around the motel pool. One afternoon, she was hanging onto the pool's edge, singing and talking to herself very loudly, disturbing the other guests. I said to her in the usual, powerful, daddy-hiss-voice, "Emily, be quiet."

Then louder, "Emily, be quiet!"

Then even louder, "Emily, stop! Be quiet!"

She looked up, then rolled over and put her head underwater, and civilization vanished with one last bow.

David Doubilet
New York, October 1988

School of anthias, "The Temple,"
near Ras Um Sid, Egypt.
ANTHIAS SQUAMIPINNIS

17

THE RED SEA

From space, the Red Sea looks like a blue arm holding up two fingers in Churchill's "V for Victory" gesture. The fingers are gulfs surrounding the triangular Sinai Peninsula: Suez to the north, Aqaba to the east. Finding the Sinai is easy; clouds rarely cover the land, and the deserts' khaki stands out against the sea's strong blue.

The Red Sea lies along the Great Rift Valley, created by geological forces that are driving the continents of Asia and Africa apart. Its shores are continental shelves that drop off abruptly a few hundred yards from land. Near the tops of these precipices, where underwater light is strongest, corals, sponges, and fish compete fiercely for living space. There are places in the Red Sea that harbor an abundance of marine life equaled nowhere else on earth. The reef at Ras Muhammad, a headland that juts like an errant nose hair from the southern tip of the Sinai Peninsula, is one of those places.

I first dove at Ras Muhammad on a late fall day in 1974. My diving partners were my wife Anne, the noted marine biologist Dr. Eugenie Clark, Dr. Yehuda Melamed, David Fridman, and Howard Rosenstein. Howard, an expert guide to the Red Sea's coral reefs, was going to show us Ras Muhammad's sunken islands. But first we had to haul regulators, double tanks, weight belts, masks, fins, snorkels, and safety vests from our Jeeps to the sea, a process we call "going down to the sea in schleps." We followed this with a true sporting event—International Wetsuit Wrestling. You don't simply don wetsuits, you fight them. And always, no matter how carefully you brush off your feet, Sinai sand creeps up the pants and joyfully migrates to the tender nether parts.

Ras Muhammad, Egypt.

Once dressed, we waded in ankle-deep water until we reached the brink of a submerged cliff 50 yards from shore—the end of the Sinai's narrow continental shelf. Then, with masks over faces and regulators in mouths, we stepped off the edge of Asia. The desert, bleached like an old Ektachrome slide, vanished, and we sank into the richness of the Red Sea. As we trundled down the reef, everybody carried at least one camera. It was like some classic African safari: Bwana with camera bearers. I was Bwana.

We followed a wall that stair-stepped into the depths. Yellow- and black-striped sweetlips and blue-striped sturgeon slipped in and out of a maze of plate coral covering the heights. I swam deeper, to a series of little bays and points. Half a dozen anemones, some as large as card tables, covered one point—a virtual anemone city. The sea surge made the tops of their yellow tentacles and the red velvet surfaces of their skin undulate gently.

From hovering nimbus clouds of yellow clownfish and black damselfish, clownfish darted out and burrowed into an anemone's venomous tentacles, weapons so lethally armed that the anemone itself exudes a protective mucus along the sides of its tentacles to prevent self-destruction. To swim safely in the anemone's couchlike but deadly embrace, the clownfish covers its body with this mucus.

We swam along the reef until we came to its rounded end, where a huge sea fan grew at a depth of 80 feet. From there, a remarkable view opened northward to a sunken island connected to the reef by a coral ridge. In the clear water, sunlight brightened the island's heights. I was in a Western movie drenched in blue dye, an underseascape filled with buttes, box canyons, and arroyos. Even the sea fans might be tumbleweeds. Then the Indians came thundering down the canyon. But they weren't Indians. They were a dozen short-nosed gray reef sharks. I broke out of my late-show reverie as they began to circle each other, backlit by the sunny wall of the sunken island. One bit

another. I glanced at Genie; behind her faceplate, her eyes were as big as kiwi fruits. We were seeing sharks' courting behavior, and we were the first people to witness it in this species' native waters.

On assignment five years later, we returned to our sea fan perch to spend a month with the courting sharks. Watching them was like watching an Eastern European folk dance—with interludes from a San Diego bar brawl. As female sharks began swimming in a circle, a male shark would rush in, single one out, and chase her, biting her flanks in a dominance display which probably triggers ovulation. Before long, the females became covered with deep, jagged bites. Occasionally, a jack fish riding in a female's body wave would dart down to bite off a piece of dangling flesh.

Late one afternoon, Genie and I chanced to see two sharks mate. We spotted them far below, swimming side by side in very dark waters; the male was striving to insert one of his claspers into the female. For a few moments, the pair swam nervously together. Then they separated, disappearing in the depths.

On our first dive, we swam across the coral bridge to the sunken island. It was covered with a forest of soft alcyonarian corals whose water-filled bodies resembled broccoli—broccoli painted by Picasso. As I turned a corner, thousands of anthias appeared, veiling the island's upper ramparts. In this swarm, a large mimic blenny imitated the anthias' movements and occasionally bit one. Chromis came out from their homes in coral heads to feed on plankton. Orange, yellow, blue, and green, the veil of fish shimmered against the sea's blue curtain in an apparently peaceable kingdom. Suddenly, as a group of feeding jacks dove through, the veil recoiled, like someone taking a punch in the stomach.

Ras Muhammad's coral gardens look onto a grand promenade where

schools of pelagic, or ocean-going, fish parade. On our first dive, we watched the parade from the northern island's tip: school after school of jacks; 500 batfish, their silver sides reflecting afternoon light; five fat, bomberlike dog-tooth tunas; a hammerhead shark high overhead, silhouetted against the path of the sun; a school of shuri swimming in a loose funnel shaped like an emerging tornado.

The current grew stronger; I floated backwards along the reef, slipping from handhold to handhold. Genie and Anne disappeared into a cave. I peered in. A yellow chandelier of gorgonian coral grew from the ceiling. Sponges and tunicates hung from the walls like melted candle wax. Its mouth open like a dental patient's, a blue grouper with tiny red spots was having its jaws and gills picked over by a blue-striped cleaning wrasse. As the wrasse went to work on its teeth, the grouper blushed, turning pale gray.

I pushed out of the cave and let myself go in the current, flying past fields of soft coral and through schools of orange anthias. At the corner of the island, I rested in a coral alcove, sitting with my back against the reef. Above, a huge school of barracudas circled slowly. I knew exactly where I was: at the tip of Ras Muhammad, at the end of the Sinai Peninsula, looking south into the heart of the Red Sea. To my left was Asia, to my right, Africa. Between them, I had at my back the richest reef I'd ever seen.

Howard swam up to me and pointed out a large humphead wrasse, green and blue with a reticulated pattern over its body like tiles in an Arabian mosque. Although the fish was almost the size of an early Honda Civic, it was very shy. We could not get within 50 feet of it.

Two years later, a group of German divers befriended the wrasse by feeding it hard-boiled eggs. It spat out the shells with a delicacy strange to see in a creature whose mouth opens as wide as a 30-gallon garbage can. It became a pest, following divers around, its sharp eyes rotating like ball turrets, easily spotting anything resembling food in the pockets of the divers' safety vests.

One day that year, I watched Anne swimming along the reef with a pair of yellow diving gloves in her vest pocket. The wrasse zeroed in for the kill. Anne was oblivious. There was a great thump; she screamed, and the wrasse hovered, its eyeballs snapping rapidly from side to side as it tasted the gloves. Then with a whoosh that sounded like the word "feh" it spat them out. In the blast of water from the wrasse's mouth, the gloves danced the way Mickey's hands did in "The Sorcerer's Apprentice."

It began to grow late. We crossed a saddle connecting the northern and southern sunken islands. Maroon clumps of gorgonian coral covered the southern island's deeper slopes, and pairs of hawkfish hid in the branches, feeding with their forcepslike snouts on detritus and plankton caught in the coral. Colored like tablecloths at an Italian restaurant, the fish blended in perfectly with the rosy branches.

David Fridman and I swam into a cave. Through holes in the roof, shafts of sunlight illuminated thousands of glassy sweepers fleeing across the cave's mouth—a living curtain. Our bubbles mingled with them in a dance of silver light and black shadows. A lionfish, fins spread like a Chinese fan, swam through, taking advantage of the confusing light and bubbles to snap up sweepers. A scorpionfish hung on the cave's ceiling, camouflaged, watching, waiting.

Riding a countercurrent, we swam around the back of the southern island to a part of the reef that seemed strangely dead. I thought, "What a wonderful place for a shipwreck." Five years later, during a freak storm in the dead of night, the motor vessel *Jolanda,* 230 feet long, ran aground here. Bound for Aqaba, she carried a mixed cargo of Hunt's tomato paste, Chips Ahoy cookies, sinks, bathtubs, toilets, a BMW, hideously flowered vinyl wall covering, and drillers' mud for oil wells. Amateurish salvage schemes threatened to turn the wreck

into a disaster. If mud were to be spilled, the blanket of filth would choke the reef to death. Alerted to the problem by Howard Rosenstein and other Red Sea divers, U.S. Ambassador to Israel Samuel Lewis managed to halt the salvagers, and the reef was saved. In 1987, during another storm, the *Jolanda* slid off the reef and vanished most mysteriously into deep water.

One by one, my diving partners ran out of air and began the long snorkel back to shore. Alone, I swam along the reef's edge. I spent the last of my air and the last of my film photographing a green turtle sleeping on a ledge where the continent drops off.

When I came out of the water, the afternoon sky had turned brassy; dust from the desert hung over Ras Muhammad. We did not talk as we piled the equipment into the Jeeps. In the silence, we heard a strange fluttering sound. We climbed over a ridge and looked down into a mangrove channel. Thousands of white European storks filled it, resting and feeding after migrating across the Mediterranean. By morning, they would be gone, flying southward down the Red Sea on their age-old route, with Asia on their left and Africa on their right.

Humphead wrasse, Ras Muhammad, Egypt.
CHEILINUS UNDULATUS

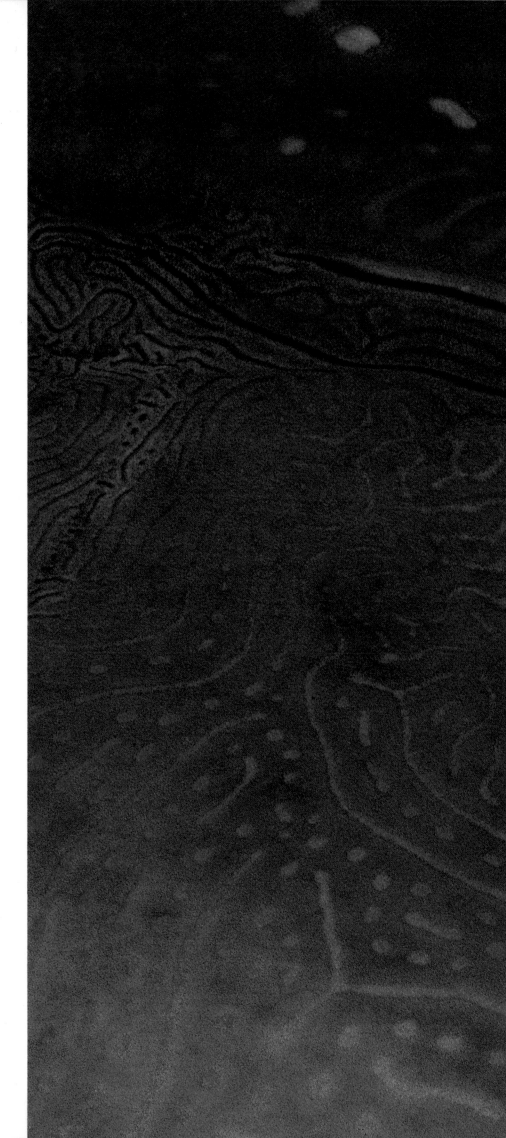

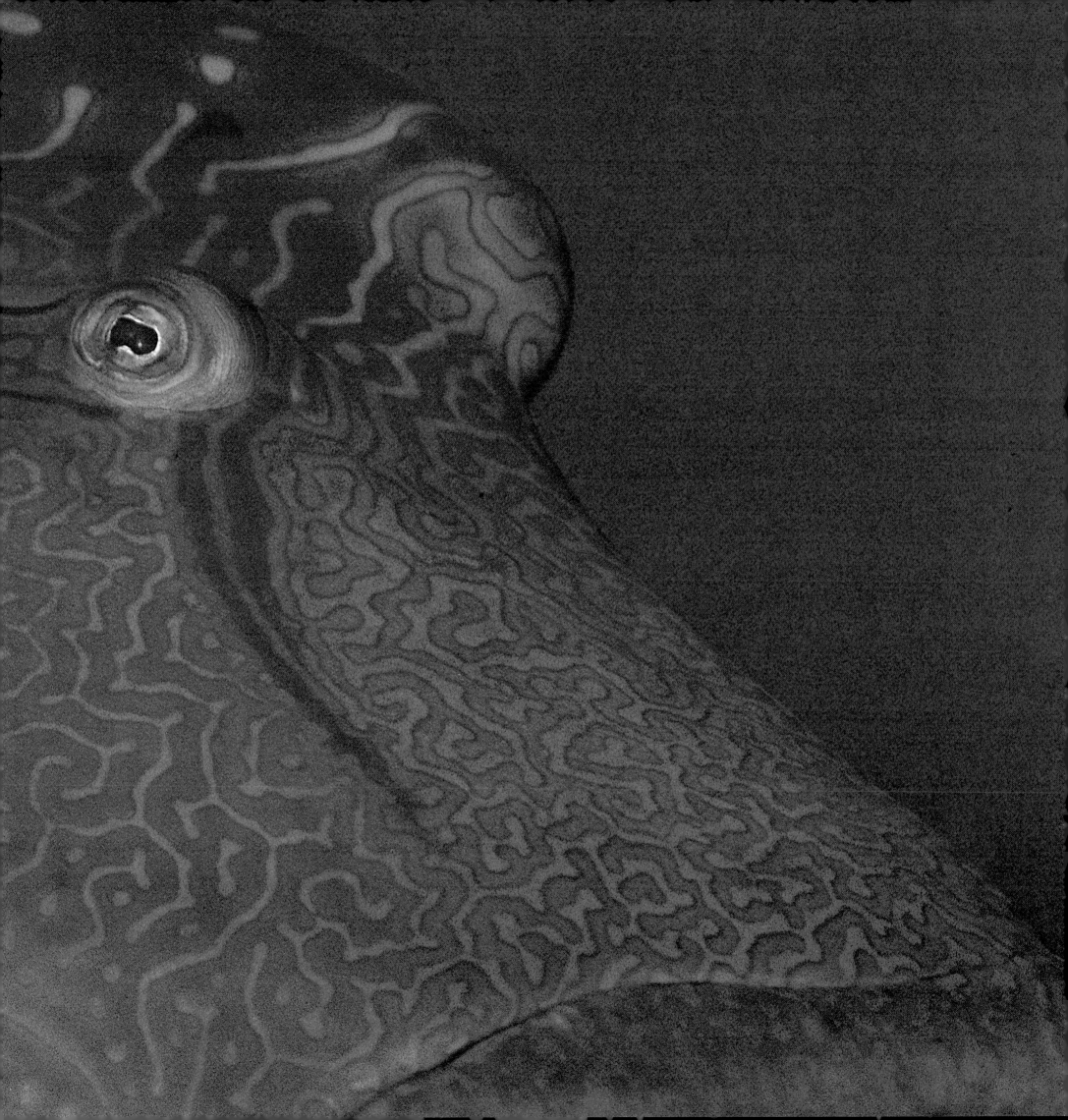

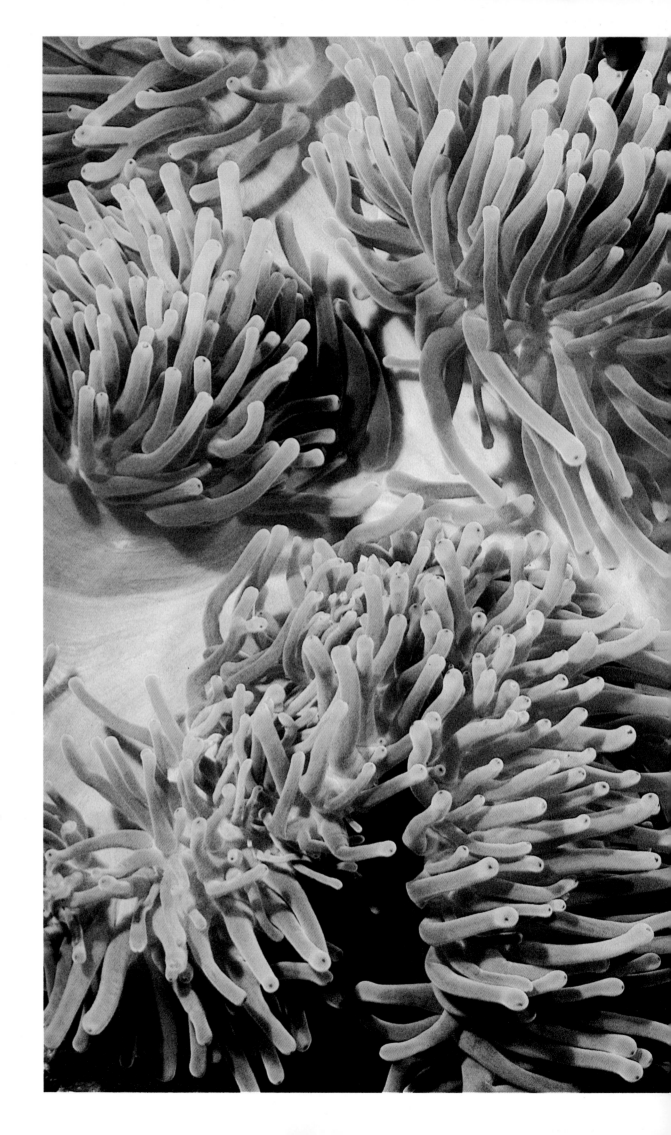

Clownfish among sea anemones,

Ras Muhammad, Egypt.

AMPHIPRION BICINCTUS

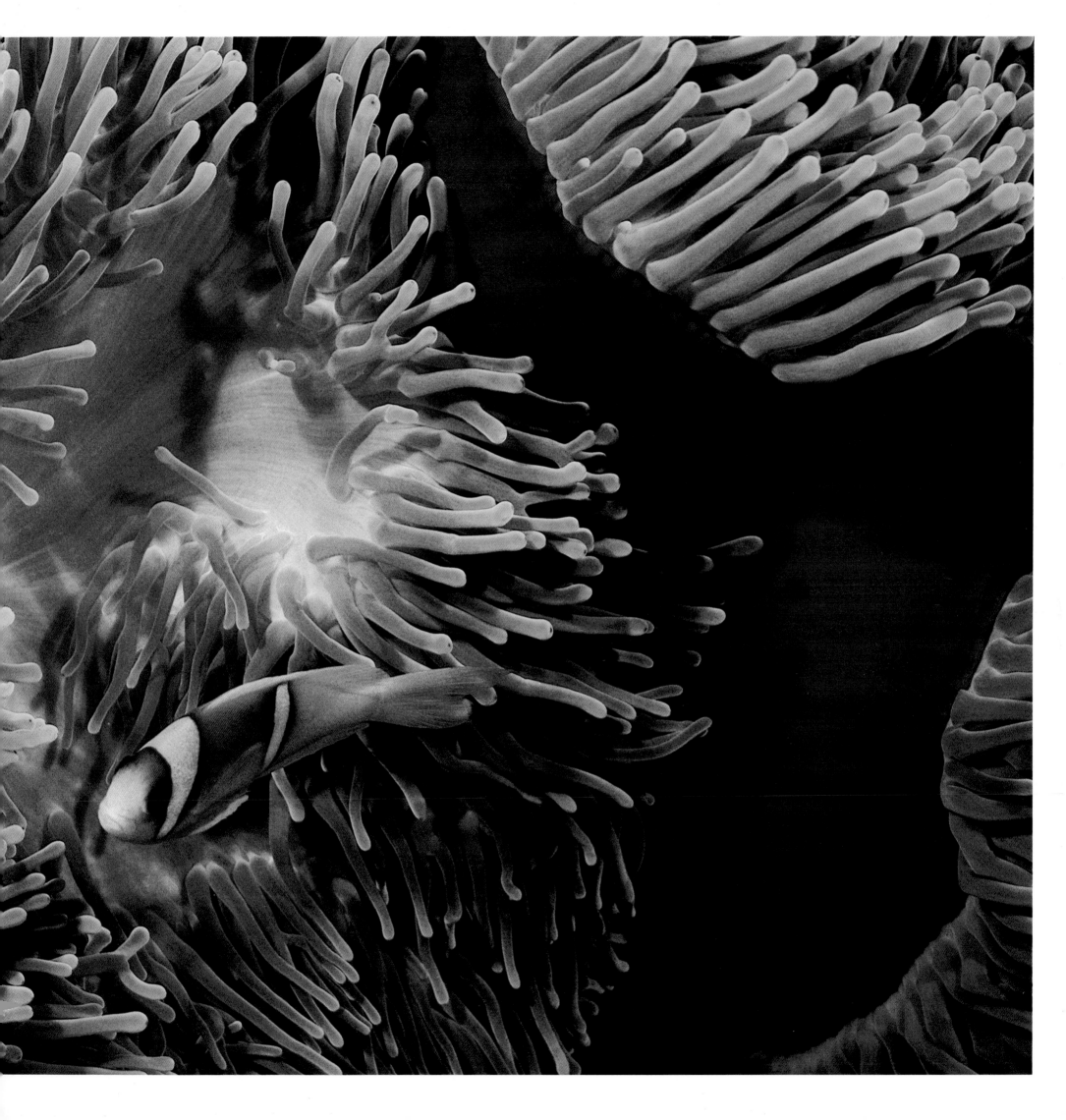

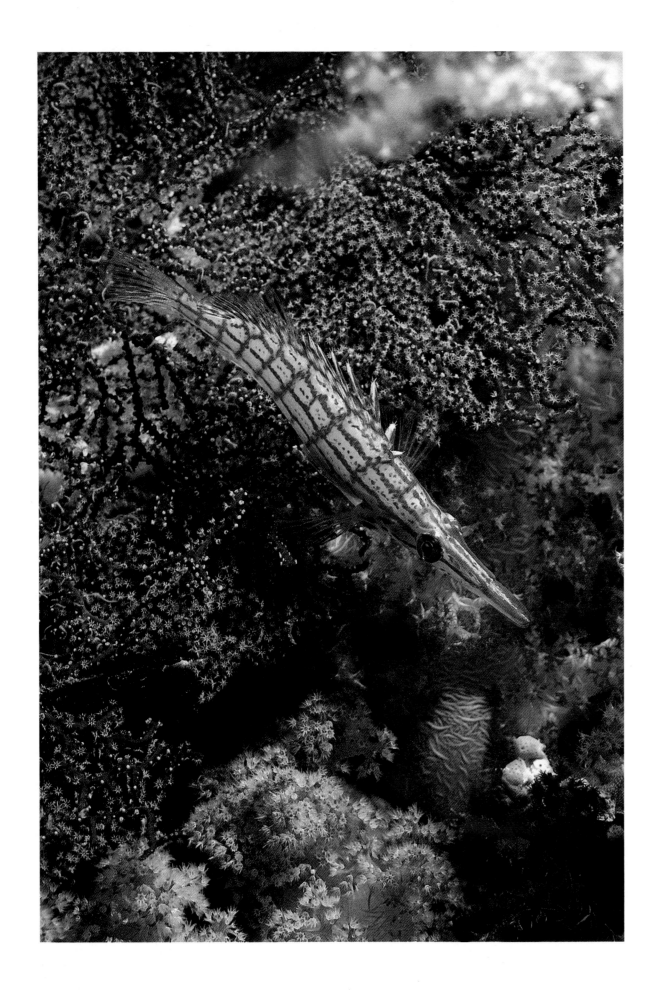

Hawkfish in gorgonian coral,
with alcyonarian coral in lower
right, Ras Muhammad, Egypt.
OXYCIRRHITES TYPUS

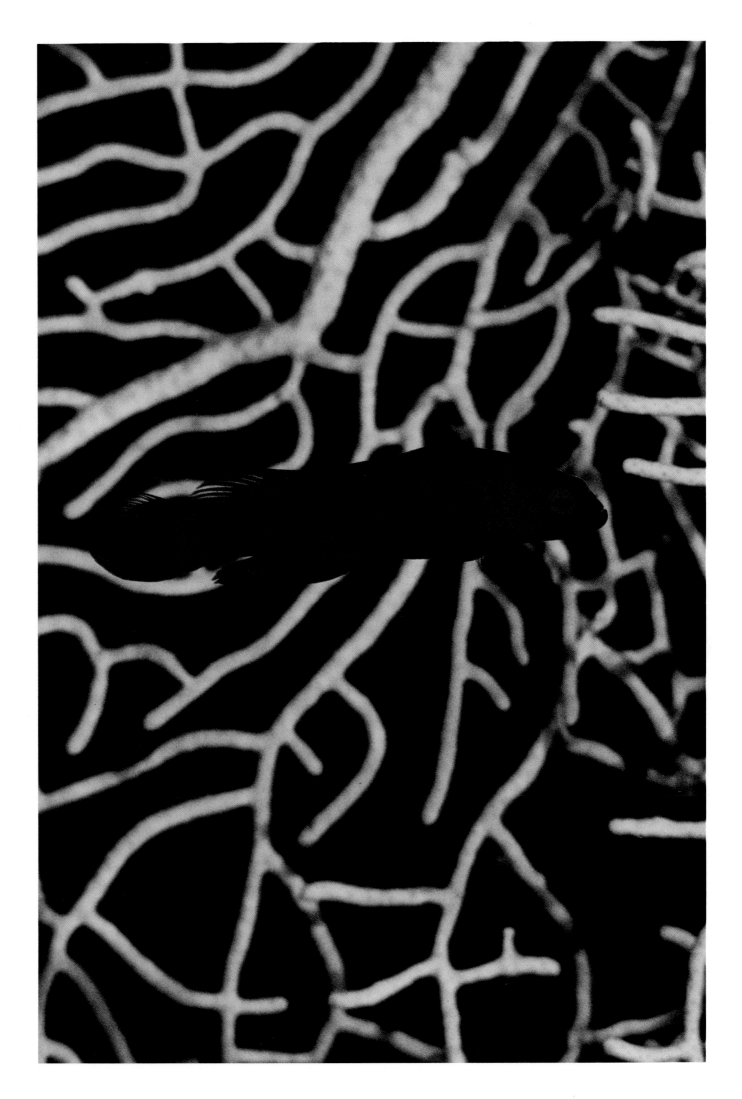

Chromis and gorgonian coral,

Red Sea.

PSEUDOCHROMIS FRIDMANI

*(Below) Naturalist David Fridman
and pufferfish, near Elat, Israel.*
CHILOMYCTERUS ORBICULARIS

*(Facing) Jackson Reef, Strait of
Tiran, Red Sea.*

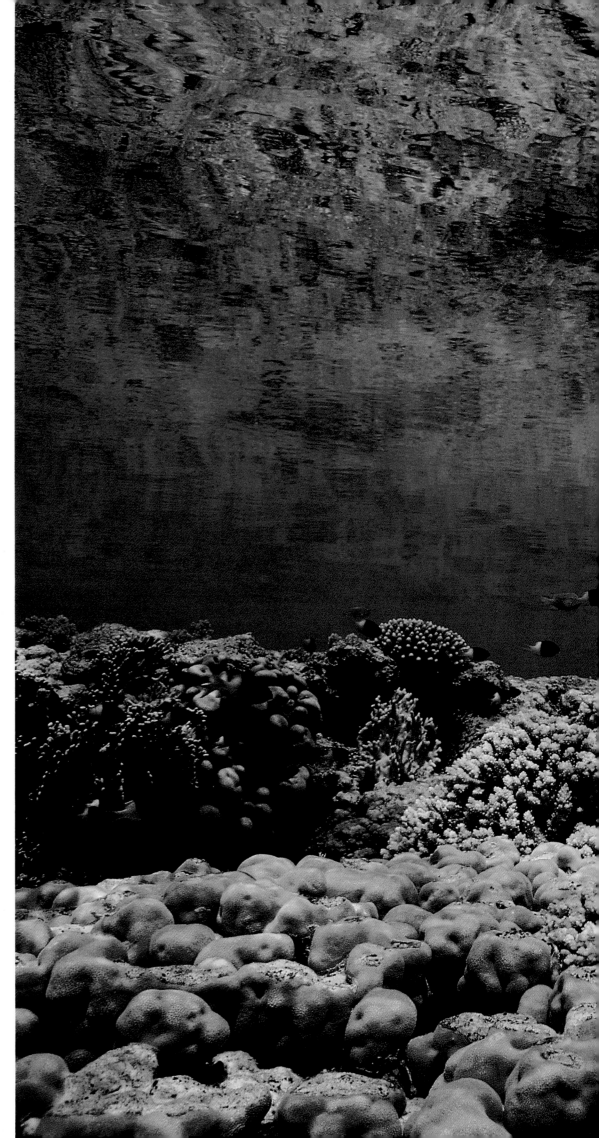

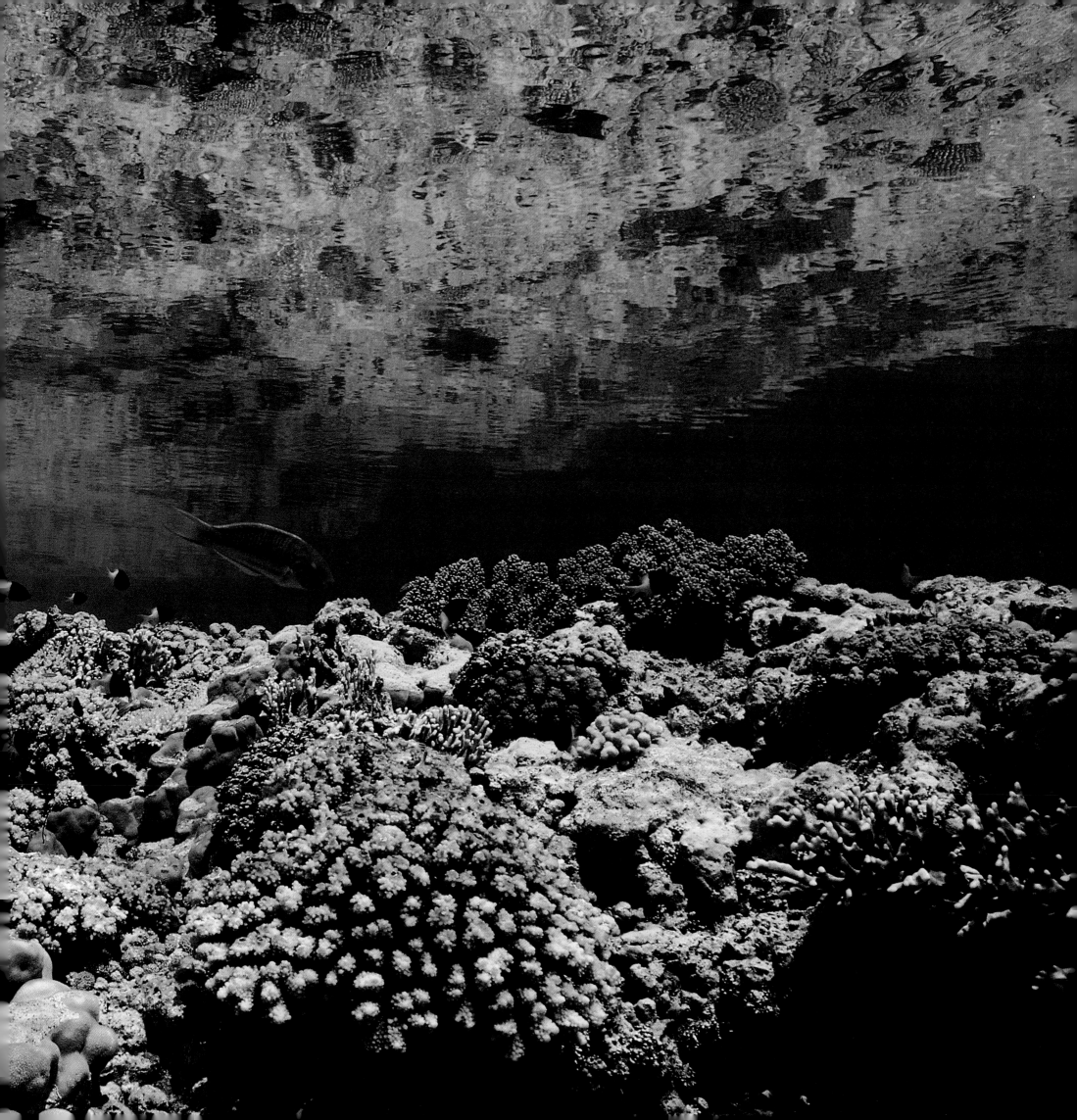

Lionfish herd school of

silversides, near Elat, Israel.

Lionfish hunts with

stinging dorsal fins erect,

near Elat, Israel.

PTEROIS MILES

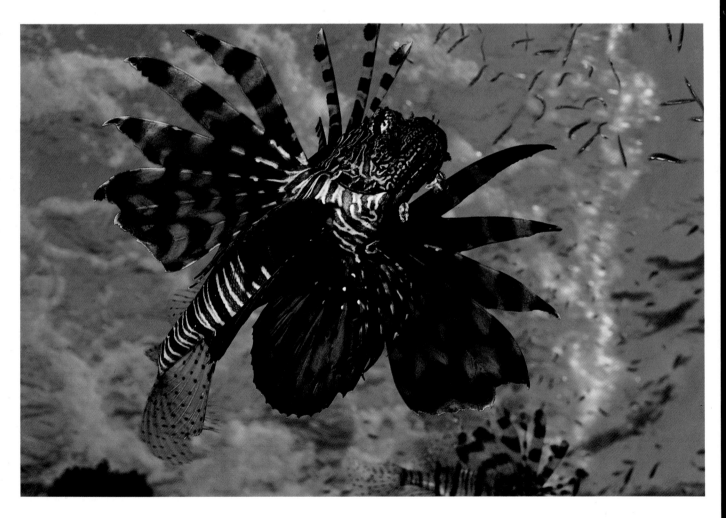

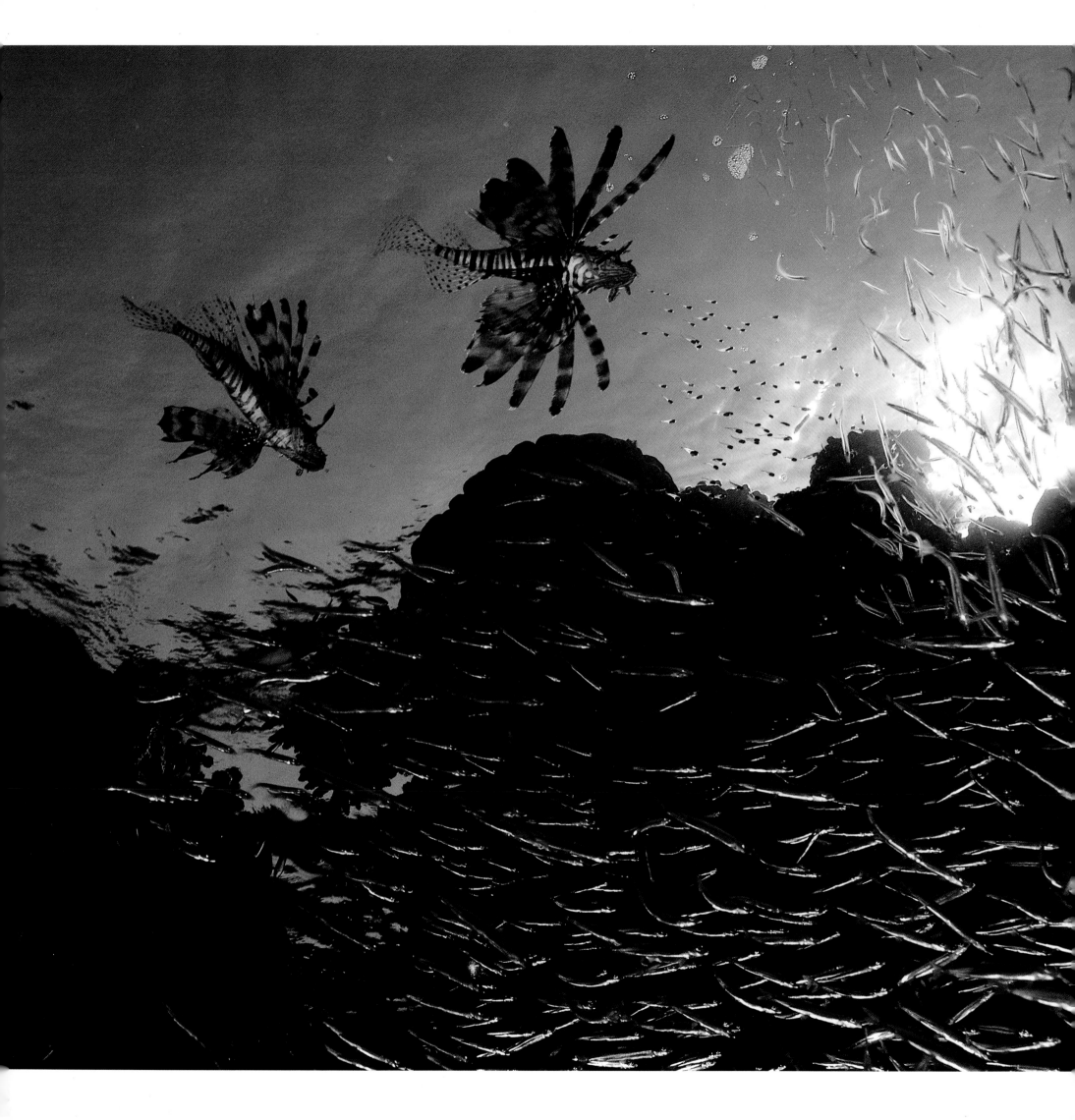

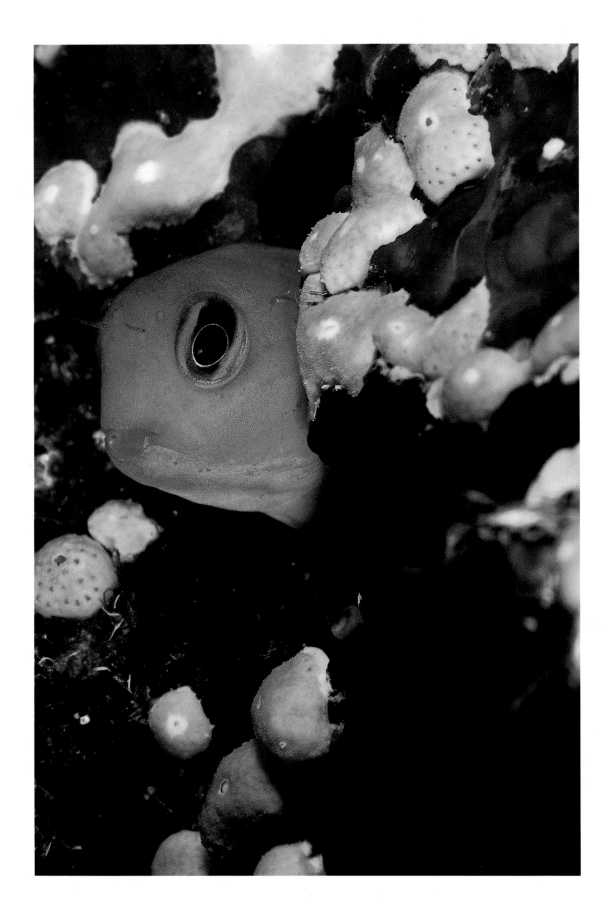

Mimic blenny in home on
sponge-covered reef wall,
Ras Muhammad, Egypt.
ECSENIUS MIDAS

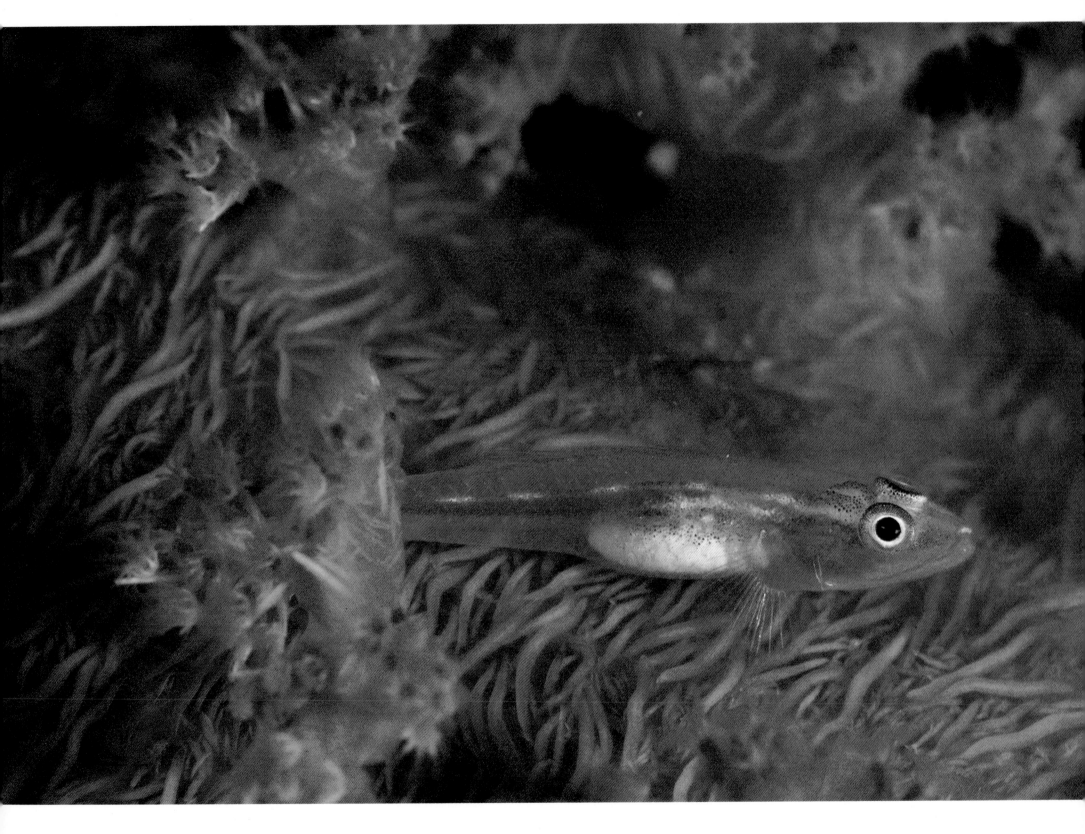

Soft-coral goby in branches of soft

coral, Red Sea.

PLEUROSICYA SP.

(Overleaf) White moray eels in

discarded oil drum, Marsa el

Muqabelah, Egypt.

SIDEREA GRISEA

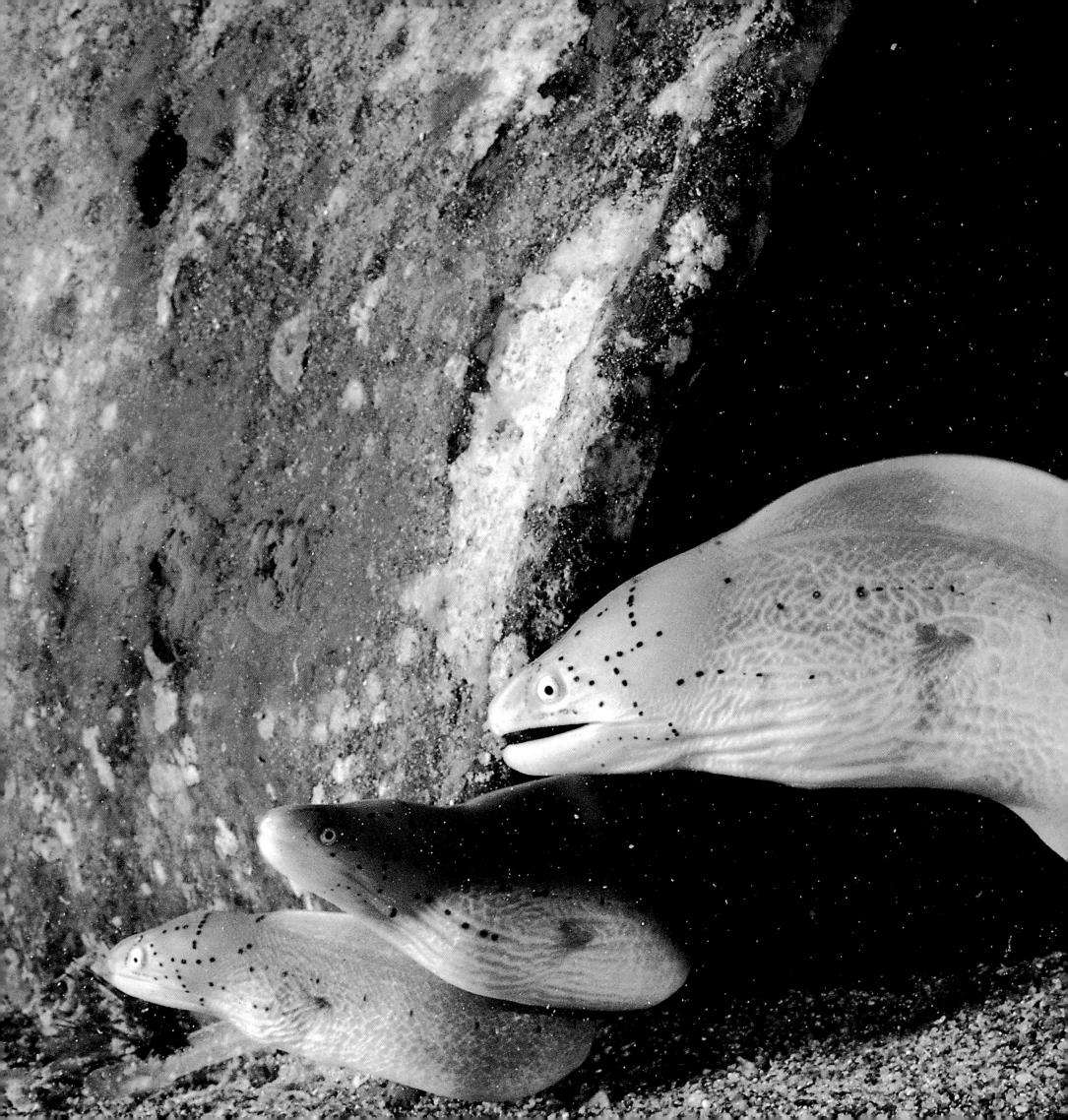

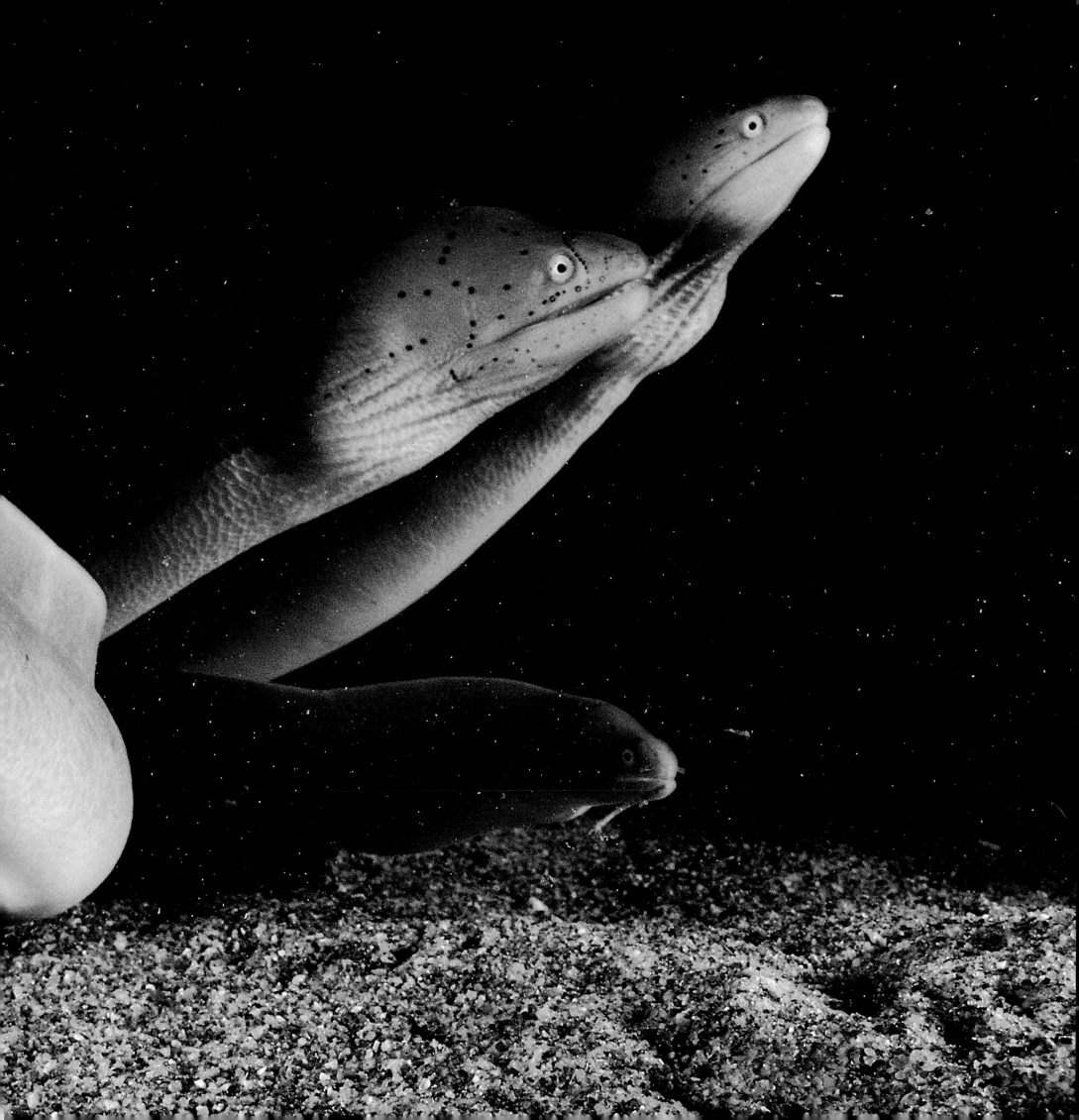

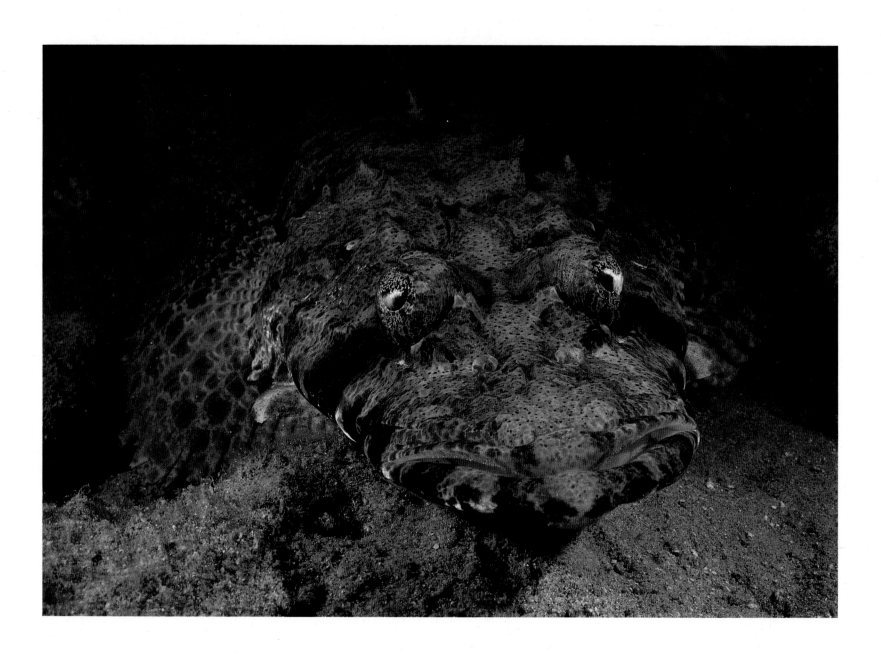

Crocodile fish, near Elat, Israel.

PLATYCEPHALUS INDICUS

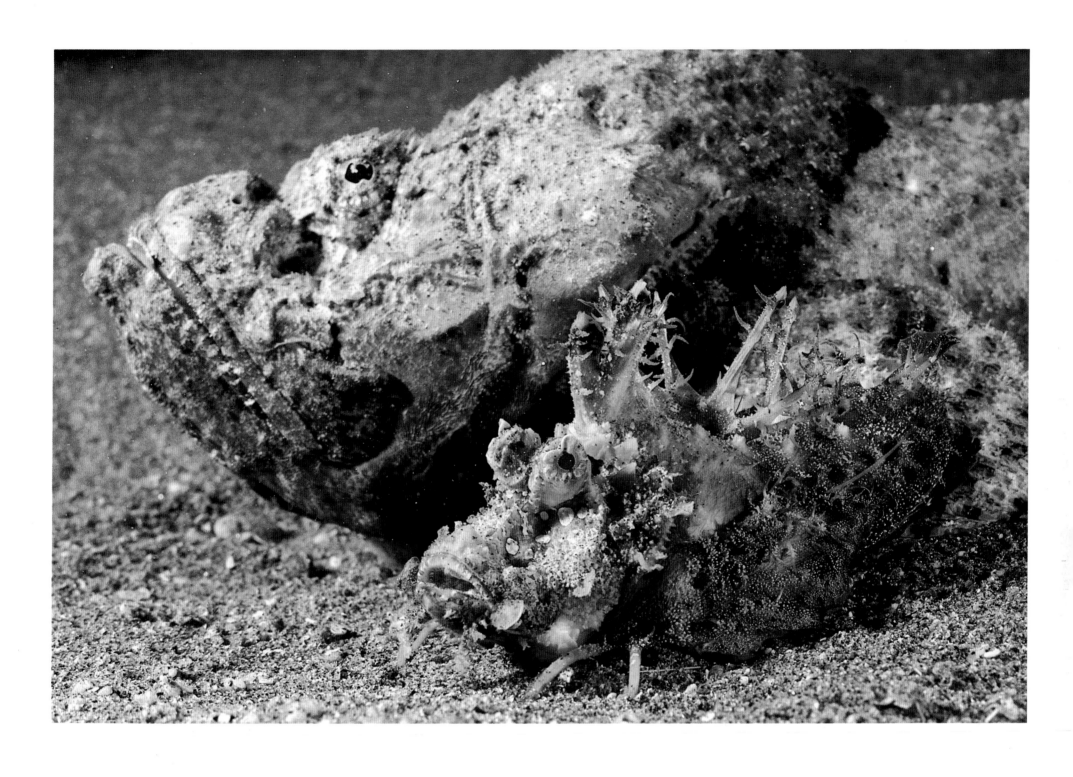

Inimicus in front of devil

scorpionfish, near Elat, Israel.

INIMICUS FILAMENTOSUS;
SCORPAENOPSIS DIABOLUS

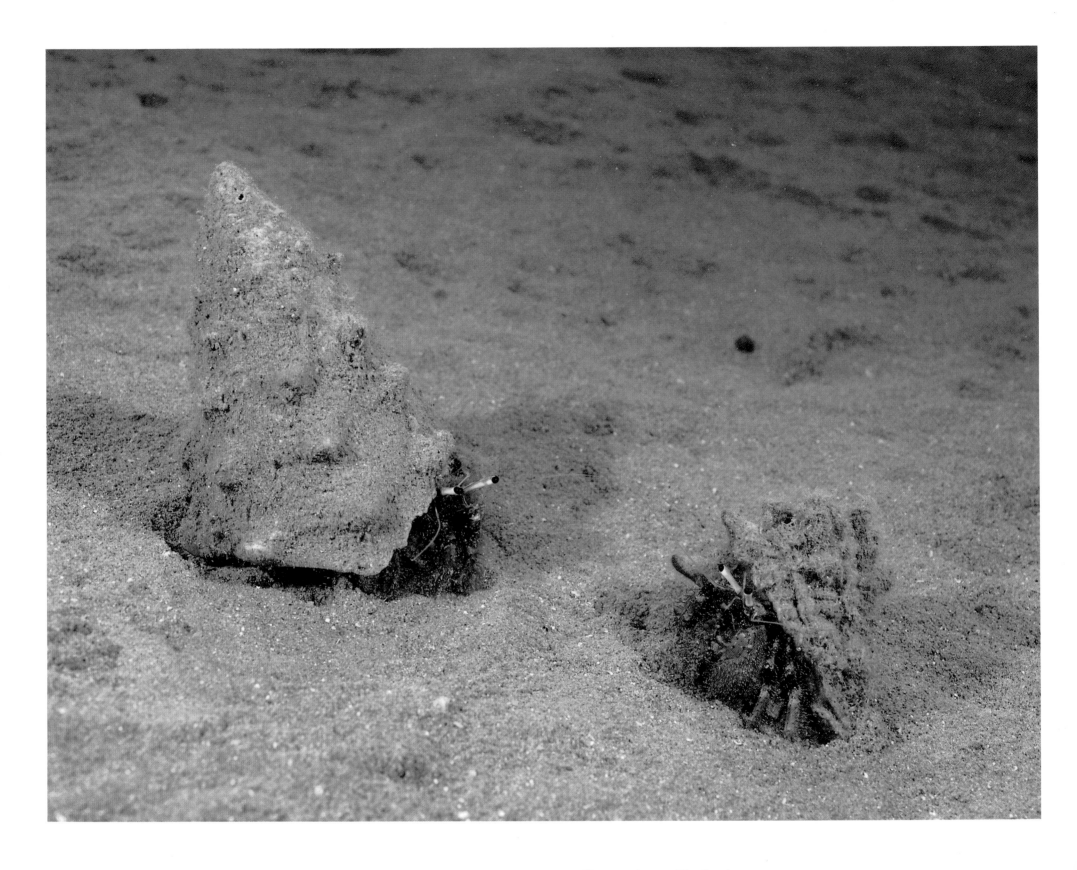

Hermit crabs, near Elat, Israel.

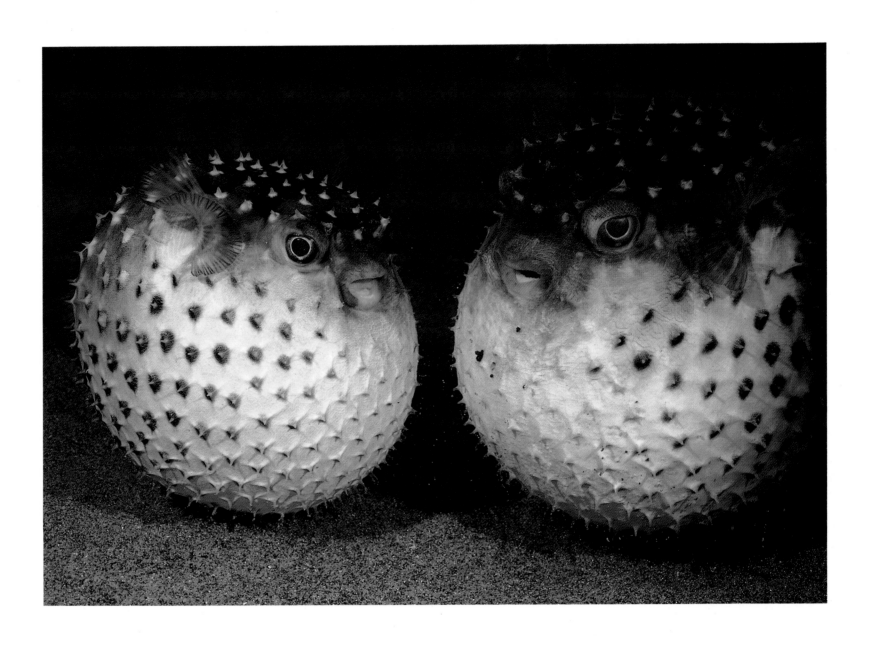

Yellow-spotted pufferfish, near

Elat, Israel.

CHILOMYCTERUS SPILOSTYLUS

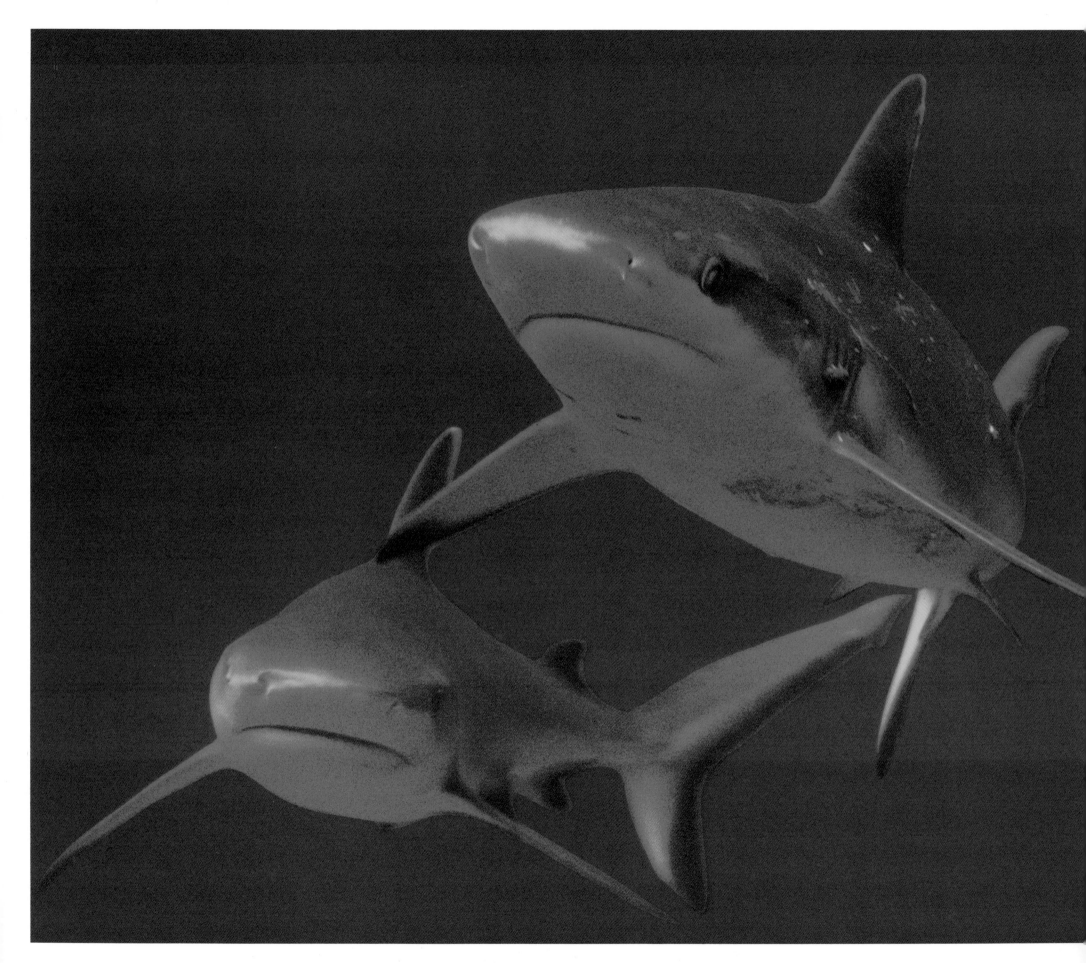

Male short-nosed gray reef shark

chases female scarred with bites,

Ras Muhammad, Egypt.

CARCHARHINUS WHEELERI

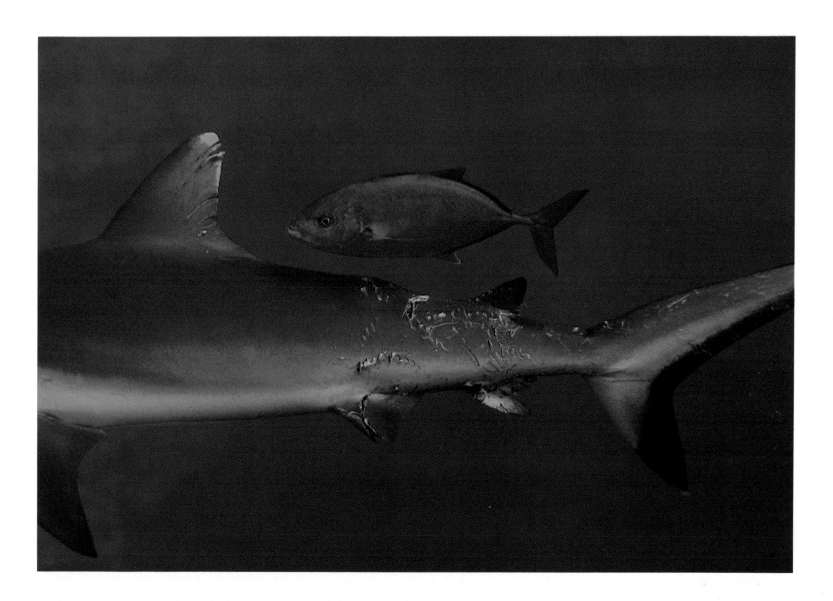

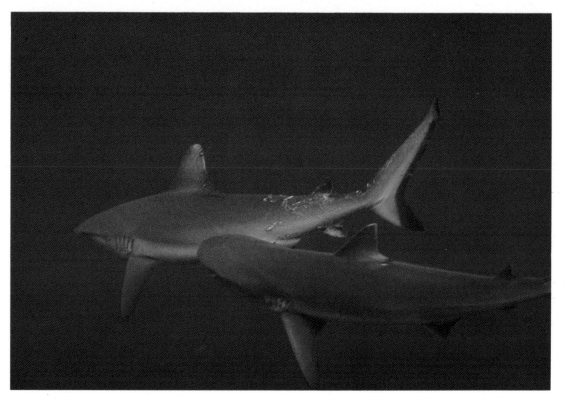

(Above) Jack feeds on loose skin of female short-nosed gray reef shark, Ras Muhammad, Egypt.

CARANX SEXFASCIATUS
CARCHARHINUS WHEELERI

(Left) Male short-nosed gray reef shark bites female, Ras Muhammad, Egypt.

(Overleaf) Glassy sweepers, near Elat, Israel.

PARAPRIACANTHUS GUENTHERI

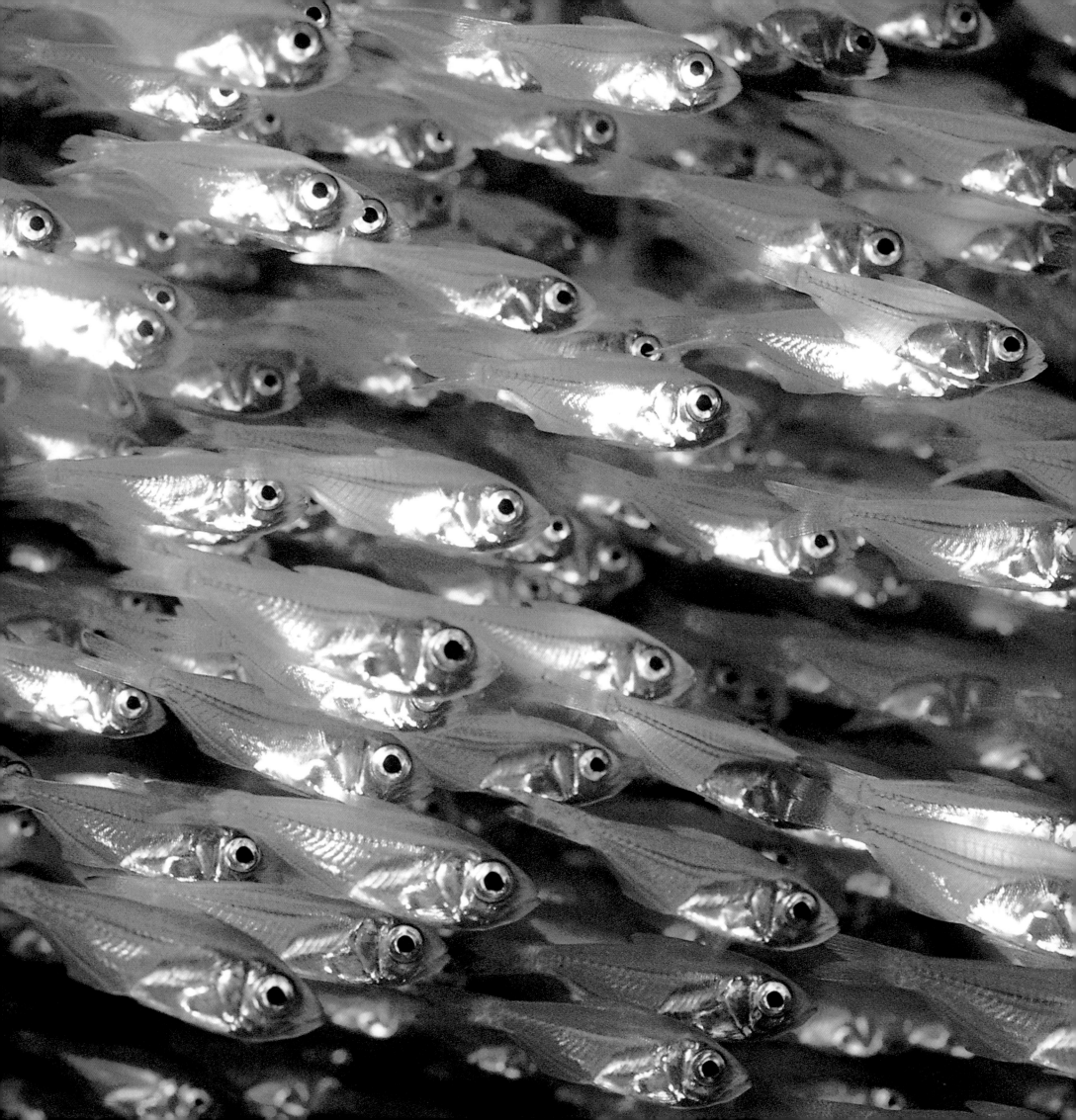

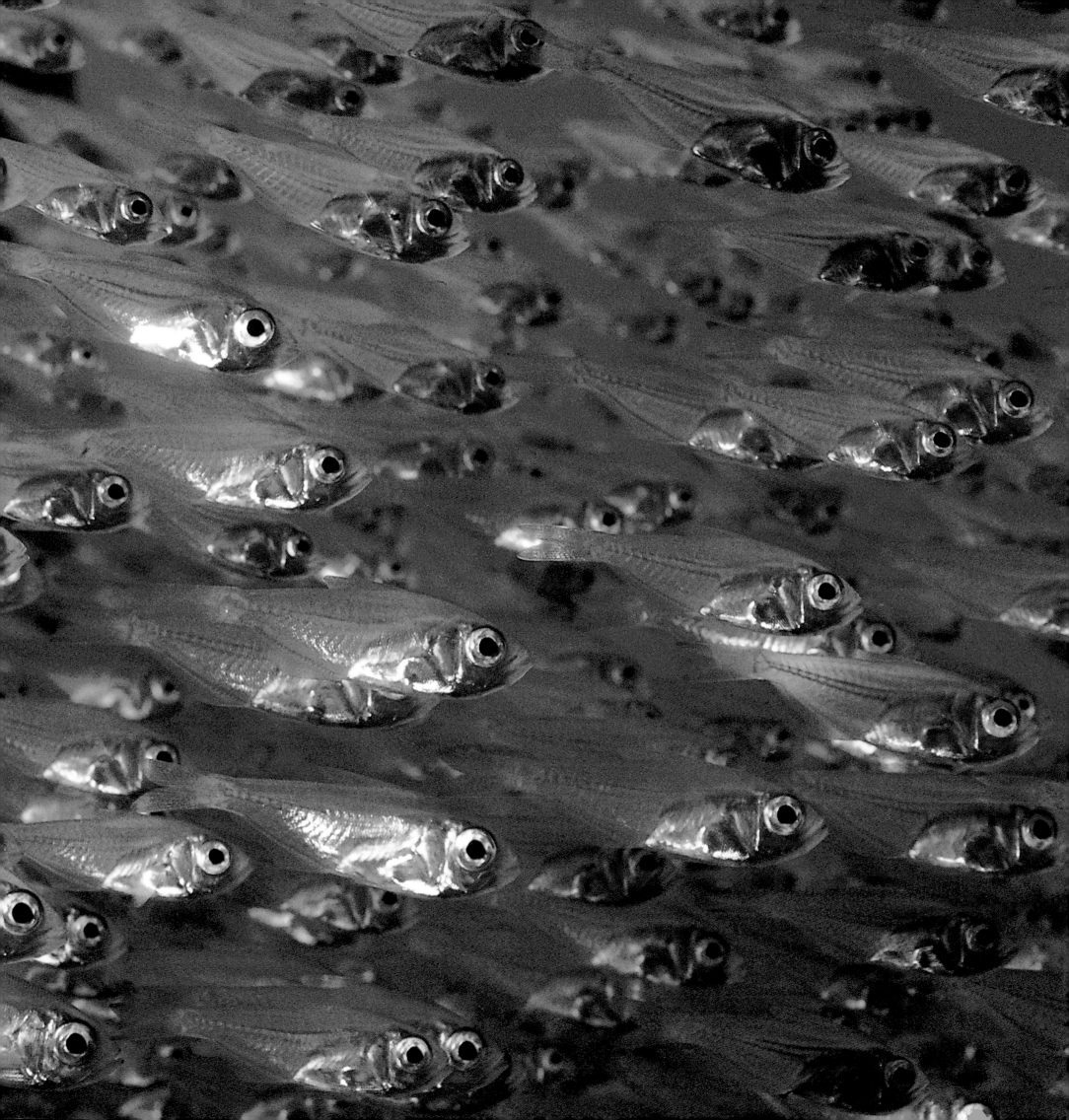

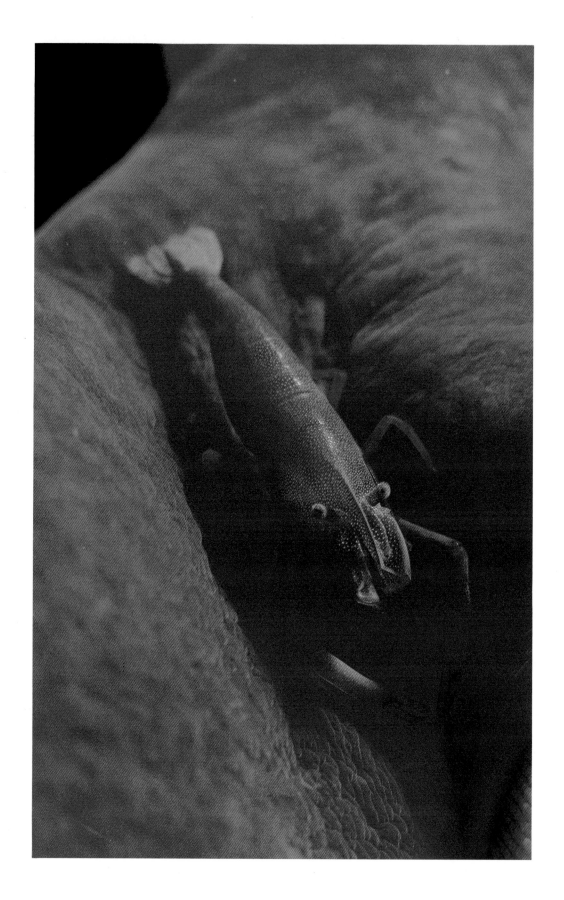

Half-inch shrimp rides on nudibranch where it forages for detritus, Marsa el Muqabelah, Egypt.

PERICLIMENES IMPERATOR;
HEXABRANCHUS SANGUINEUS

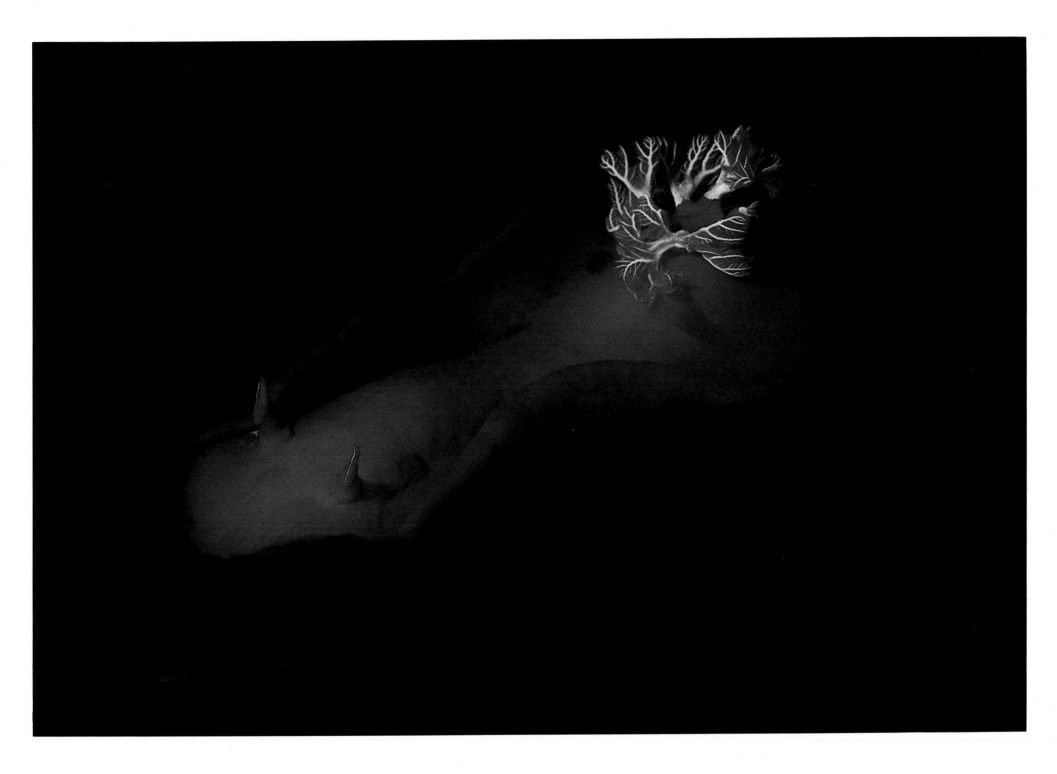

Nudibranch, Marsa el Muqabelah,

Egypt.

HEXABRANCHUS SANGUINEUS

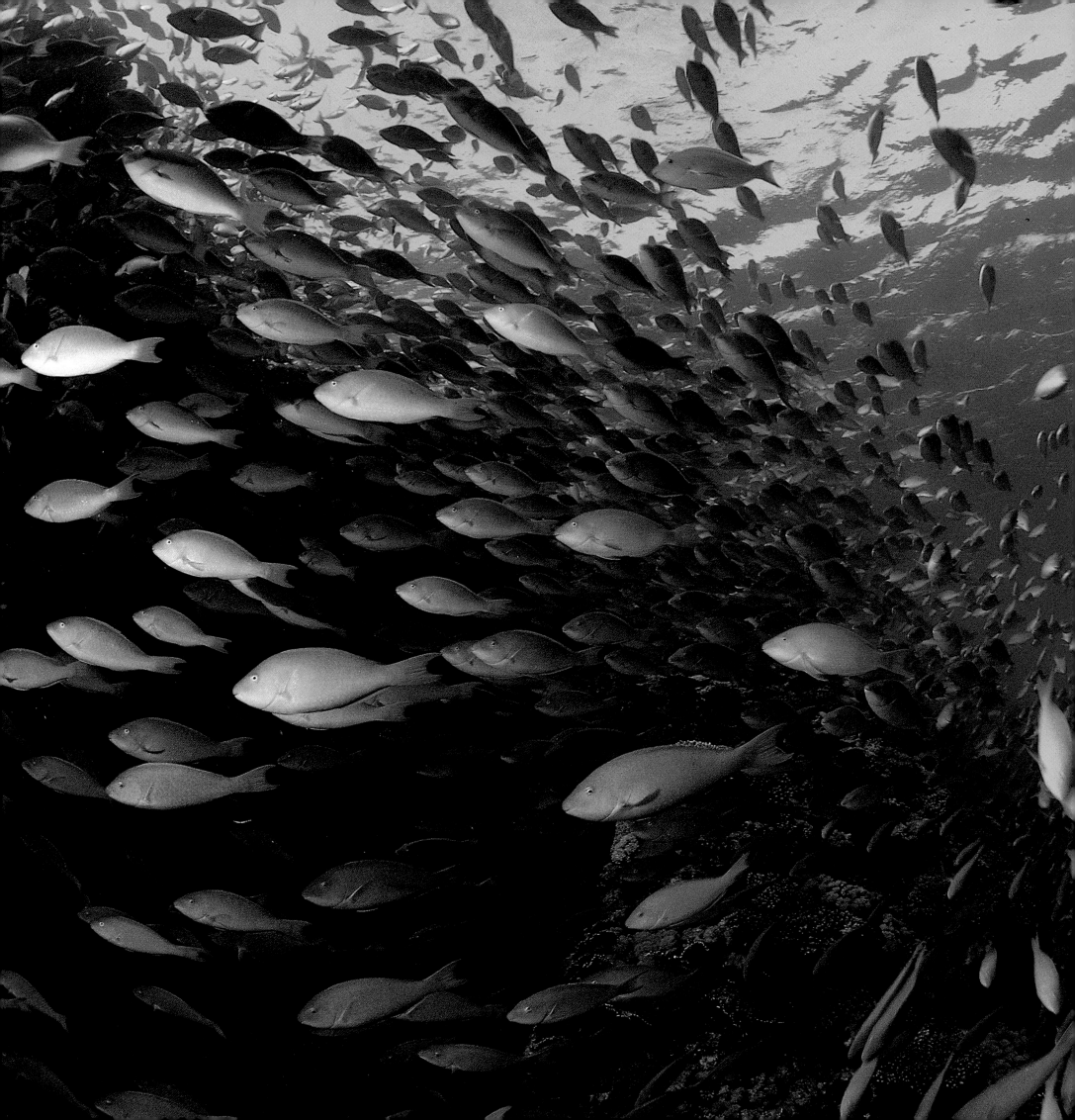

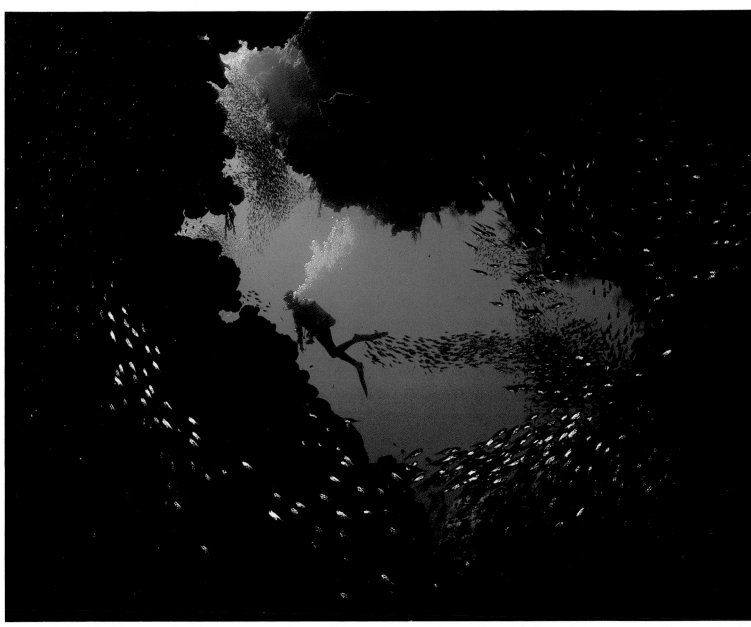

*Longnose parrotfish
gathered in unusual numbers,
possibly to mate, Ras Muhammad,
Egypt.*
HIPPOSCARUS HARID

*Diving guide Howard
Rosenstein at mouth of Yatza's
Cave with school of glassy
sweepers, Marsa Bareika, Egypt.*
PARAPRIACANTHUS GUENTHERI

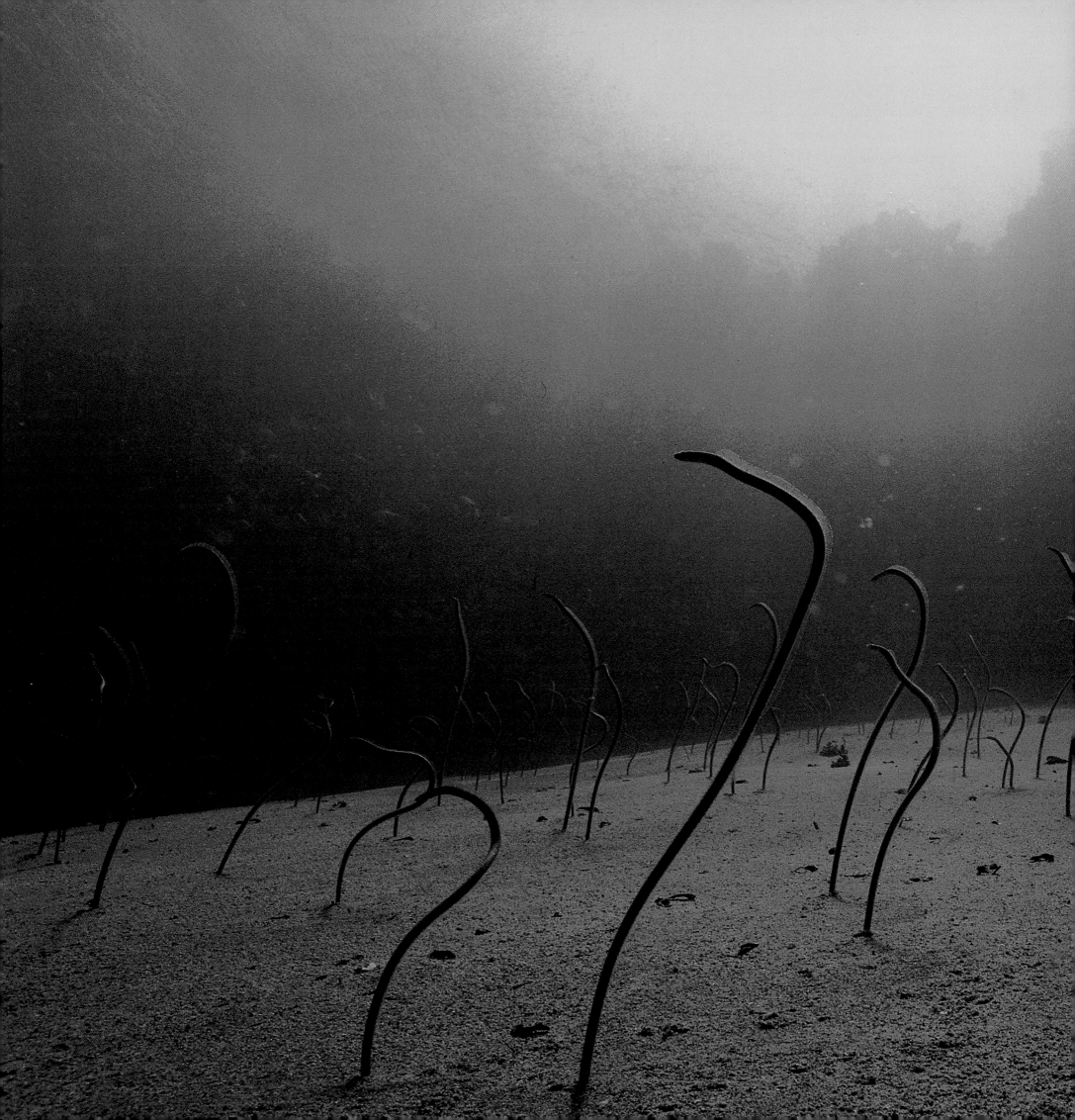

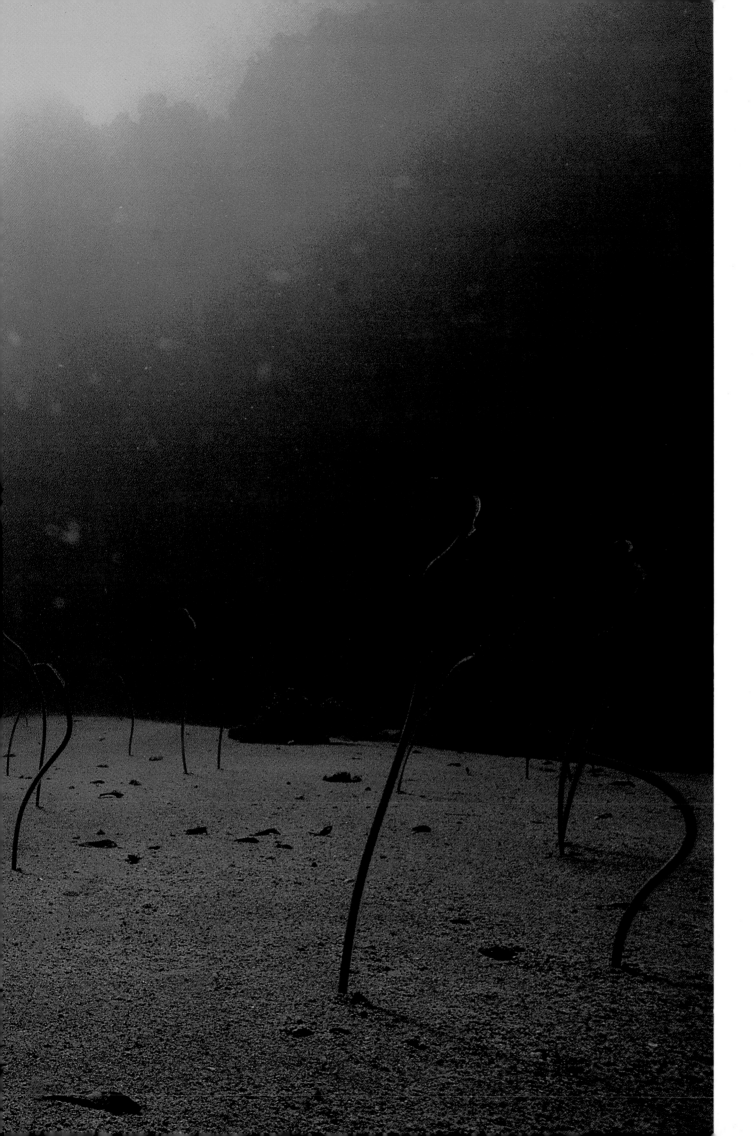

Garden eels reaching out of their
burrows to feed,
Ras Muhammad, Egypt.
GORGASIA SP.

49

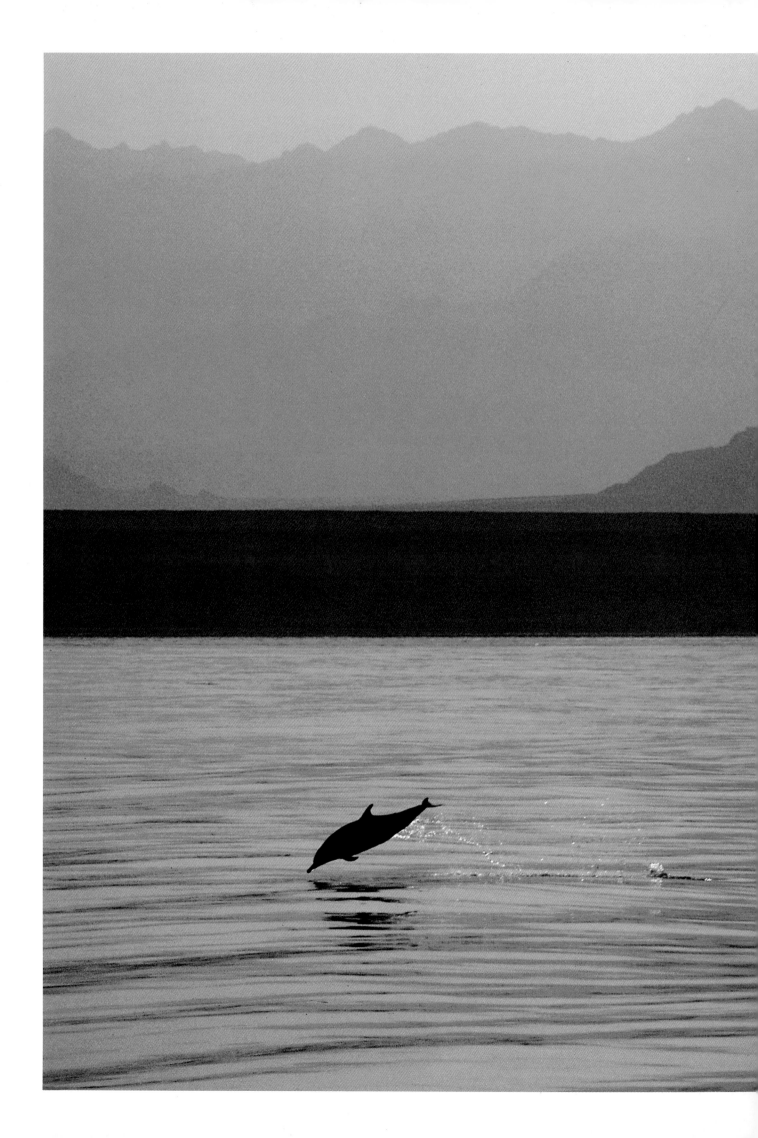

Spinner dolphin, Strait of Tiran,

Red Sea.

STENELLA LONGIROSTIS

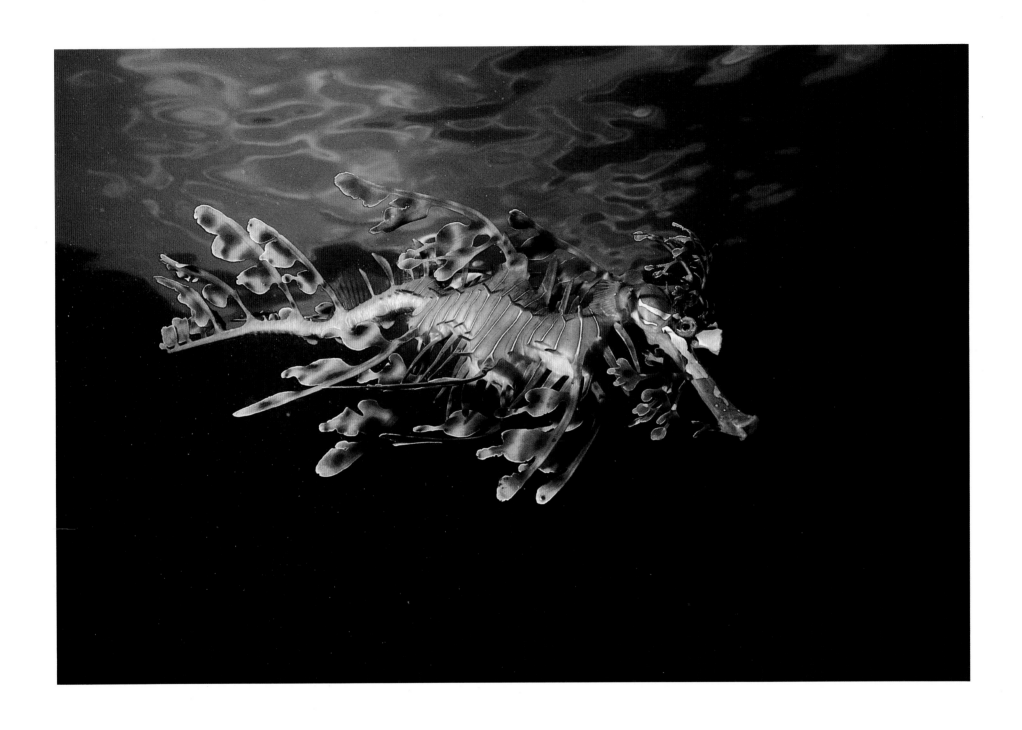

Leafy sea dragon, Victor Harbor,

South Australia.

PHYCODURUS EQUES

THE SOUTHERN OCEAN

The Southern Ocean was breathing. Flying 100 feet above the coast of South Australia in the open cockpit of Don McBain's Tiger Moth biplane, I could taste salt spray. I adjusted my goggles, opened the side door panel, and peered out. Big waves from a storm down toward Antarctica, thousands of unbroken sea miles to the south, rolled under the wing toward deserted beaches.

Washing over a wide, shallow continental shelf, the cold Southern Ocean meets a warm landmass and sustains a menagerie as rich and strange as any in the world. Below us, leafy sea dragons swam, tiny pinstripe squid jetted about, and giant cuttlefish stretched their tentacles. Fresh water seeped from springs in the clay marl bottom, and vast seaweed forests slid disconcertingly to and fro. Hunting for rock lobsters, banded wobbegong sharks stirred from their usual lethargy and moved through the forests. Also called carpet sharks, these hideous 12-foot-long items really do look like carpets — blotched and threadbare ones that haven't been cleaned since the reign of King James I.

Wobbegong sharks and Don McBain share one passion: rock lobsters. In predawn gloom that morning off Port MacDonnell, I had watched Don guide his boat, *Pamela J,* through lurching seas, hoisting lobsters which had strayed into his traps. Don speeds his search for these crustaceans, shipped live in chilled water to restaurants in Far Eastern cities, with a computerized depth sounder. On its color video screen, the sea bottom glows like an electrified impressionist painting.

Rock lobsters are not the only sought-after creatures in the Southern Ocean. These seas are a giant icebox filled with valuable seafood. Western king prawns abound in Spencer Gulf. Huge schools of southern bluefin tuna cruise the Great Australian Bight. Green-lipped and black-lipped abalones cling to rocky reefs.

A kind of emerald among shellfish, the bright green abalone is prized both for its meat and for the mother-of-pearl inside its shell. To prevent over-harvesting, only two dozen people are licensed to dive for abalones in this part of Australia. It is hard work; the shellfish can only be gathered by hand, and Southern Ocean weather allows for about 100 days of diving a year. When good weather comes, a diver will spend up to seven hours a day in the cold ocean — a true rubber-collar job.

The rewards are great. Divers have been known to make over $200,000 in a season. It's simple — you jump in the water, pry abalones from rocks, and put the money in the bank. There is one problem: the great white shark.

White sharks like to eat Australian sea lions, which live on rocks and reefs around the mouth of Spencer Gulf. To a shark, a diver looks very much like an Australian sea lion. No one knows this better than Rodney Fox, a former state spearfishing champion and abalone diver, and now a world expert on great white sharks. His fascination with great whites began after he was nearly bitten in half by one while diving in a spearfishing contest in 1963. He recovered miraculously, and continued to dive. Obsessed with sharks, he studied their ways. When film companies came to South Australia, hoping to shoot footage of the monsters, Rodney quickly became known as the man with the knowledge and the ability to find great white sharks.

On a warm February midsummer morning in 1980, Anne, Genie Clark, and I joined Rodney Fox on Dick Leach's boat, *Tradewinds,* and went to look for a great white shark. Diving gear, odoriferous shark food, and two yellow shark cages jammed the back deck. The sea was calm — a rarity off South Australia.

Once we were underway, Rodney ladled blood and minced tuna guts into the water with the grace of a French chef. By midmorning, a chum slick

trailed behind the boat to the horizon. After a few hours, a very large shark appeared, swimming toward the boat with its dorsal fin sticking through the chum. Dick Leach screamed something unintelligible and tossed out a 25-pound hunk of meat. The shark raised its head from the sparkling sea and gulped it down. "Gawd," said Dick, "Right down the tucker shoot."

The shark mashed into *Tradewinds'* stern, lunged onto the swimstep, and clacked its jaws. It thrashed its tail, shot halfway out of the water, curled back its lips, rolled its black pupils out of sight, and seized a massive chunk of meat we'd hung from *Tradewinds'* railing. After swallowing the meat, it circled, then came in for a bite of *Tradewinds'* outdrive and propeller. It bit down so hard that some of its teeth shattered with a sound like a ballpeen hammer smashing porcelain.

Every time the shark struck, *Tradewinds* shook, almost knocking us down. Rodney said, "OK, time for the cages." We pushed them in the water; floats held them just below the surface, and polyurethane lines secured them to the boat. Wire cables, Rodney explained, could entangle the shark, cages, and divers. The white shark opened its mouth and swam through a line, breaking it with a soft snick. I was aghast. Rodney shouted, "Come on, get in, David. This is a beautiful shark. It won't be around forever, you know."

Slowly I pulled on my wetsuit, weight belt, and tank, while the shark made a big circle. Then I flung myself from boat to cage. My tank clanged against the bars. With a boathook, Rodney reached over and shut the top. I was alone with a 16-foot shark.

Lobsterman Don McBain's
De Havilland Tiger Moth, near
border of South Australia and
Victoria, Australia.

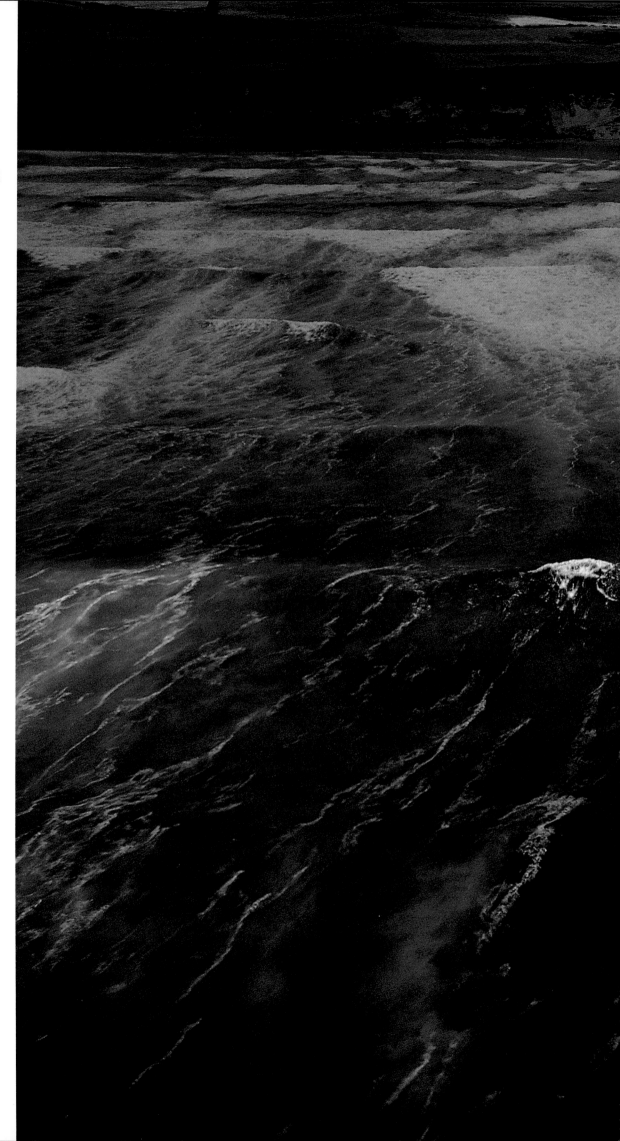

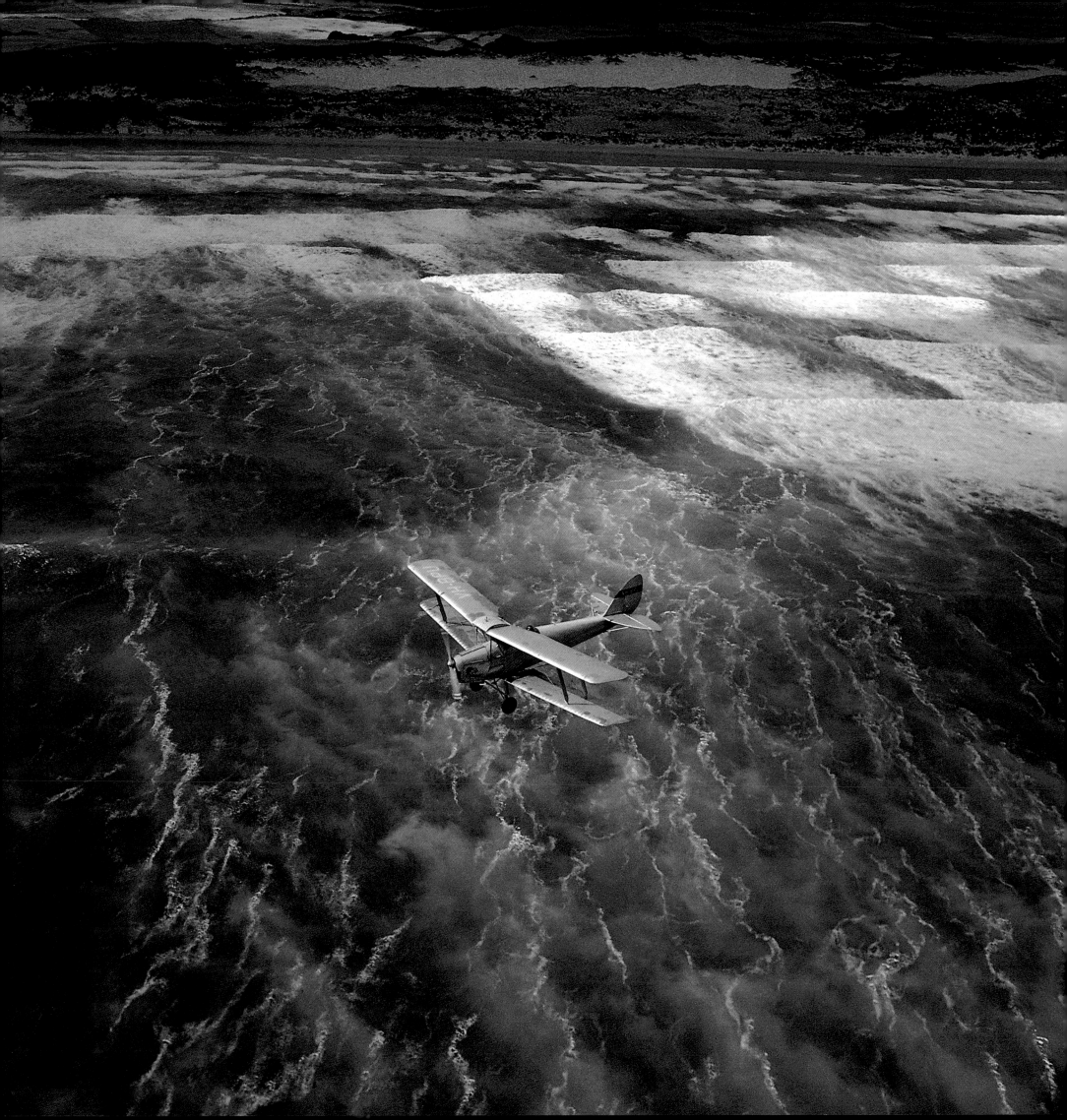

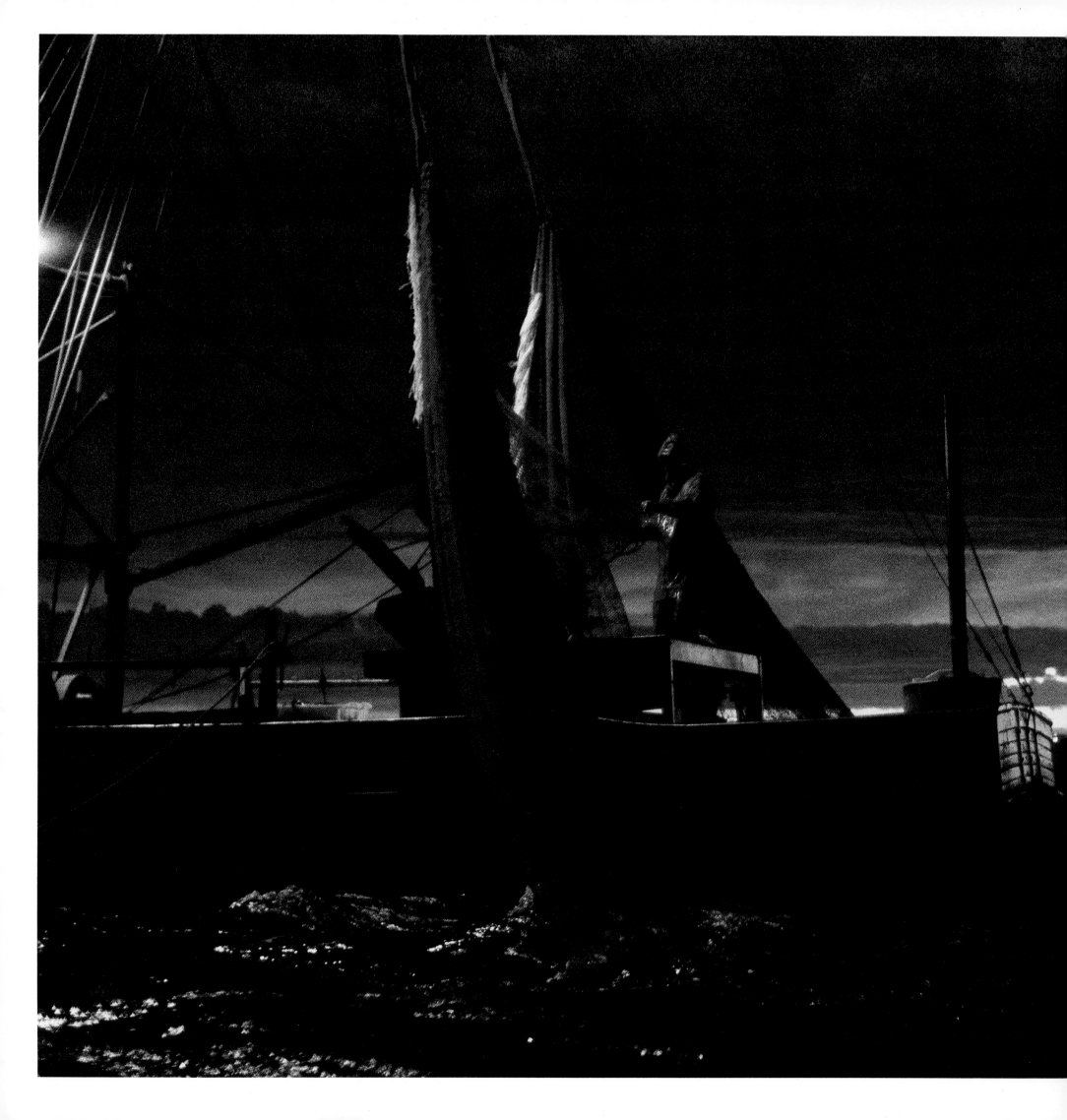

In the clear water, the sun made spidery patterns along the shark's back as it slowly circled. I leaned through the cage's camera port. The shark approached. I backed into the cage, but my tank caught on the camera port's upper bar. I was trapped. I pushed the shark away with my camera housing, wiggled like a crazed badger, and managed to pull my head inside.

On the next pass, the shark bit tentatively at the cage's float, sank a foot, and looked at me. Its eye was a soulless lens, not a creature's eye. Pushing its snout at the camera port, it could not get its lower jaw inside. It opened its jaws and banged its snout against the bars. I looked down its throat as its bottom teeth scraped the dome of my camera housing.

The shark stayed with us the entire afternoon. Genie, my wife, and Rodney came into the cages. Two smaller sharks approached. With the day's last light, the wind came up, the sea's surface became corrugated, and the sharks vanished.

That night, we anchored in a cove protected from the wind. At two in the morning, the big shark came back. It slammed into the stern and bit the propeller. Everyone except Genie woke up; we all simultaneously smashed our heads into the bunks overhead and all simultaneously cursed. Genie slept on. The shark swam back and forth, rubbing its back against the boat's bottom. My bunk was in the bow, and my ear lay on the hull. The shark's skin hissed like sandpaper as it scraped by.

Taking the anchor chain in its teeth, the shark used it like some great piece of dental floss, rocking the boat up and down. Then it left. We drifted back to sleep while the wind whistled against the deckhouse windows. Two hours later, Genie sat bolt upright, tight in the grip of a howling shark nightmare.

Prawn trawler Nenad *takes in last haul at dawn, Spencer Gulf, South Australia.*

A few years later, on another strangely calm day, Rodney Fox and I went south from Port Lincoln to Hopkins Island to visit a colony of Australian sea lions. The world's blondest sea lions, they live only on Australia's south coast.

We anchored in a sandy cove, and when we went into the water, the sea lions followed us from the rocks and beach where they'd been resting. The water was very clear. Soft sea grass covered the bottom. The sea lions settled in as if they were lying on a down comforter.

The entire colony joined us: pups, adolescents, adult females, the bull. They chased each other, caught each other around the middle with their flippers, and swam above us, silhouetted against surface sunlight. Suddenly, they vanished. Rodney and I looked at each other and spun around quickly, searching the underwater horizon. Great white sharks were known to pass through this cove looking for a fast sea lion meal. We swam into the shallows and climbed out on the rocks with the sea lions.

Eventually they went back into the water. We followed them, hoping they could sense the presence of a white shark more quickly than we could. The pups played with our camera housings and strobes, chewed at our flippers, and nudged our sides. One extended its flipper and touched my face mask. I held out my hand, and it tickled my palm with its whiskers.

Australian sea lions, Hopkins
Island, South Australia.
NEOPHOCA CINEREA

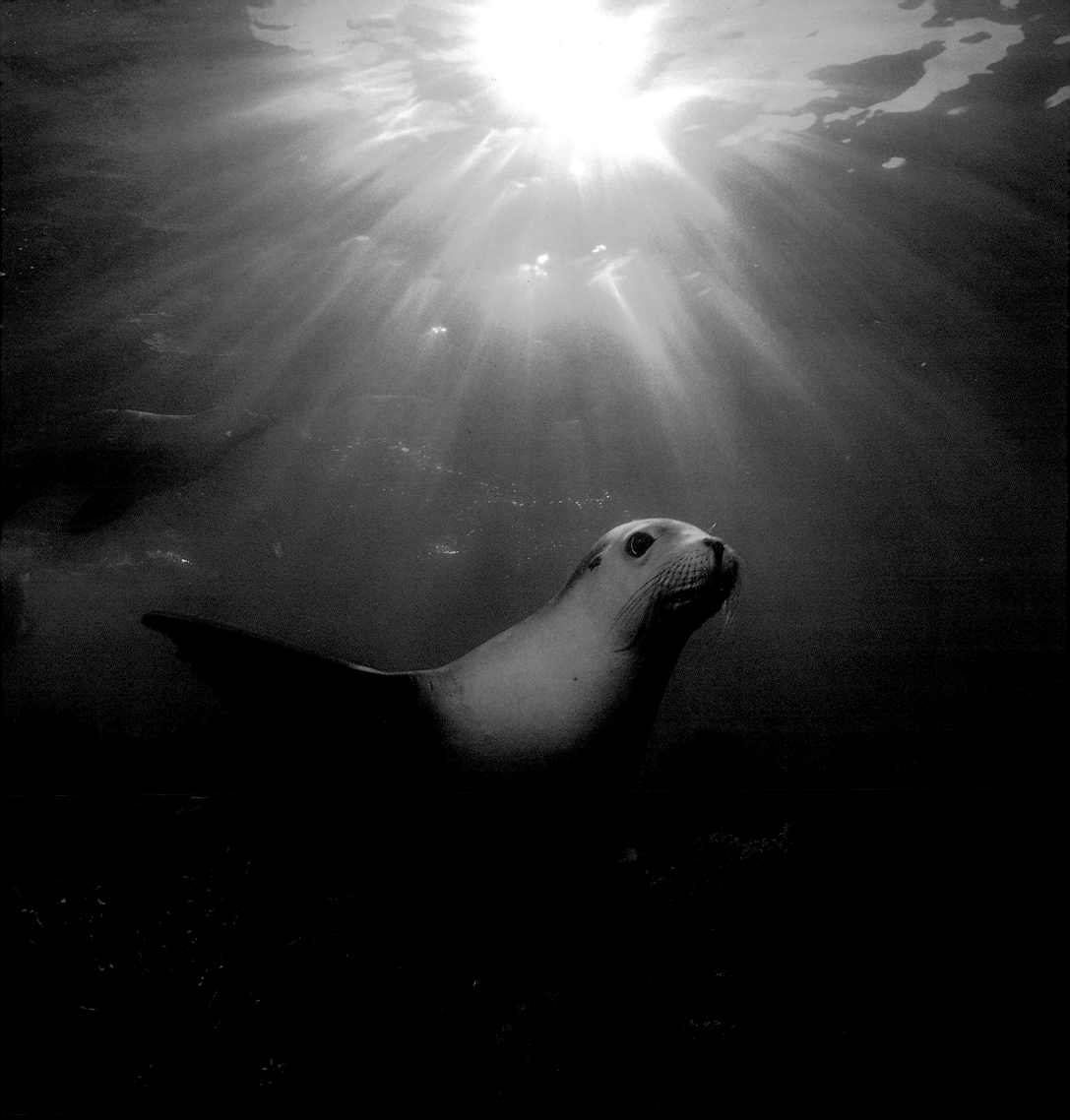

The Twelve Apostles,
near Port Campbell, Victoria,
Australia.

Australian sea lions,
Hopkins Island, South Australia.
NEOPHOCA CINEREA

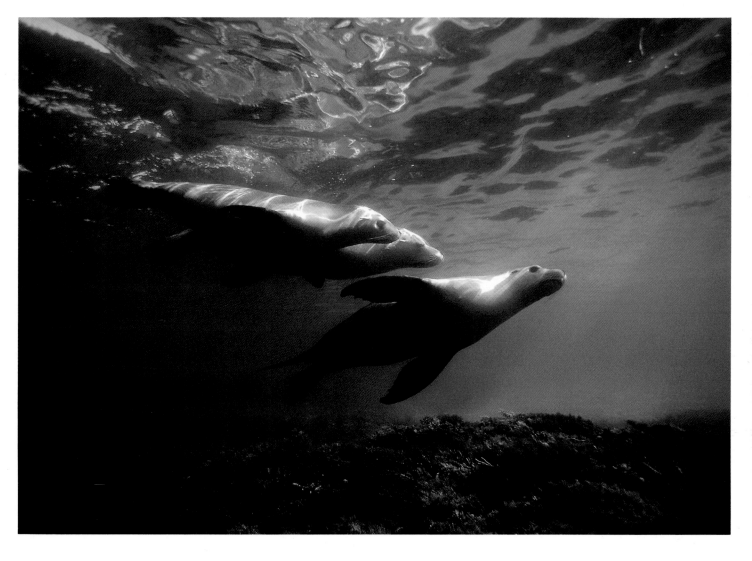

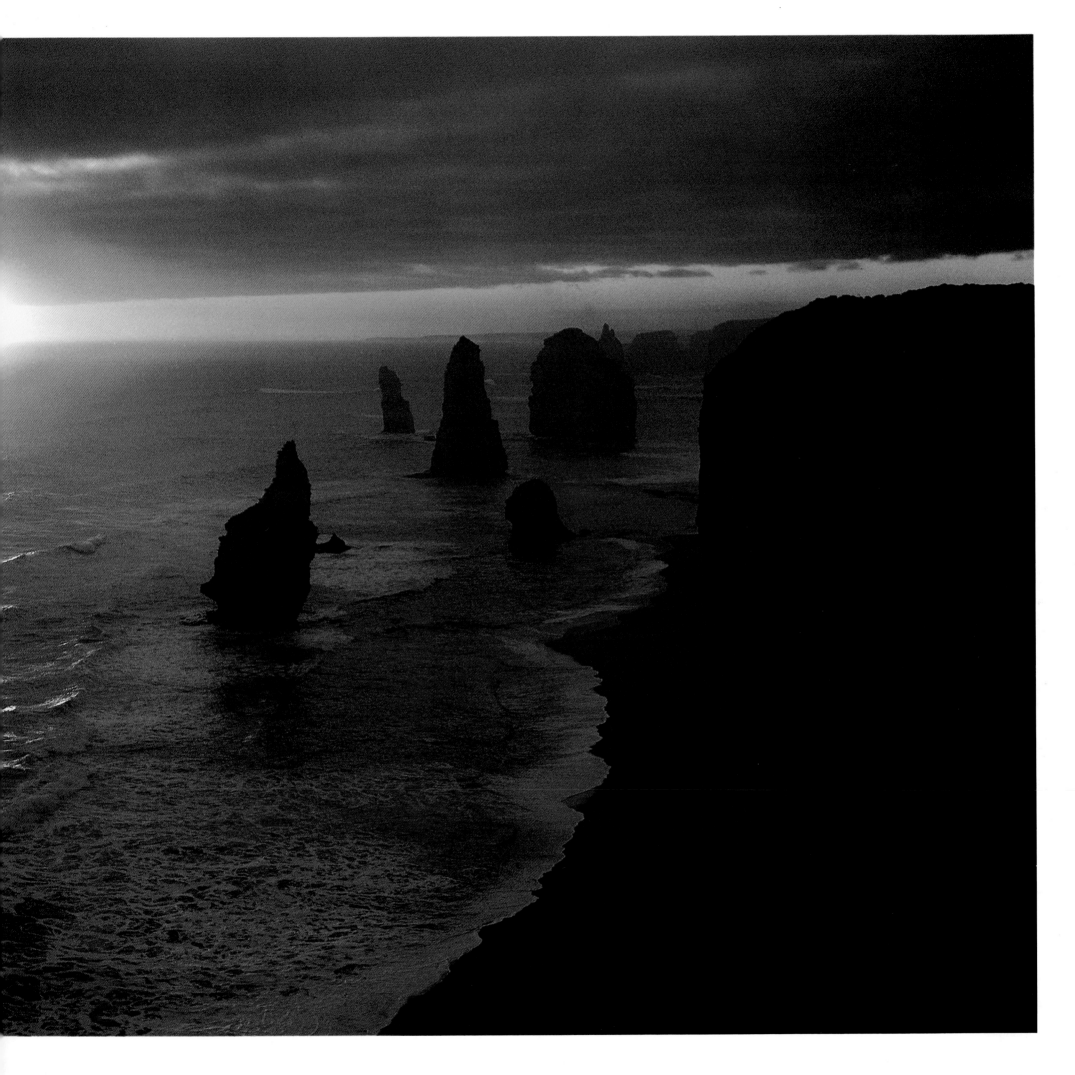

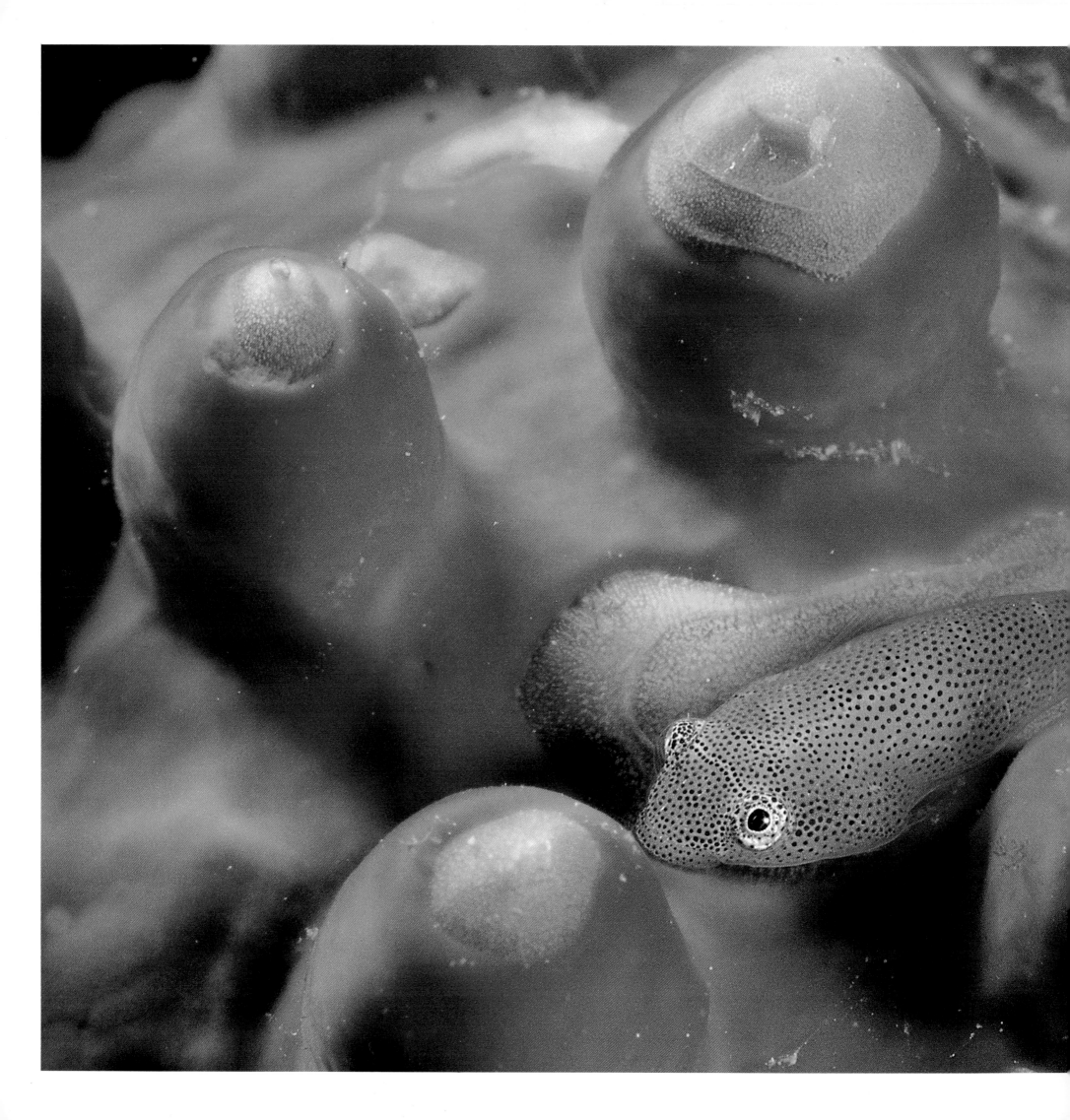

Broadhead clingfish on sea tulip,
Jervis Bay, New South Wales,
Australia.
COCHLEOCEPS SPATULA

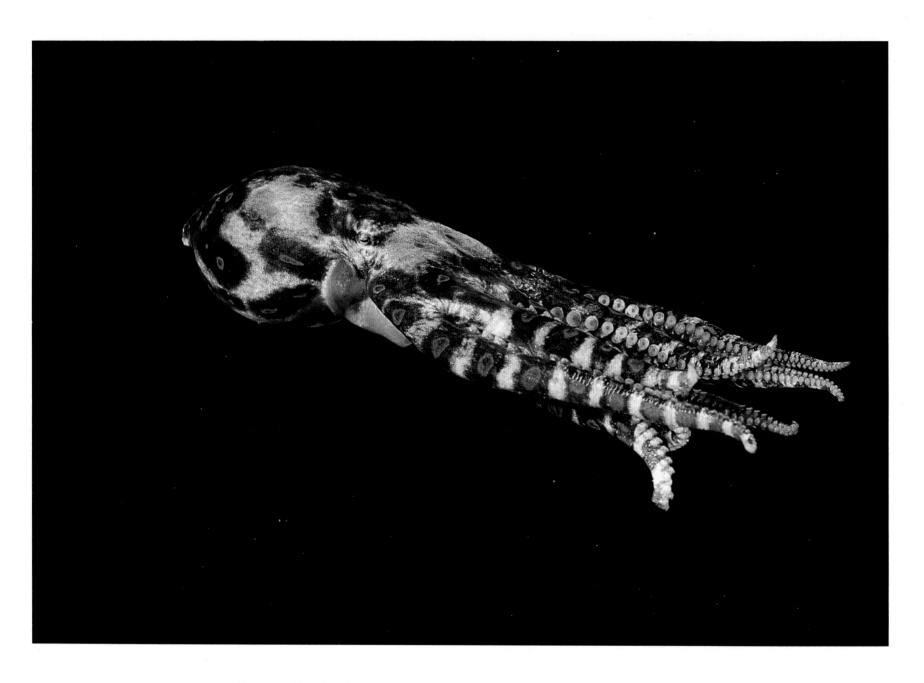

*Venomous blue-ringed
octopus, near Port Lincoln,
South Australia.*
HAPALOCHLAENA MACULOSA

*Pinstripe squid, near
Edithburg, South Australia.*
SEPIOLOIDEA LINEOLATA

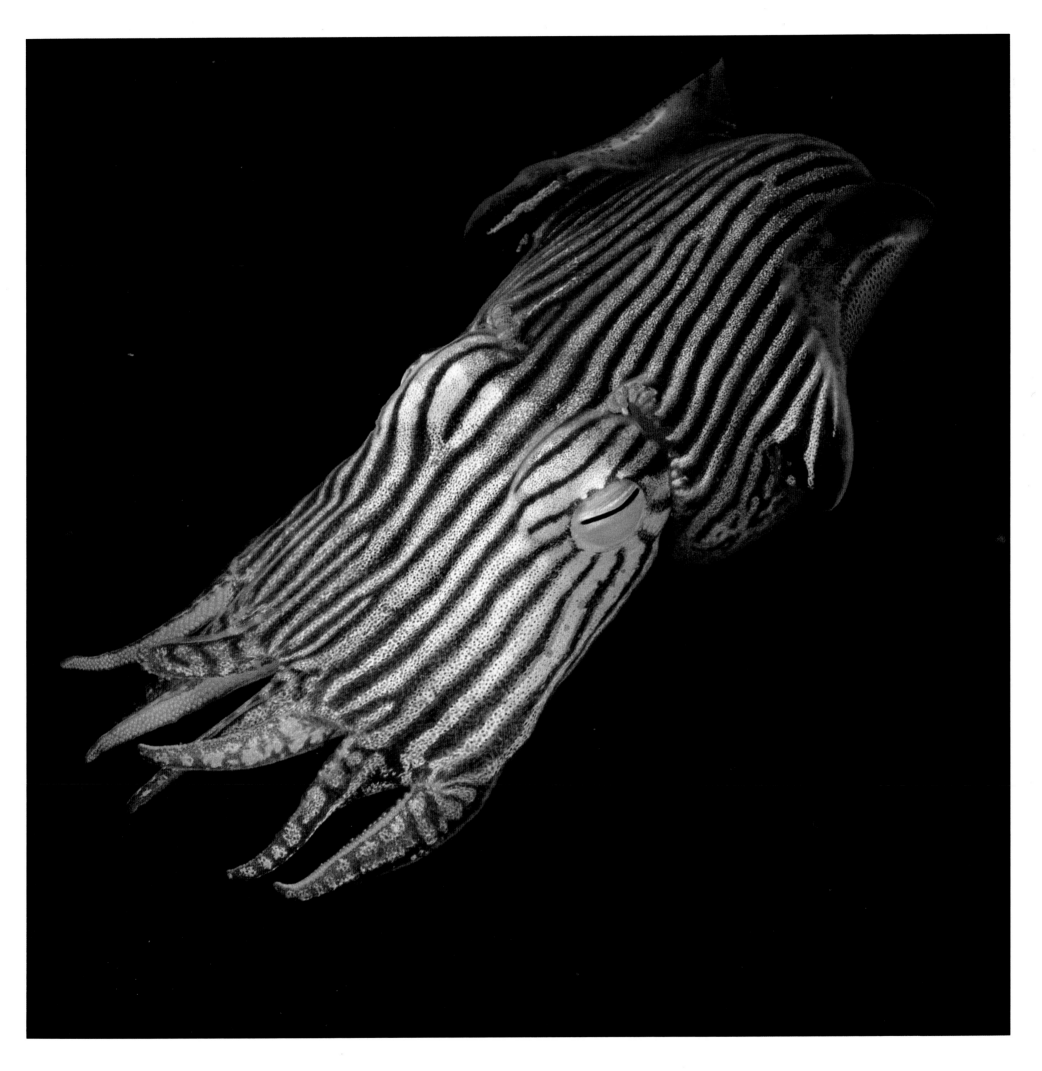

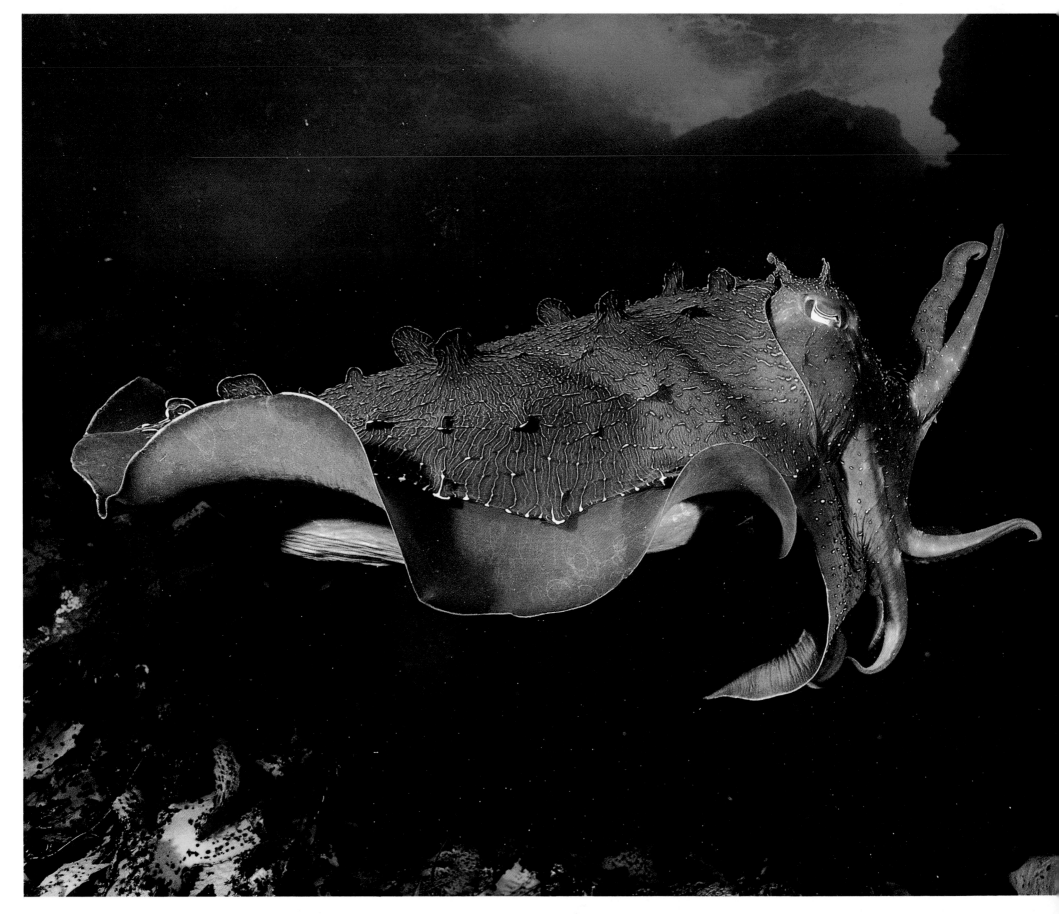

Three-foot-long giant cuttlefish,

Jervis Bay, New South Wales,

Australia.

SEPIA APAMA

Parasitical isopods feed on blue devil, Gulf St. Vincent, South Australia.

NEROCILA LATICAUDA;
PARAPLESIOPS MELEAGRIS

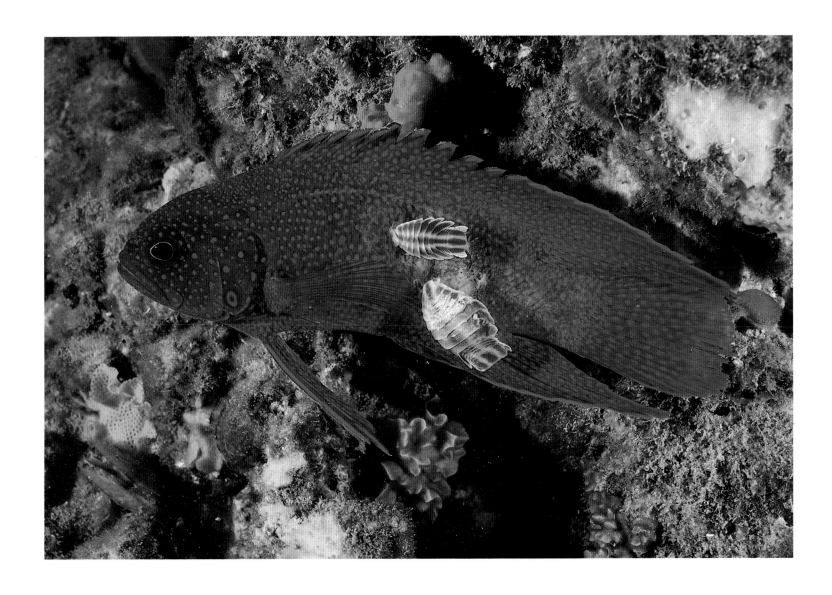

*(Above) Banded wobbegong shark,
Jervis Bay, New South Wales,
Australia.*

ORECTOLOBUS ORNATUS

*(Right) Rock lobster, favored prey
of wobbegong shark, near Flinders
Island, South Australia.*

JASUS NOVAEHOLLANDIAE

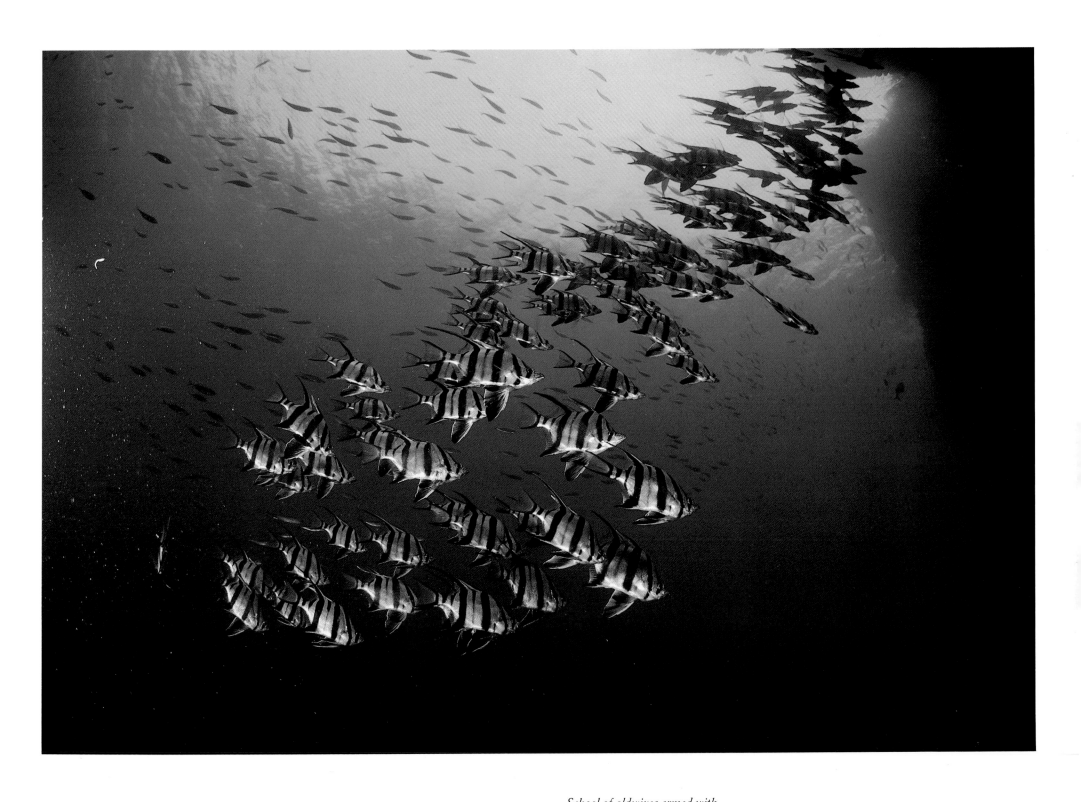

School of oldwives armed with
venomous dorsal spines, Jervis Bay,
New South Wales, Australia.
ENOPLOSUS ARMATUS

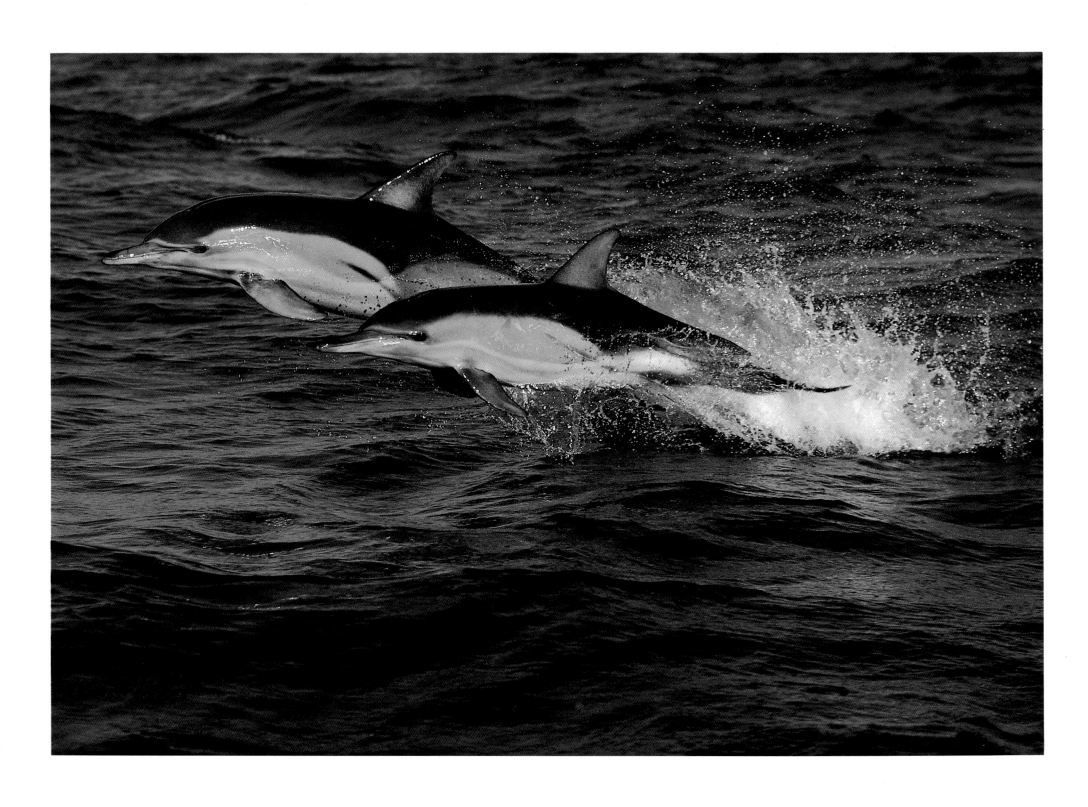

Common dolphins, near Flinders

Island, South Australia.

DELPHINUS DELPHIS

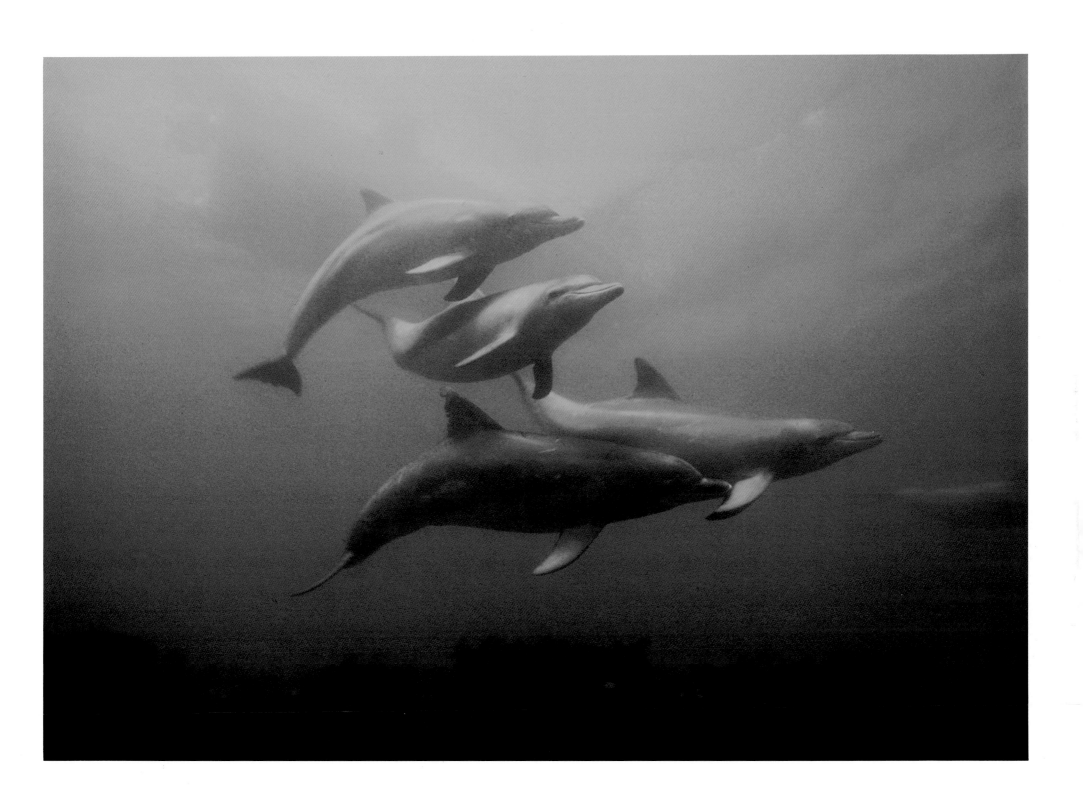

Bottle-nosed dolphins, near

Flinders Island, South Australia.

TURSIOPS TRUNCATUS

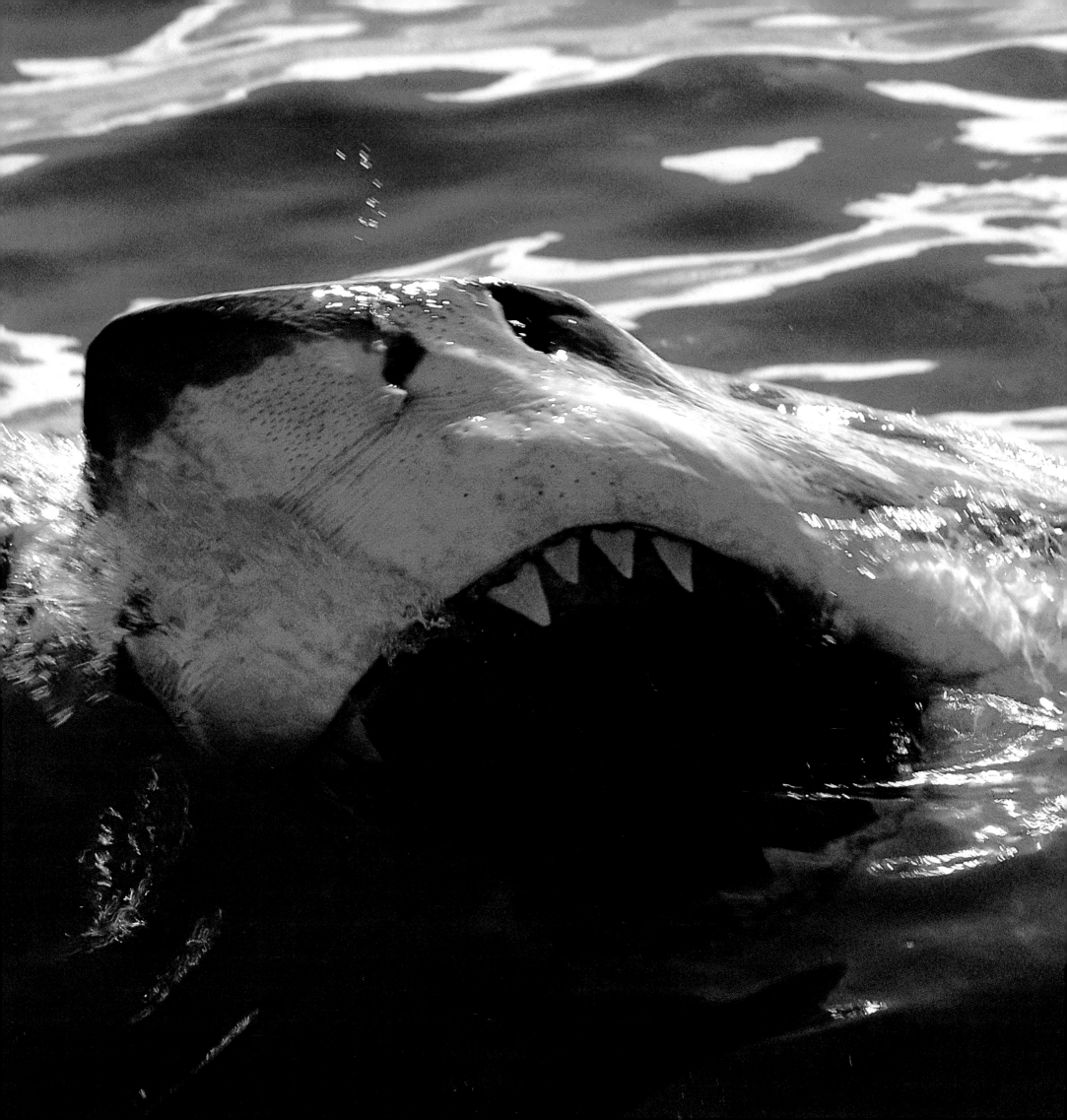

*Great white shark, near
Dangerous Reef, Spencer Gulf,
South Australia.*

*Great white shark approaches
bait, near Dangerous Reef,
Spencer Gulf, South Australia.*
CARCHARODON CARCHARIAS

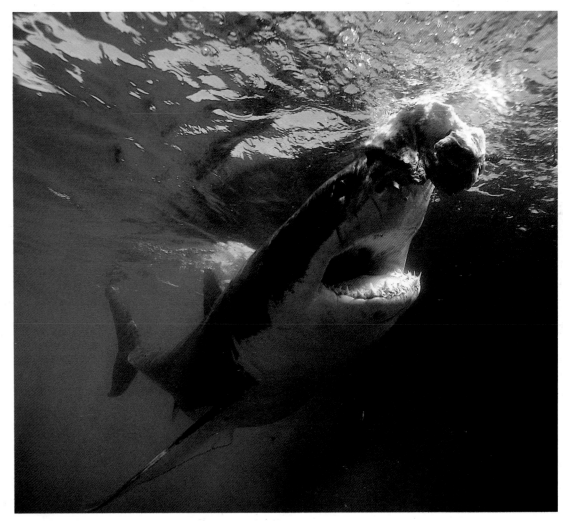

Great white shark passes diver
Herb Illic, near Dangerous
Reef, Spencer Gulf, South
Australia.
CARCHARODON CARCHARIAS

Sixteen-foot-long great white
shark bites cage; lower jaw
touches camera dome, near
Dangerous Reef, Spencer Gulf,
South Australia.

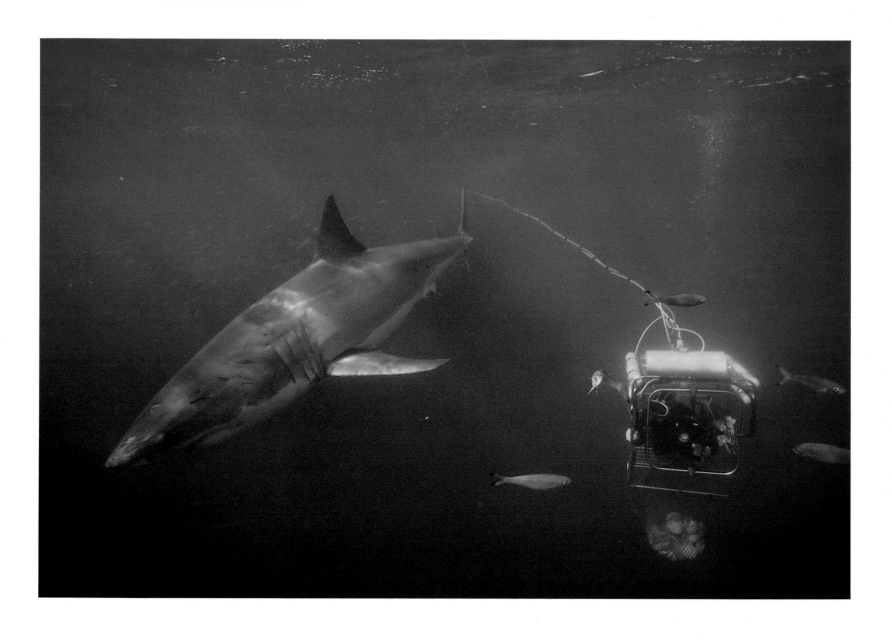

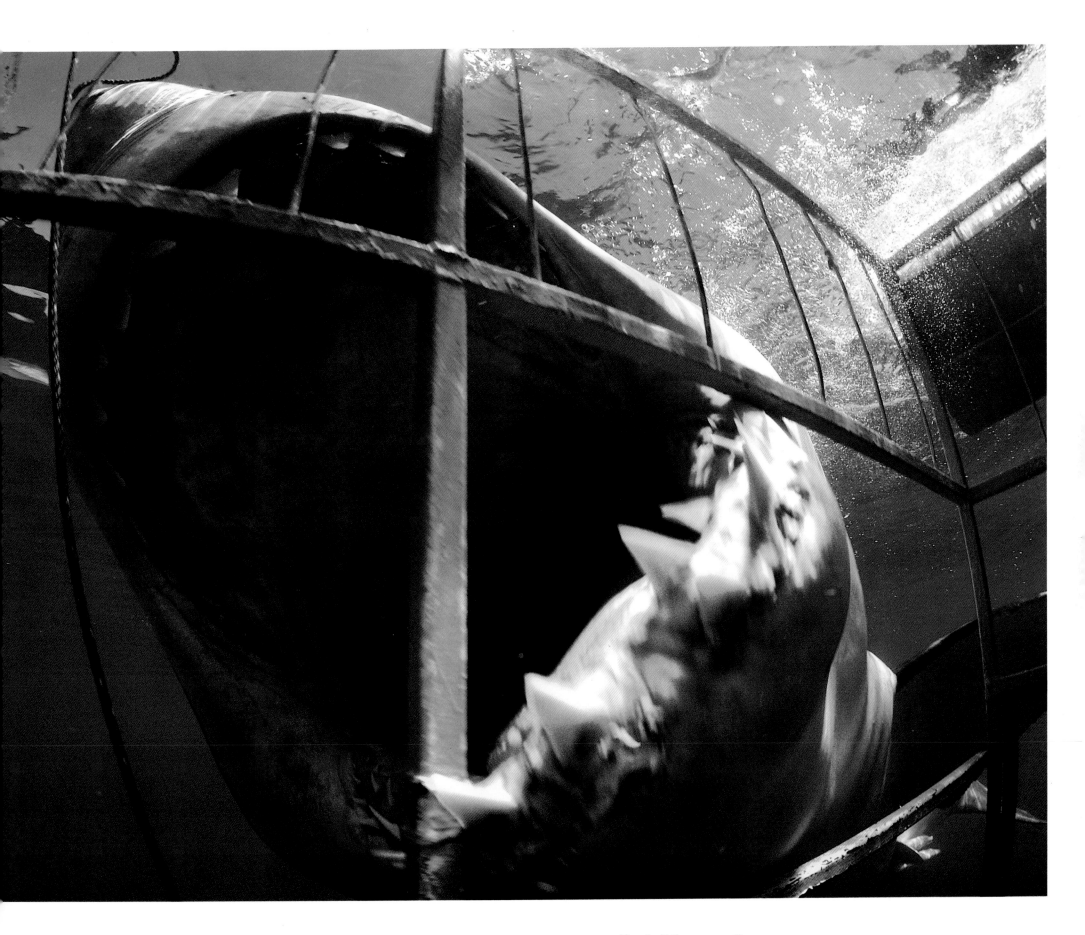

(Overleaf) Cormorants, Dangerous
Reef, Spencer Gulf, South
Australia.

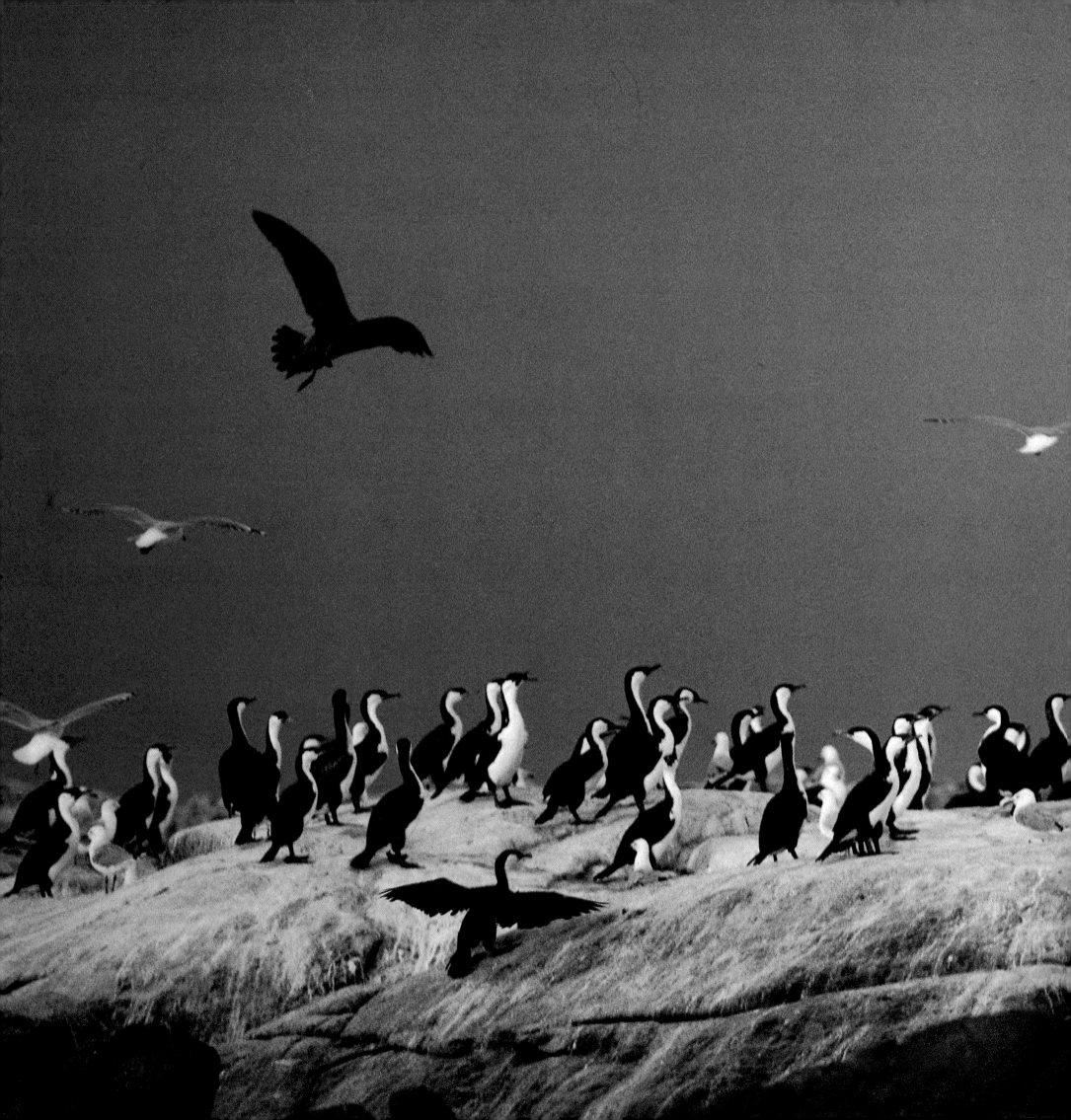

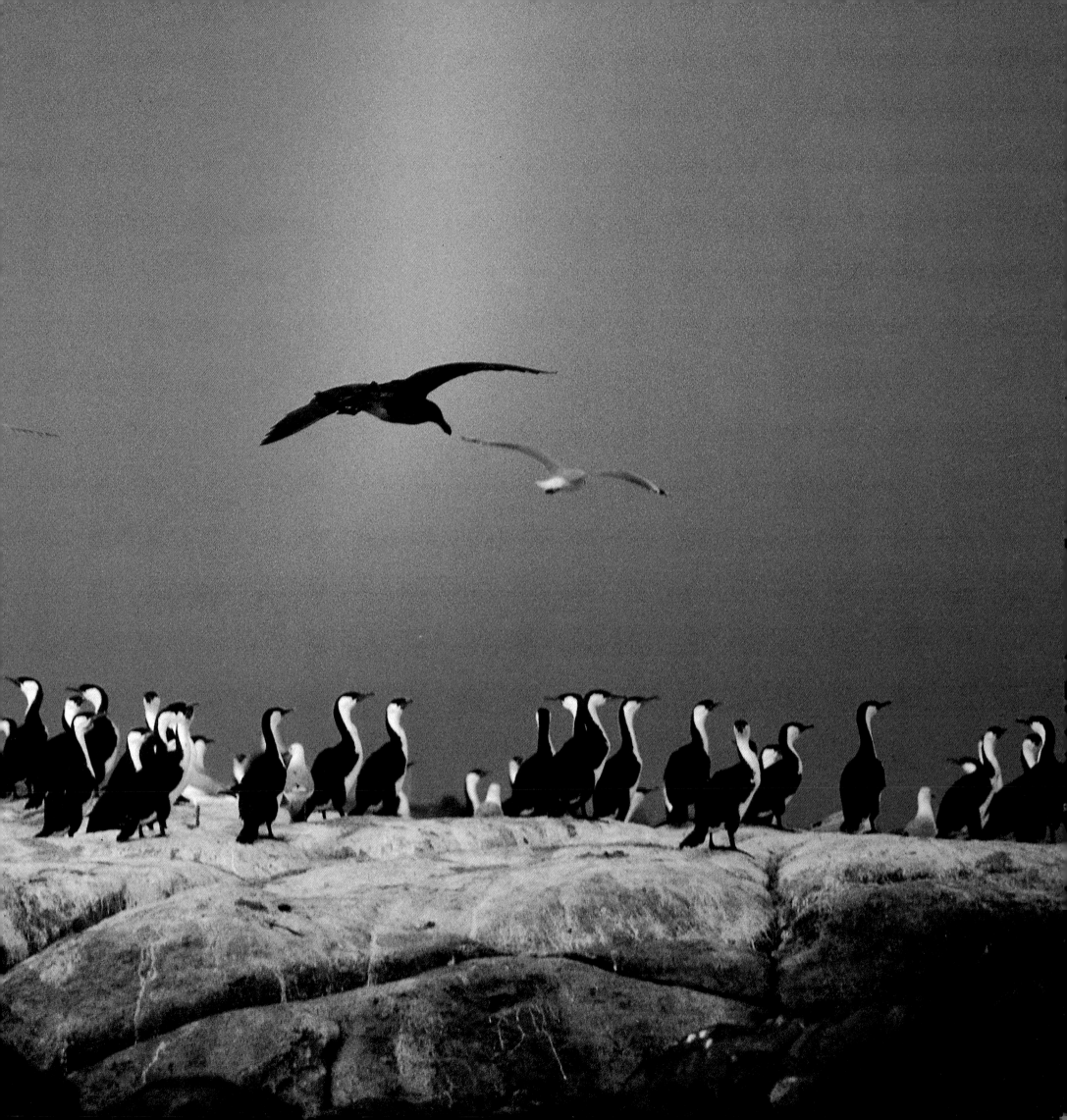

THE CARIBBEAN SEA

I lay in the shallows of Grand Cayman Island's North Sound. White sand, neatly ribbed like the raked courtyard of a Japanese temple, stretched toward the undersea horizon. The sun came and went between heavy clouds; the water was brilliant and somber by turns. I thought about my time in the sea.

When I was a teenager, I spent summers in the Caribbean at Andros Island in the Bahamas. I worked as a dive guide and boat handler at Small Hope Bay Lodge, a dive resort owned by a wonderful family, the Birches. I was a good guide and a terrible handler. Sometimes, as I threw out the anchor with a grand gesture, my ankle became strangely involved with the anchor rope, and I found myself shooting over the side with my newfound and inseparable lead friend.

Along the shallow reefs of Andros, great forests of elkhorn and staghorn coral grew. Schools of blue-striped and yellow-striped grunts hid in the shadows. Fat parrotfish munched on hard coral, digested it, then spewed it out as sand from their rear ends. At night, the parrotfish lodged in reef crevices and exhaled mucous bubbles to protect themselves from the coral's sharp edges and possibly from predators.

I made my first deep dive on the Andros Wall when I was 14. Dick Birch guided me. As we descended to 140 feet, the water became incredibly clear, darkening from blue almost to black. Shaded parts of the wall glowed with the purple and red of bioluminescent coralline algae. The bubbles from our regulators made a tinkling sound. Sponges grew all around us: tube sponges, barrel sponges, helmet sponges, and white deepwater udder sponges, spectacular as creatures by Hieronymus Bosch.

Southern stingrays, North Sound,
Grand Cayman, Cayman Islands.
DASYATIS AMERICANA

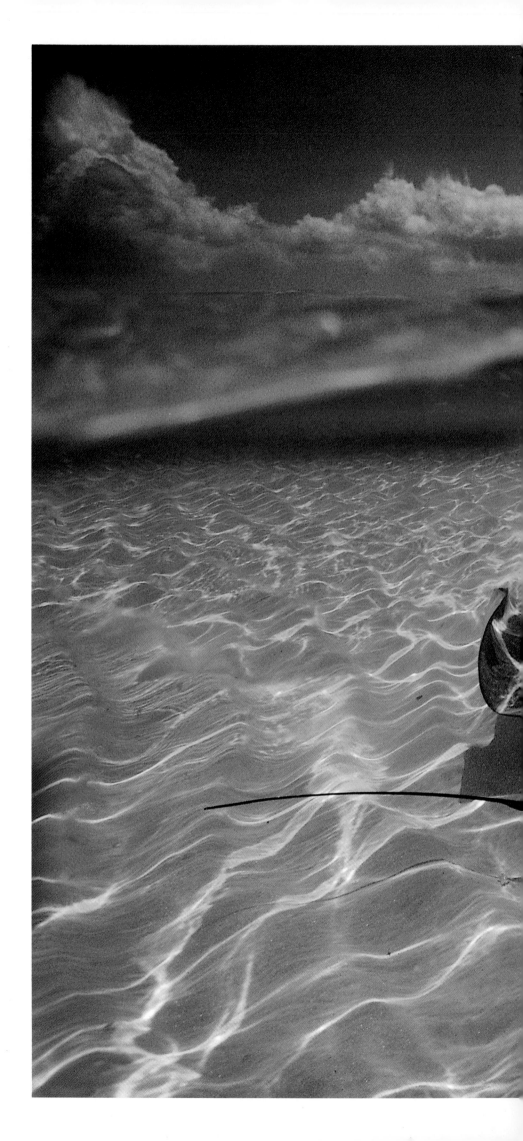

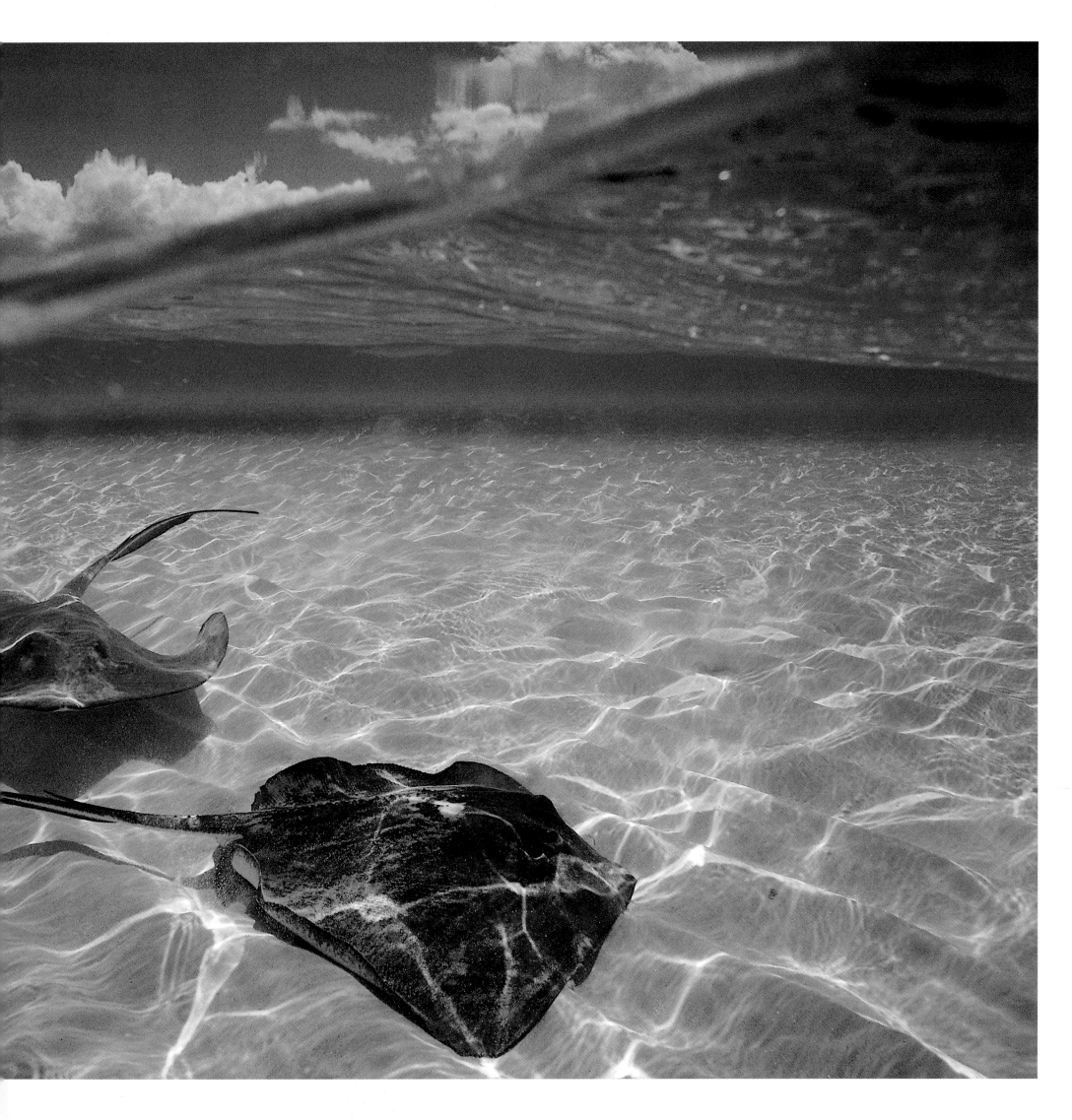

When I began to dive and photograph in other parts of the world, I measured each new place against my Caribbean memories. The Caribbean is one of the oceans' two coral-supporting regions. The other, the Indo-Pacific, sustains an infinitely more vast and complex system. Caribbean reefs are English gardens; Indo-Pacific reefs are underwater jungles. If fish had clothiers, Caribbean fish would go to Brooks Brothers; Indo-Pacific fish would parade the styles of Haight-Ashbury in the late 1960s. I never tire of the endless layers of life in the Indo-Pacific. But the simplicity and elegance of the Caribbean feel like home.

As I lay in the sand of the North Sound, eight stingrays materialized out of the blue horizon, gliding toward me like pterodactyls. Soon they surrounded me, nibbling at my hair and clinging to my diving vest in search of food. Their fearsome tails scraped the back of my neck. Their eyes were golden and empty. On their undersides, which felt as smooth as chilled jello, their mouths and nostrils formed Charles Laughton faces. When I raised my head half out of the water, I had a vision of stingrays and clouds—wondrous sea creatures banking and turning, fat clouds scudding across a tropical sky.

Juvenile crevalle jacks fend off attack by great barracuda, near wreck of Oroverde, *Seven-Mile Beach, Grand Cayman, Cayman Islands.*

CARANX HIPPOS;
SPHYRAENA BARRACUDA

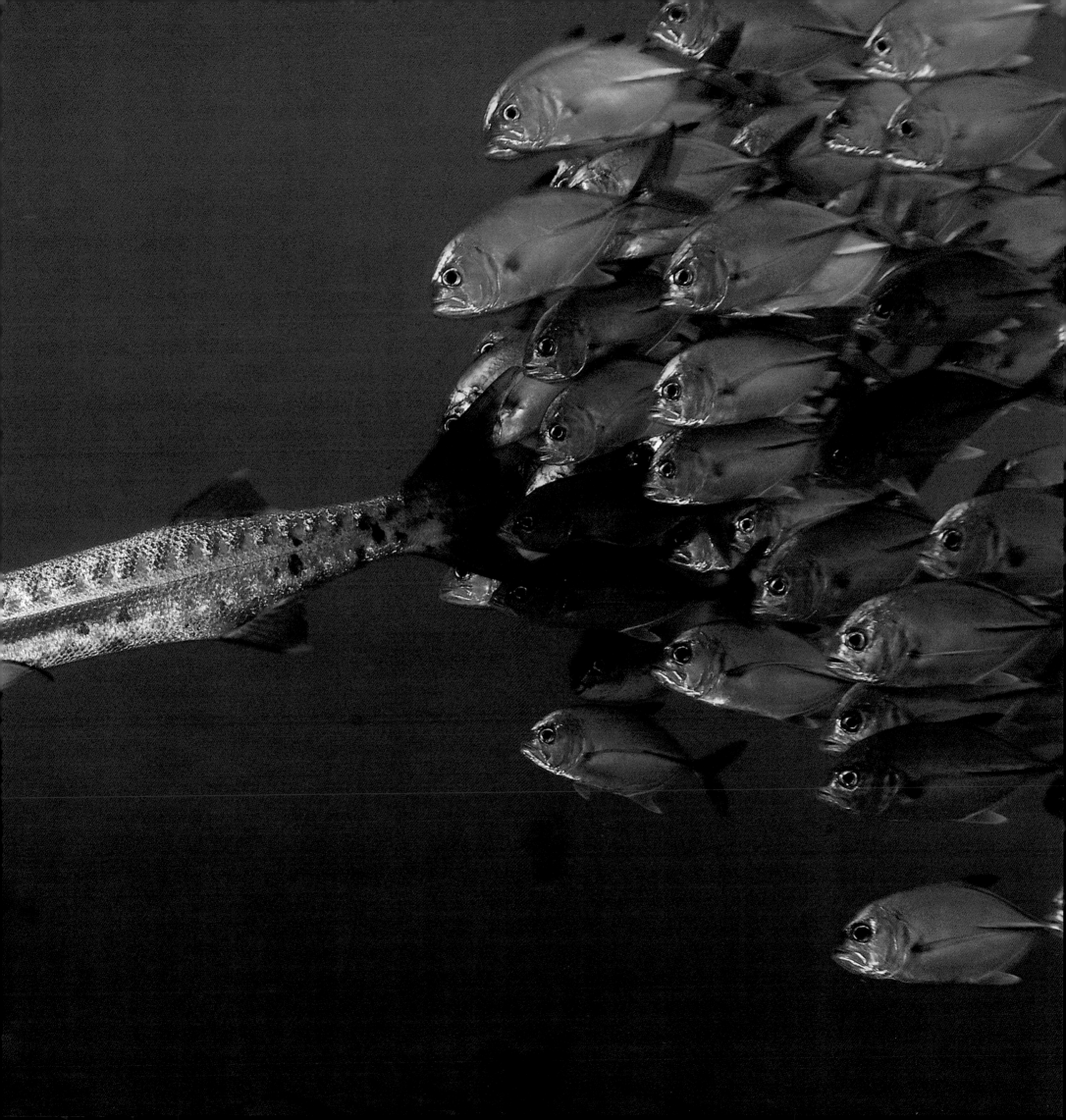

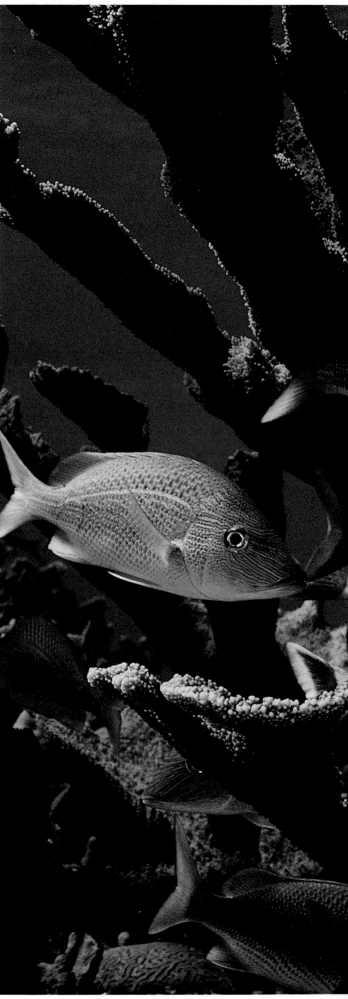

Blue-striped grunts and
elkhorn coral, Trumpet Reef,
Andros Island, Bahamas.
HAEMULON SCIURUS

Yellowhead wrasses duel
for territory beneath pier, Bonaire,
Netherlands Antilles.
HALICHOERES GARNOTI

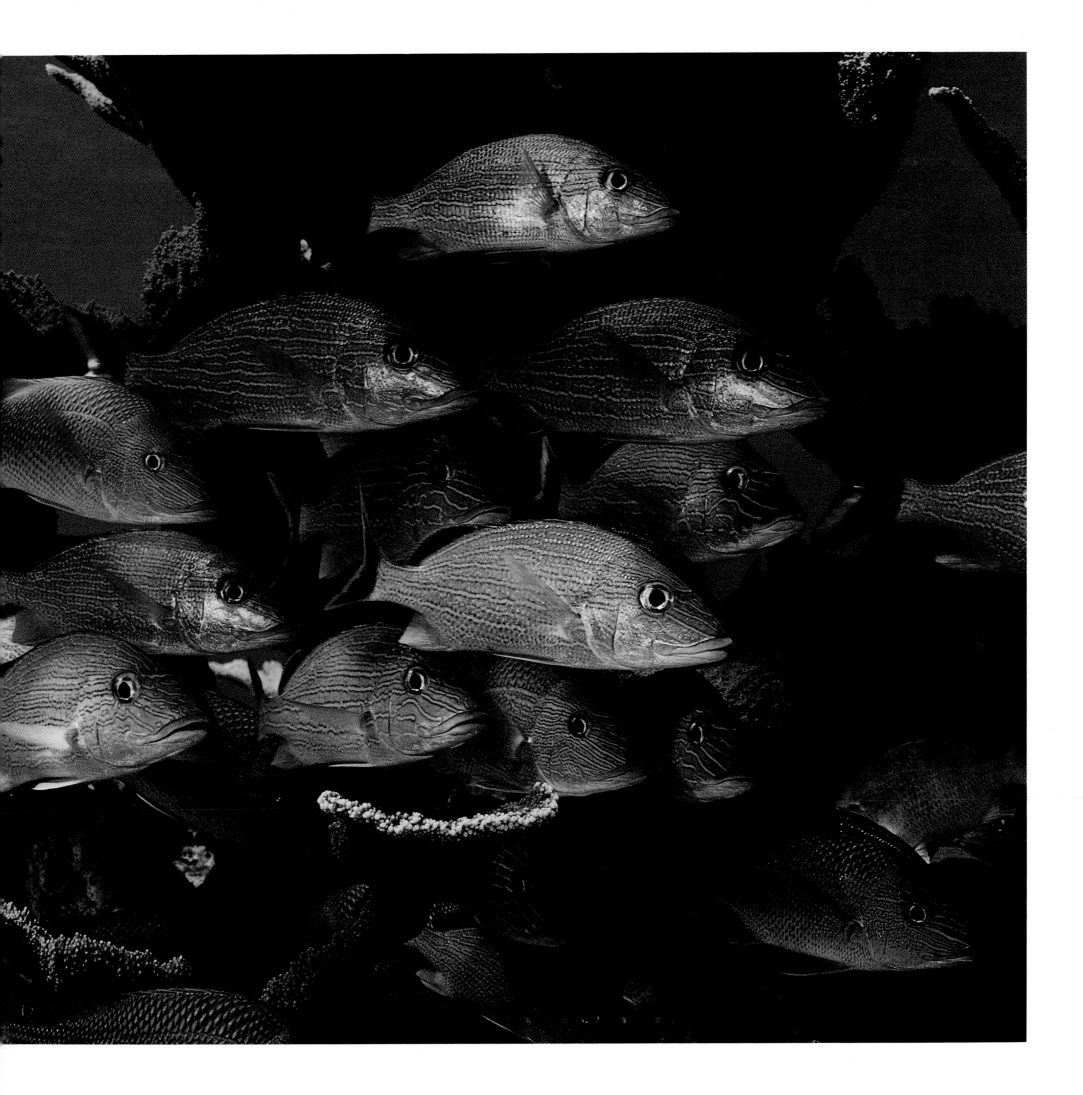

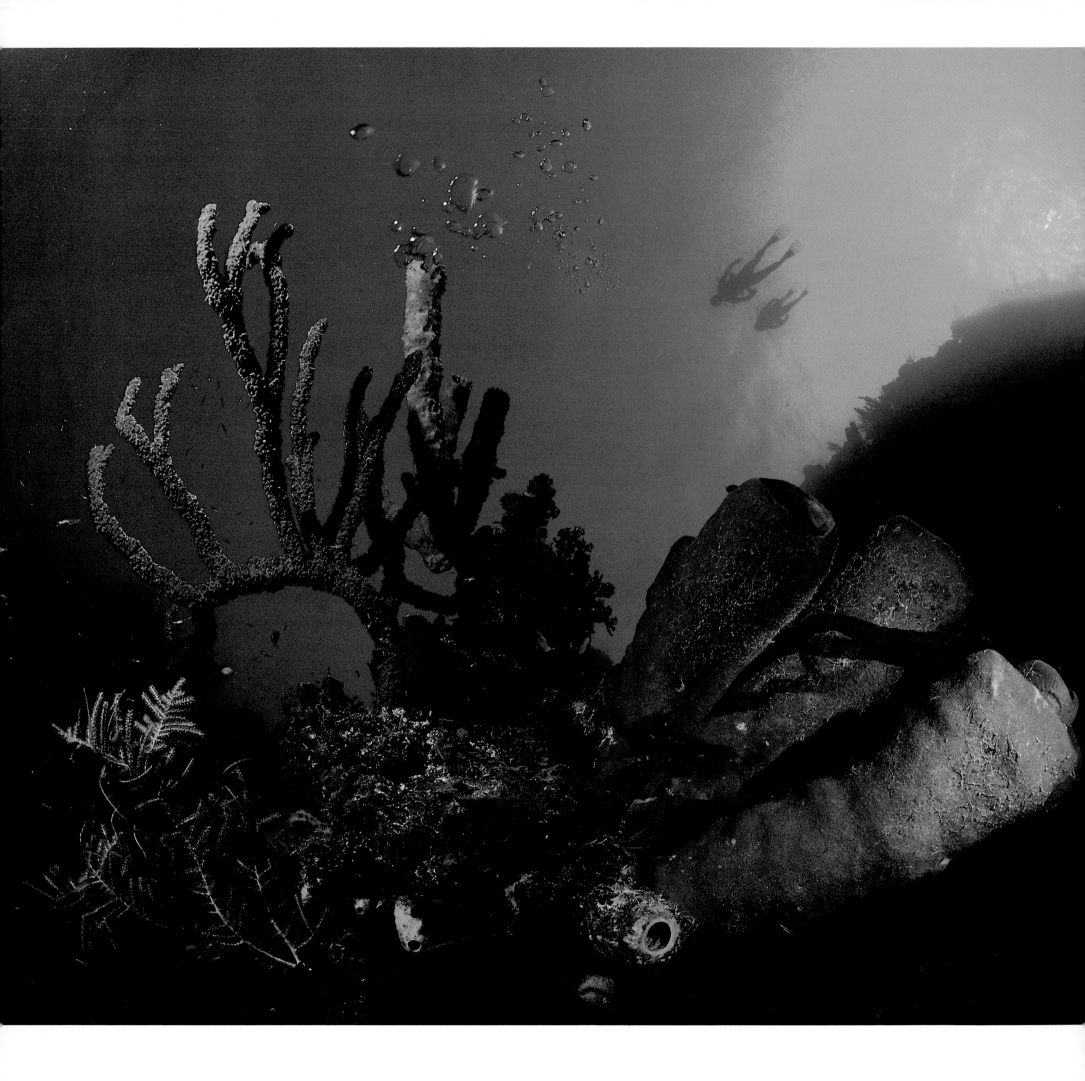

*Sponges on coral
outcropping, Bloody Bay, Little
Cayman, Cayman Islands.*

*Queen parrotfish sleeps
inside mucus bubble which
protects against predators, wreck
of* Balboa, *George Town, Grand
Cayman, Cayman Islands.*
SCARUS VETULA

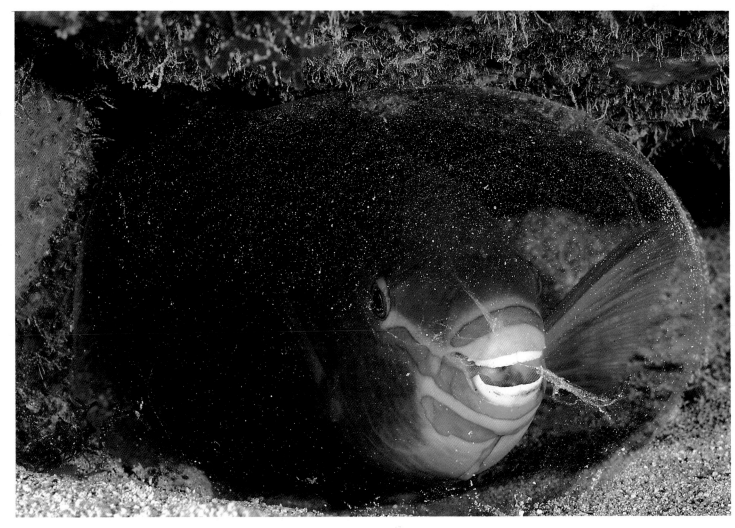

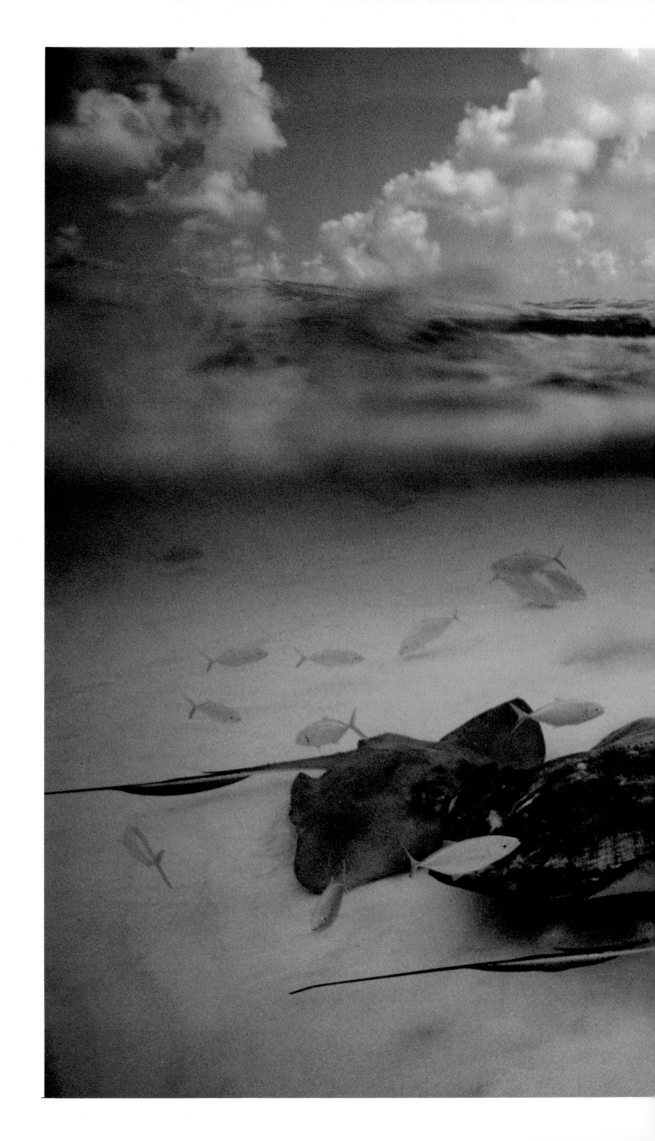

Southern stingrays, North Sound,

Grand Cayman, Cayman Islands.

DASYATIS AMERICANA

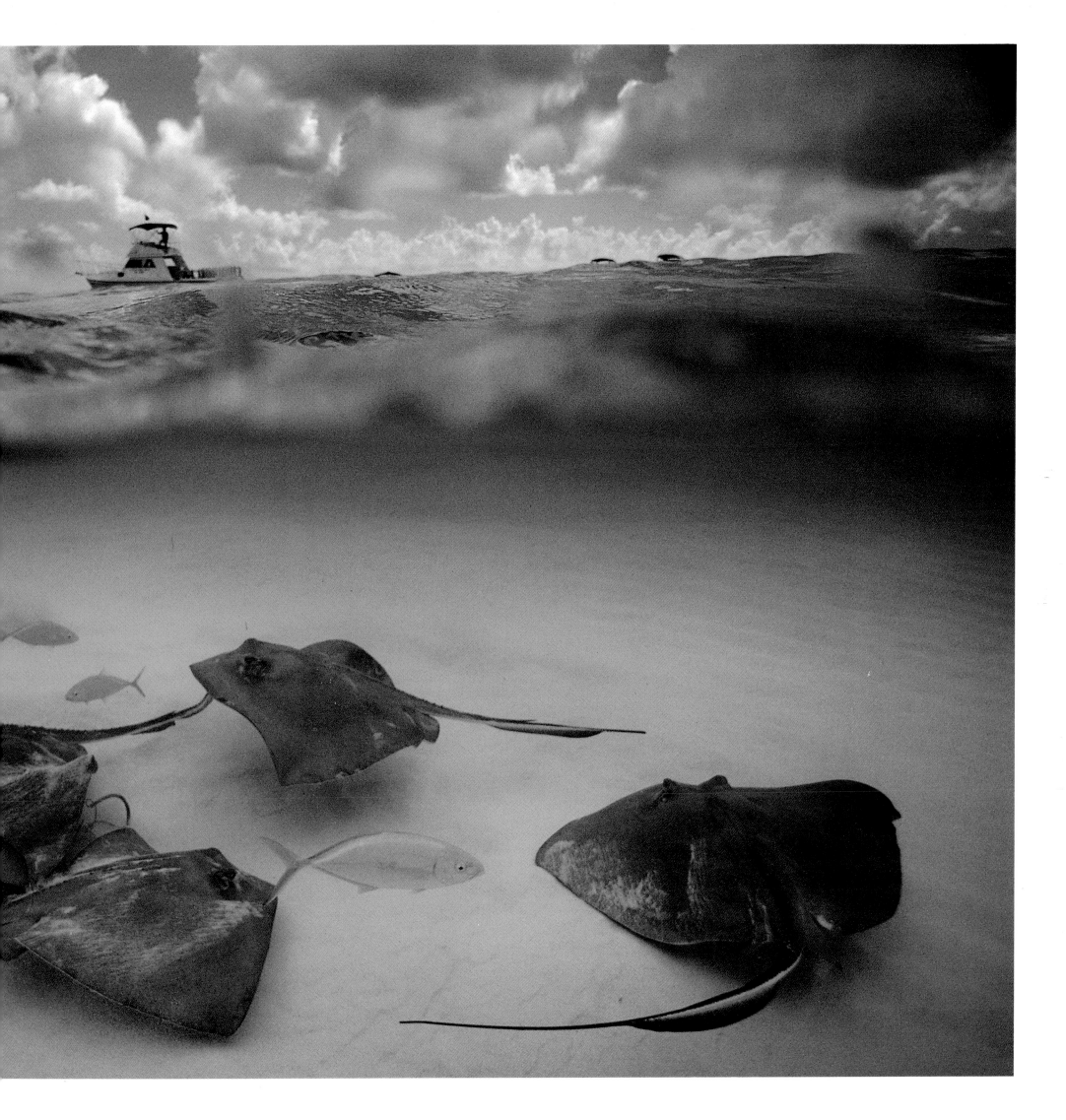

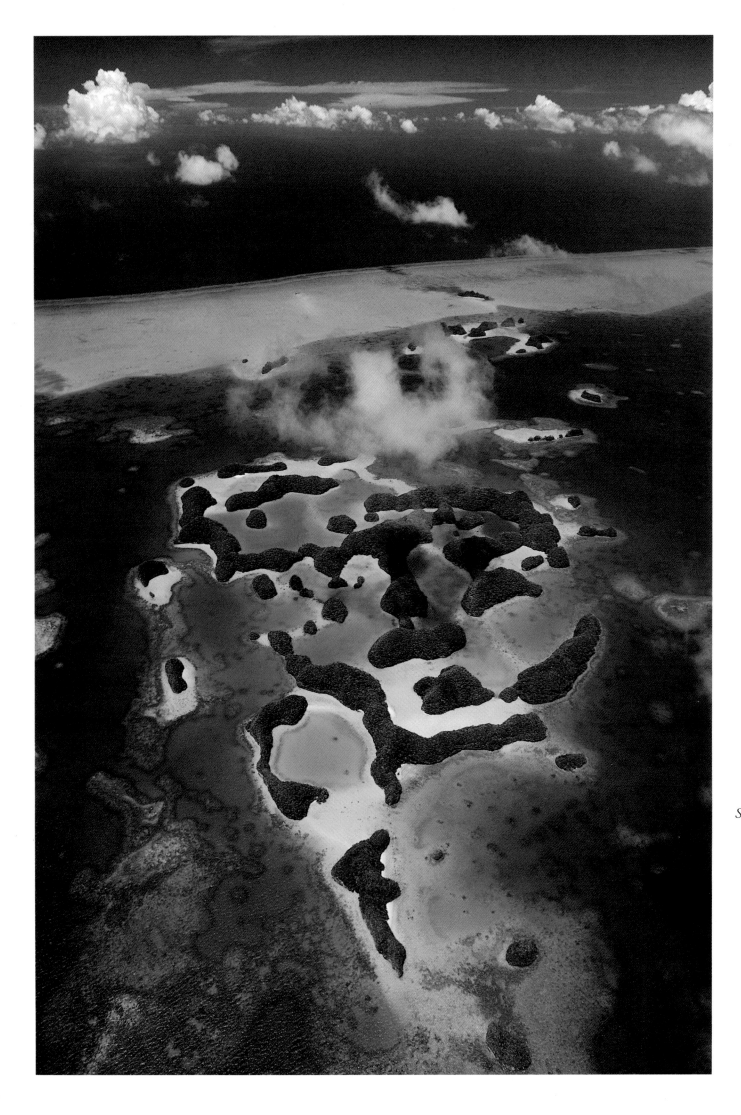

Seventy Islands, Palau.

PALAU

From our airplane, the strange contours of Palau's islands looked like a message scrawled upon the blue-black Pacific by intergalactic visitors. Waves and coral-eating organisms have sculpted the steep shores of these former reefs raised above sea level 20 million years ago. Their jungle-clad ridges enfold mysterious salt lakes.

Anne and I were on our way to photograph the lakes with marine biologists Bill and Peggy Hamner, who have studied them for many years. Other islands have salt lakes, but no place has as many as Palau: 35 are scattered through the archipelago. Each is unique, supporting chance groupings of marine species trapped there as the ocean has risen and fallen over time. Some are tenuously linked to seawater by subterranean caverns and tunnels.

The large island of Eil Malk has five salt lakes. We took a boat there in the morning, steering a course between round islands whose sharply undercut white bluffs and conical tree-covered tops made them look like floating topiary. When we reached Eil Malk, we stepped up from the boat directly into thick jungle. "Watch out for the poison trees, the ones with big sword-shaped leaves," warned Peggy Hamner. If the tree's thick sap touches skin, massive blisters erupt, foaming like bubble bath. We looked around. Every tree looked like a poison tree.

The jungle was dark, airless, and boiling. As we climbed the ridge, our feet slipped on crumbling coral covered with moss. Carrying the air tanks, inflatable boat, and heavy underwater camera equipment, our Palauan assistants bounded past like adolescent antelopes. Eventually we joined them on the shore of what Bill called Big Jellyfish Lake, a green, still pool about a quarter-mile long, surrounded by mangroves. A white tropicbird with a long tail skimmed the surface.

We put on our wetsuits and tanks, paddled out in the boat, and plunged

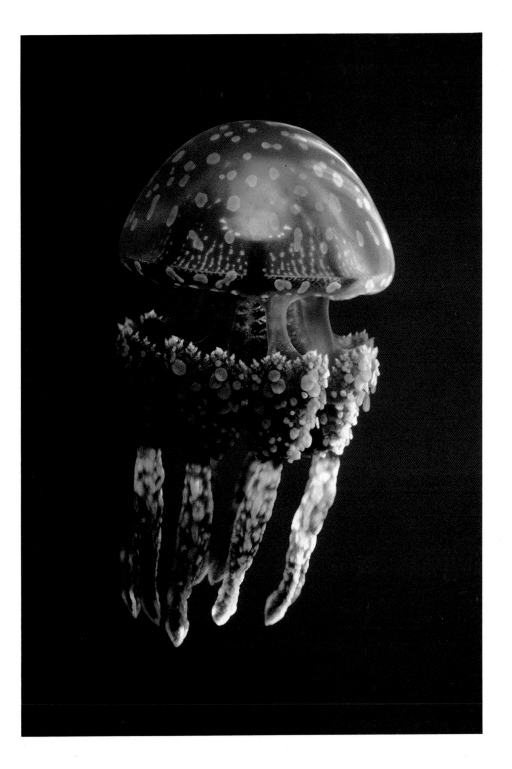

Mastigias jellyfish in marine lake,
Eil Malk Island, Palau.
MASTIGIAS PAPUA

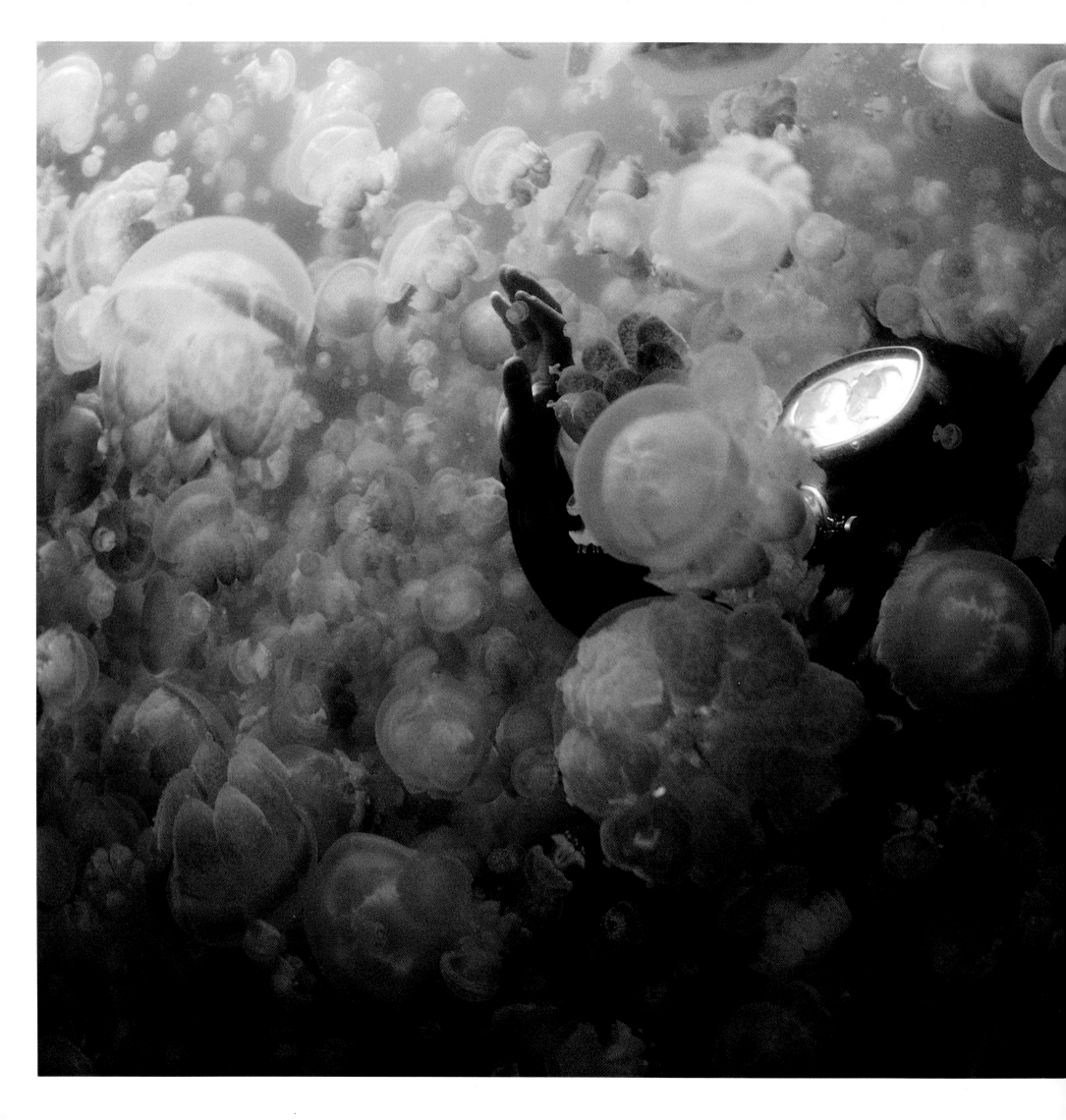

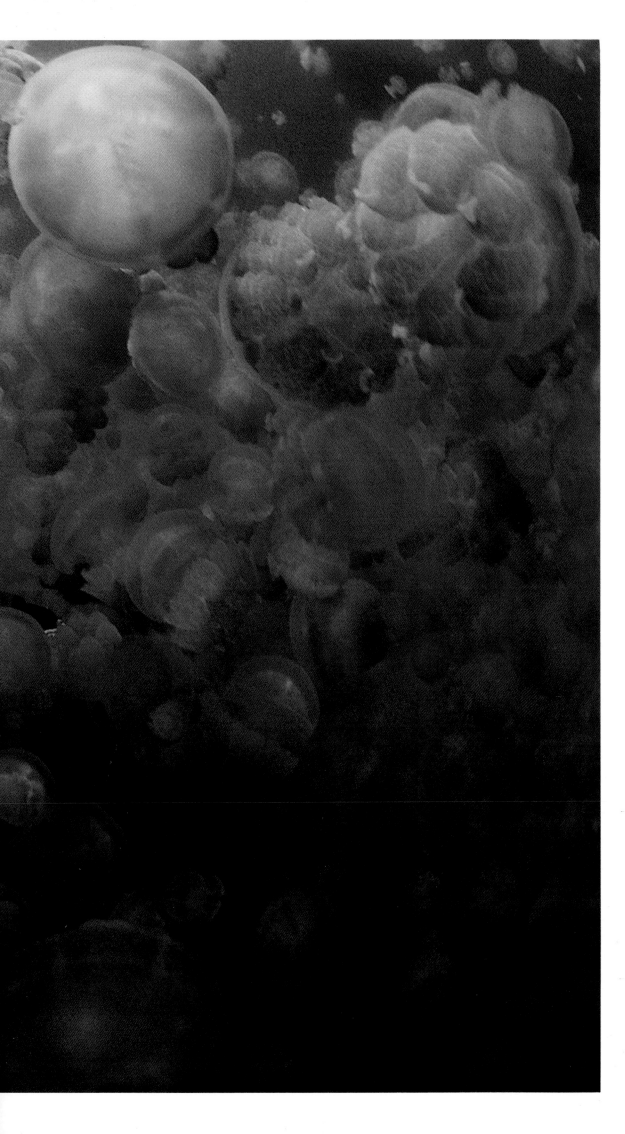

in. Warm as blood, Big Jellyfish Lake was layered like a Rainbow Room cocktail. Beneath a foot-deep mantle of clear rainwater lay milky white, rose, crimson, and maroon zones.

From day to day, Palau's lakes hardly stir. Algae blooms, and dust and pollen blow in. Gradually they sort themselves by weight into these strata. In Big Jellyfish Lake, the strata end with a layer of bacteria at 50 feet. Below that, the water is dead; the bacteria consumes all the phytoplankton filtering down from above and oxygen rising from rotting vegetation below.

Bill and I made an experimental dive into the lifeless depths beneath the bacteria and passed suddenly into very clear black water. Our rising bubbles poked holes through the layers. A rotten-egg smell seeped into my mask— evidence of diffused, toxic hydrogen sulfate gas. We quickly ascended. Three minutes in the poisonous water had turned a shiny brass spring clip on my light meter black.

I swam along the lake's edge, peering at mangrove roots coated with mussels. Cardinal fish with deep bellies floated among the roots. The jungle cast shadows over the water.

At the lake's far end, the Hamners found the jellyfish school, which drifts there every morning from the other side and drifts back every evening. Fist-sized, yellow and white, thousands of them bunched together, pulsing like hearts. When I swam into their midst, they slurped around my mask and slid across the back of my neck. I glanced at Bill, who was reaching out toward a tiny jellyfish. His faceplate glinted in the sun; he was joyously engulfed in a living cloud.

Marine biologist William Hamner
swims through school of mastigias
jellyfish, Eil Malk Island, Palau.
MASTIGIAS PAPUA

SHARKS

With my wife Anne, my colleague Flip Nicklin, and Dr. Genie Clark, I spent a year and a half photographing sharks for *National Geographic.* We discovered the world's best shark repellent: a loaded, functioning camera and an assignment to shoot sharks. Now and then, patience and luck prevailed, and we caught entrancing glimpses of these notorious creatures.

In the Bonin Islands, 600 miles south of Tokyo, Genie Clark and I encountered three sand tiger sharks. These snaggle-toothed monsters lived in a cave with a white sand floor. Genie described them as vampires in a castle. We would swim toward them; they would slide away. They would swim toward us; we would back away: a shark waltz in the middle of the Pacific.

In the Sea of Cortez, near Baja California, the deep-sea sportsfisher *Cowboy* suddenly sped up. A nearby boat had spotted a whale shark, a species seen so rarely that photographers regard it as a kind of underwater holy grail. Our skipper raced up the tuna tower, where he could drive the boat while tracking the creature. We waited on deck, tanks on and cameras ready.

The world's largest shark species, the whale shark lives on plankton and small fish. In spring, when vast masses of plankton bloom in the Sea of Cortez, a few whale sharks sometimes emerge for the feast from their deep-sea retreats.

Cowboy circled the shark, then cut into its path in a classic naval maneuver called "crossing the T." Genie and I launched ourselves off the stern. When we stopped tumbling and the bubbles cleared, the whale shark

Caribbean reef shark and bar jacks,
near Isla Mujeres, Mexico.
CARCHARHINUS PEREZI;
CARANGOIDES RUBER

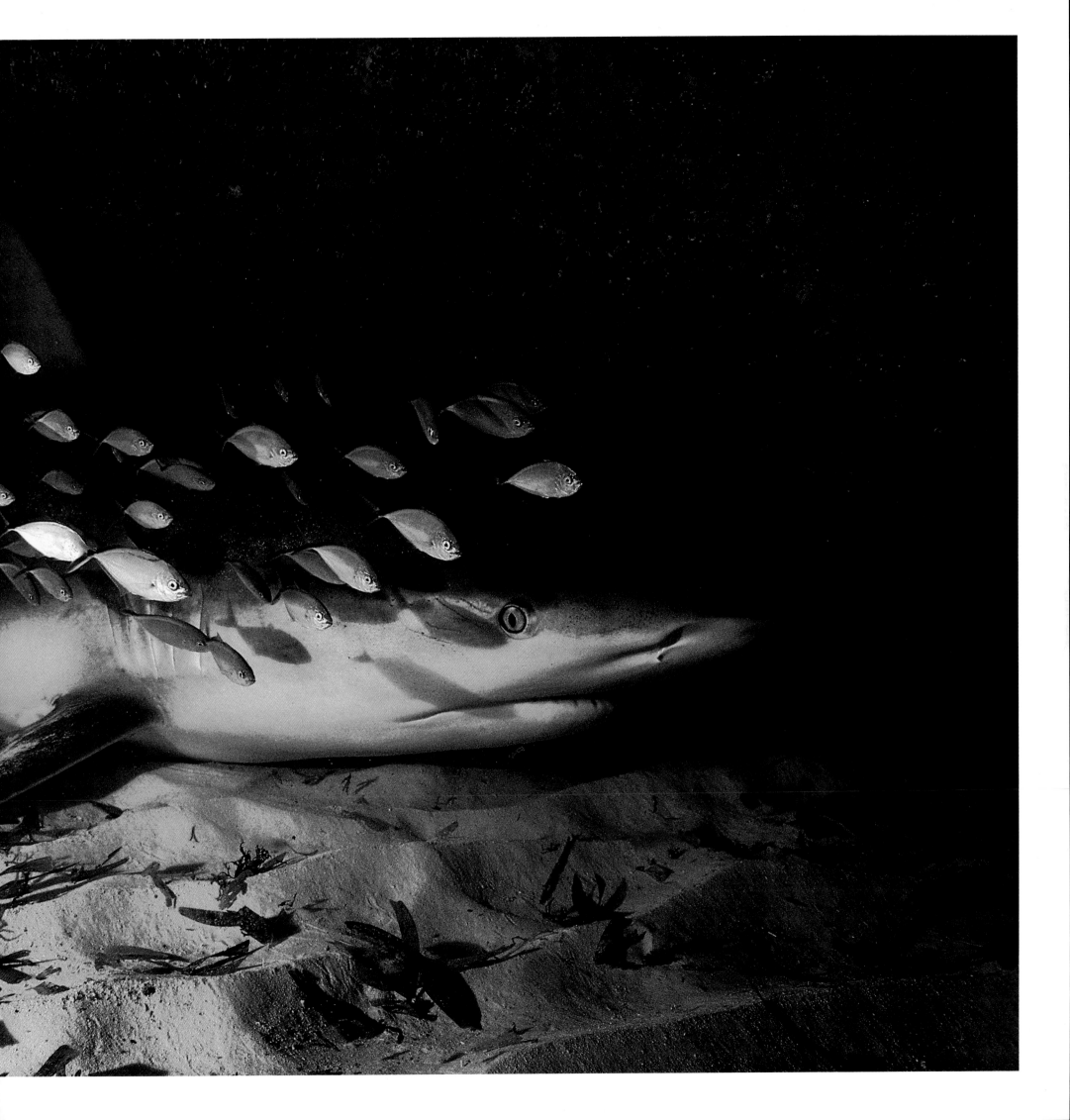

*Fifty-foot-long whale shark,
the largest ever photographed, Cabo
San Lucas, Baja California, Mexico.*
RHINIODON TYPUS

*Devil shark, one of world's
smallest sharks, Suruga Bay,
near Izu Peninsula, Japan.*
ETMOPTERUS LUCIFER

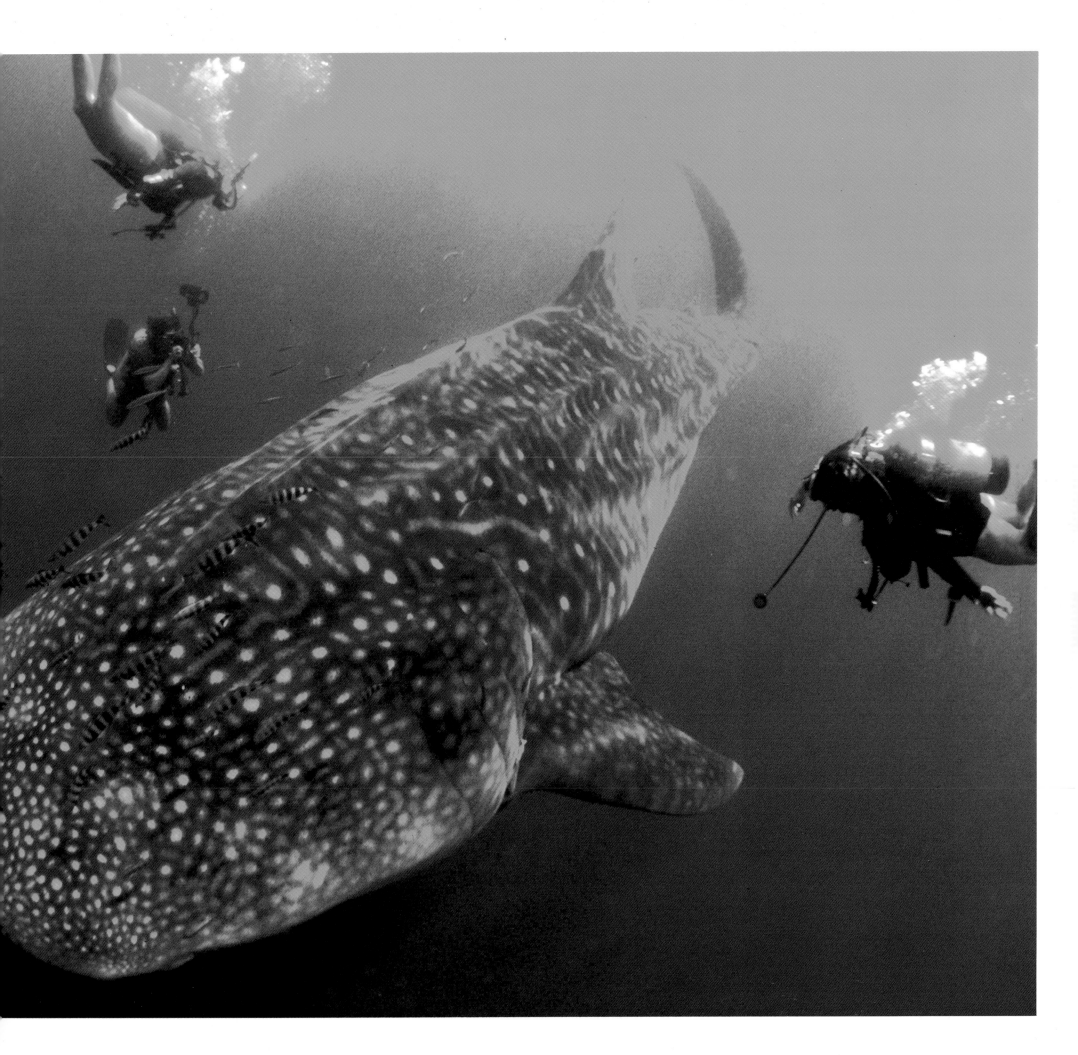

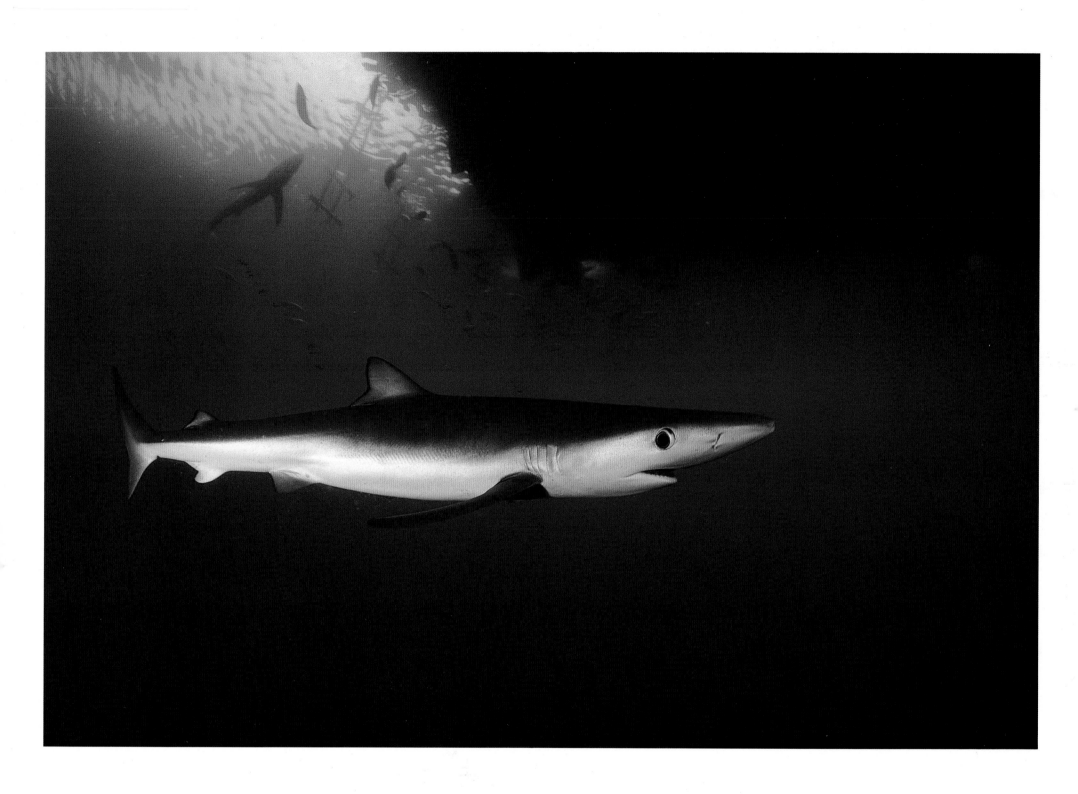

Blue shark, near San Clemente

Island, California.

PRIONACE GLAUCA

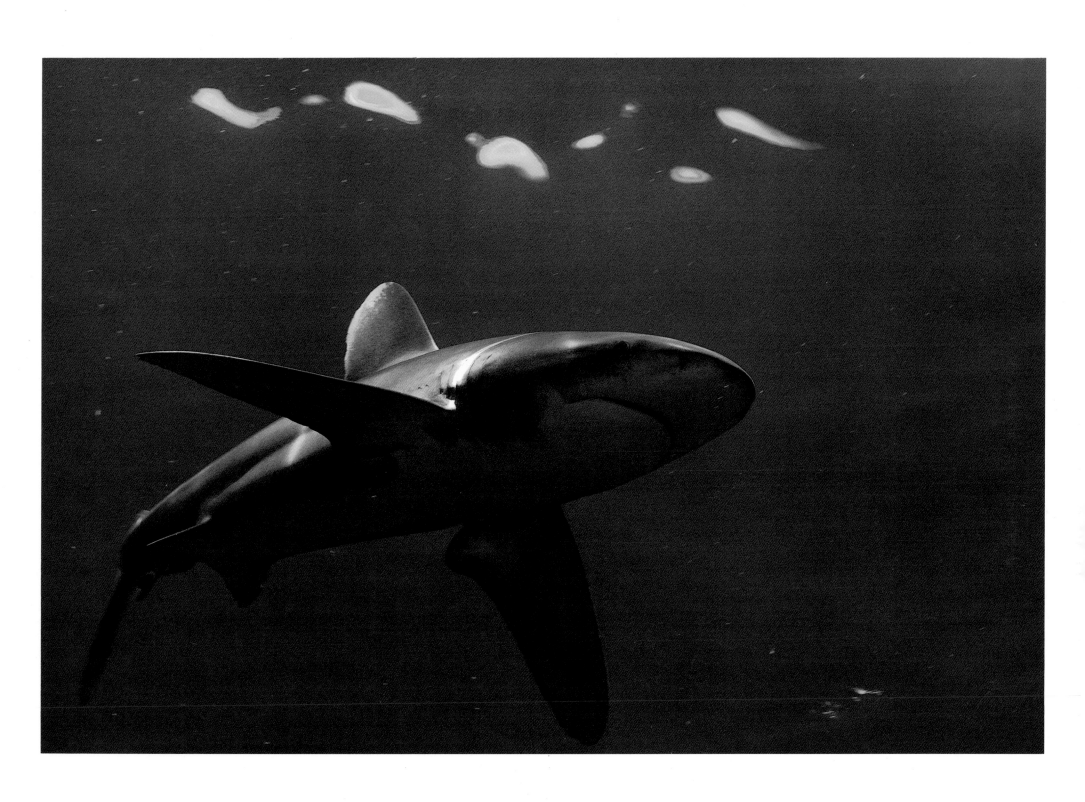

Oceanic white-tip shark,

off Maui, Hawaii.

CARCHARHINUS LONGIMANUS

was coming at us. She was 50 feet long and pregnant—the biggest shark any-one in the world had ever seen.

Her mouth was like a gigantic Hoover, a Hoover from Mars. Three doz-en remoras clung to its edges. Her body, neatly decorated with white spots, stretched away, punctuated by a great flat dorsal fin the size of a two-door refrigerator. Her giant lunate tail sculled her forward at an effortless, un-ending two-and-a-half knots. Spotting me, she turned away with delicate, elephantine grace. Hundreds of blue-striped pilot fish turned with her.

As the shark passed, Genie decided to hitch a ride and seized the dorsal fin. Her tank came loose, but she grimly held onto her mouthpiece. The shark swam on implacably. Genie slid from the dorsal fin to the tail's tip, hanging on while it made 40-foot arcs. Quickly she disappeared in the blue distance; I heard a soft "Whoo-wheee!"

Eventually, Genie surfaced a mile away. The whale shark's rough skin had scraped her legs and given her a rash—whale shark rash—a rare, wonder-ful oceanic disease.

In the cold waters of Japan's Suruga Bay, Koji Nakamura held out his red-gloved hand. A devil shark, one of the smallest sharks in the world, swam into it. A shrimp trawler had brought this member of the green-eyed, deep-water species up from 1,000 feet, where it feeds on giant red shrimp. Red shrimp are the same size as devil sharks. To me, the idea of a death struggle between a shark and a shrimp is an exquisite secret of the sea.

Sand tiger sharks in cave, Bonin Islands, Japan.
ODONTASPIS FEROX

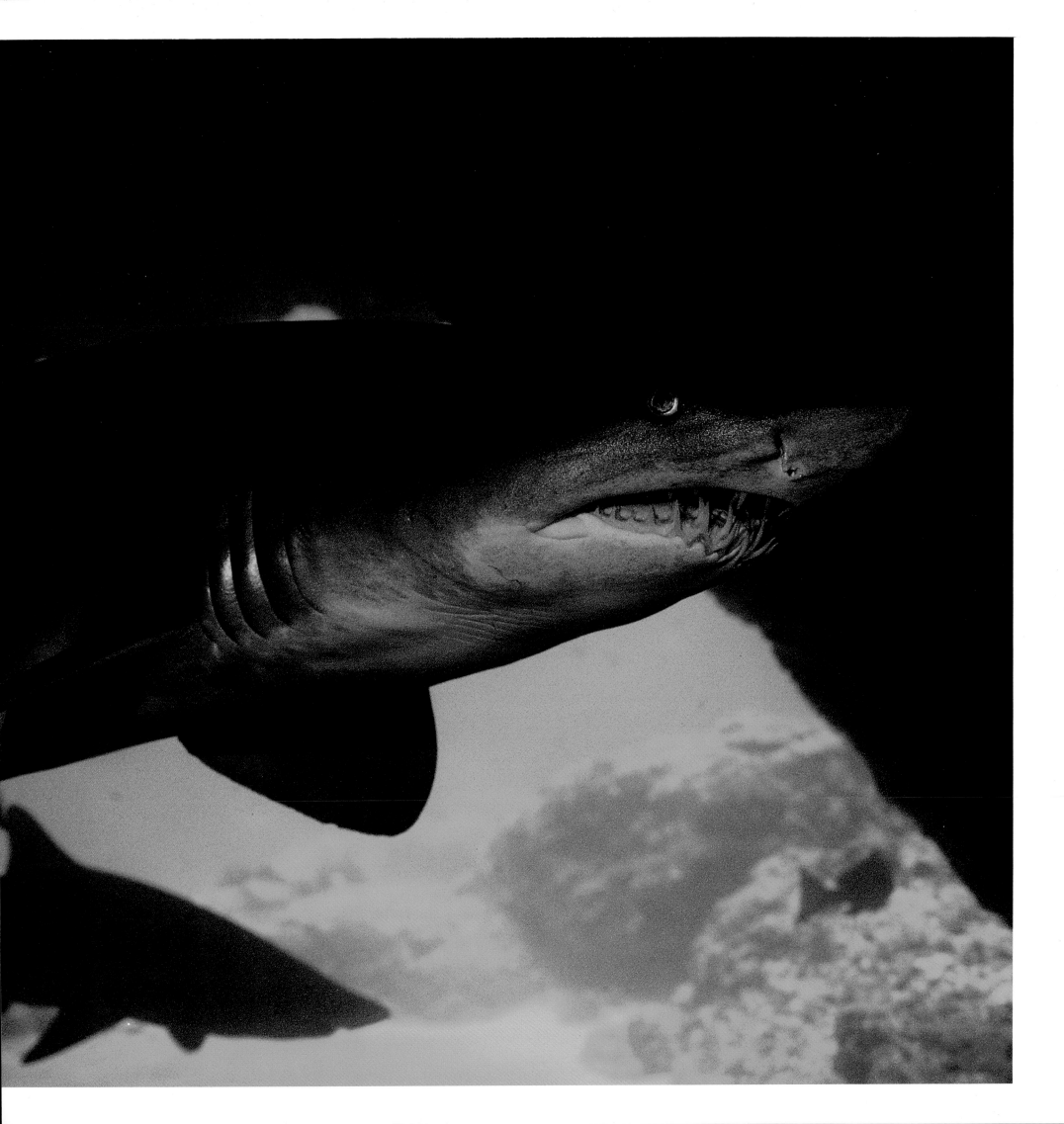

THE STRAIT OF GEORGIA

As I was swimming along the stone breakwater in Victoria Harbor, British Columbia, an octopus reached out of its den and grabbed my ankle. It was not a cardiac-arrest inducing, *Twenty Thousand Leagues Under the Sea,* ax-through-the-evil-tentacles assault. The octopus was shy, its grip hesitant and delicate. Obviously, it was fascinated by my well-turned ankle.

Seeing the situation, naturalists Jim and Jeanie Cosgrove swam over. Tentacle by tentacle, they coaxed the octopus out of its den and away from my ankle; tentacle by tentacle, they passed it to Warran Buck, our other diving partner. Warran put his hands under its mantle and swam upward. The octopus turned a furious maroon, gathered its tentacles like an opera impresario putting on his cloak, and glided away through the emerald sea.

The Strait of Georgia lies between mainland British Columbia and Vancouver Island. Twice a day, when the tides change, some of the world's strongest currents race through. Enriched by nutrients from freshwater streams and the depths of the North Pacific, the Strait's cold waters enfold a strange, diverse, and wildly colorful marine community. The world's largest octopuses jet about. Clown shrimp walk over unbelievably pink anemones. Sunflower sea stars extend hungry tentacles toward groups of scallops. Sensing the threat, the scallops levitate off the bottom like clacking joke dentures.

Warran Buck and I explored the length of the Strait, timing dives to match the slack water between tides. At Race Rocks, near Victoria Harbor, I watched a six-foot-long wolf eel crunch down on a sea urchin, spines and all. Despite their eel-like bodies, these tough-mouthed creatures are actually fish, closely related to tiny blennies. Watching the wolf eel savor its sea urchin, I felt something tugging at my leg. I turned around; a bull Steller sea lion was chewing my flipper.

Near Telegraph Cove, on the north end of Vancouver Island, we dove amid thousands of volleyball-sized hooded nudibranchs. They undulated toward the bottom and raised their crystal-clear hoods to feed on plankton. With their hoods up, they resembled a field full of radar dishes.

One gray day, when fog cloaked nearby forests, we dove around a rock pinnacle in a tiny channel off the Johnstone Strait. The water was clear, green, and still. Warran's flashlight revealed extravagant colors among the pinnacle's soft corals. Irish lord fish blended into brilliant red surroundings. Tiny pink, yellow, and red anemones grew like wildflowers. When we surfaced, snow was falling. I looked up at the forest and counted 10 eagles looking back at us in silence.

Wolf eel eats crimson sea urchin, Strait of Georgia, British Columbia, Canada.

ANARRHYTHUS OCELLATUS;
STRONGYLOCENTROTUS
FRANCISCANUS

Octopus and sea anemones, Strait of Georgia, British Columbia, Canada.

OCTOPUS DOFLEINI

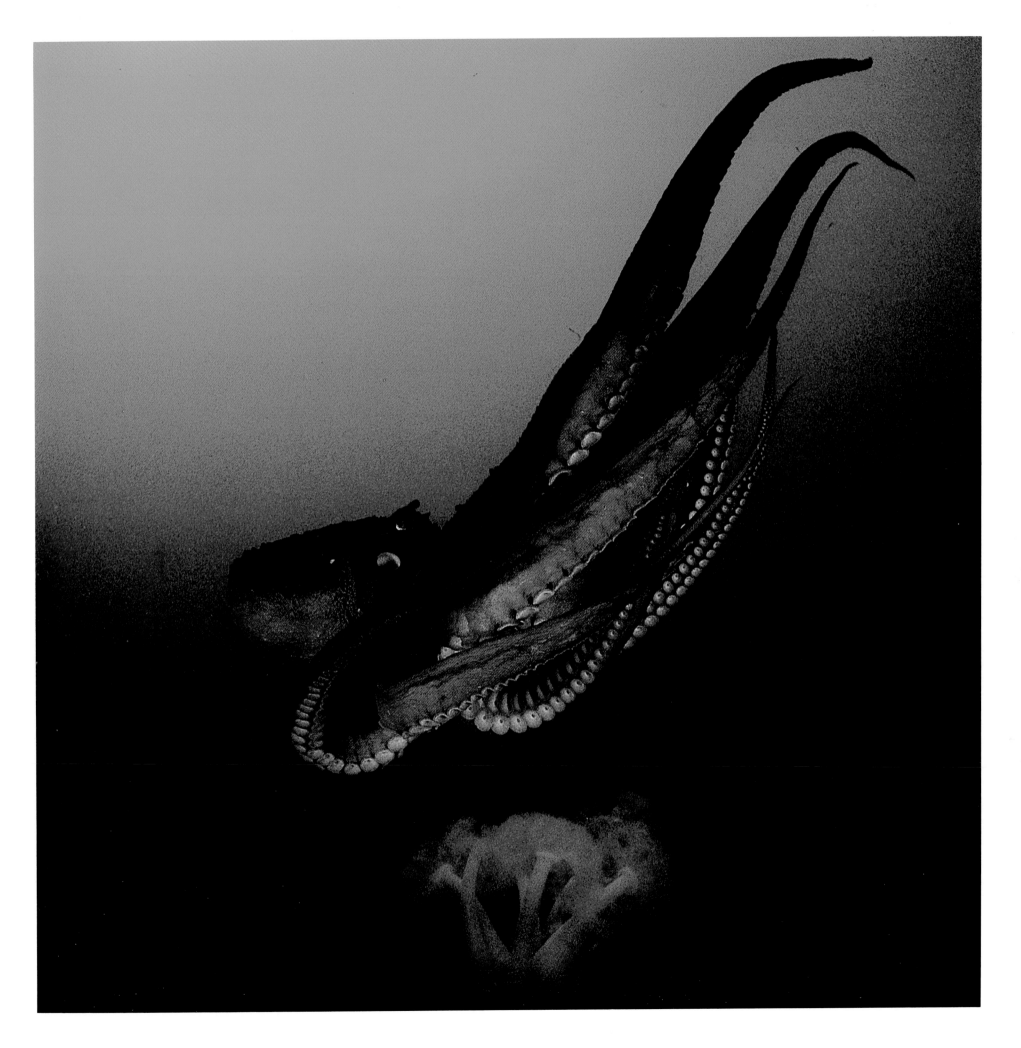

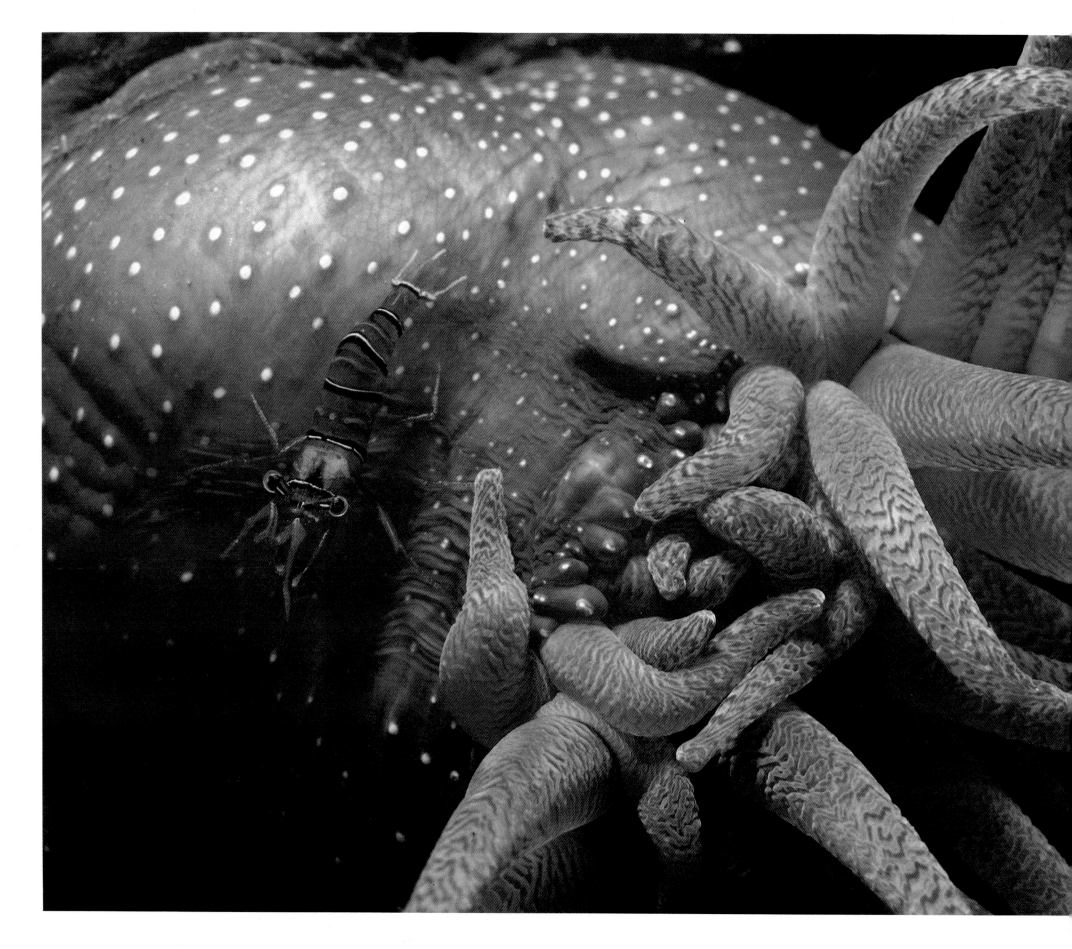

Candy-striped shrimp on sea anemone, Strait of Georgia, British Columbia, Canada.

LEBBEUS GRANDIMANUS

Hooded nudibranchs raise hoods that filter water for plankton, Strait of Georgia, British Columbia, Canada.

MELIBE LEONINA

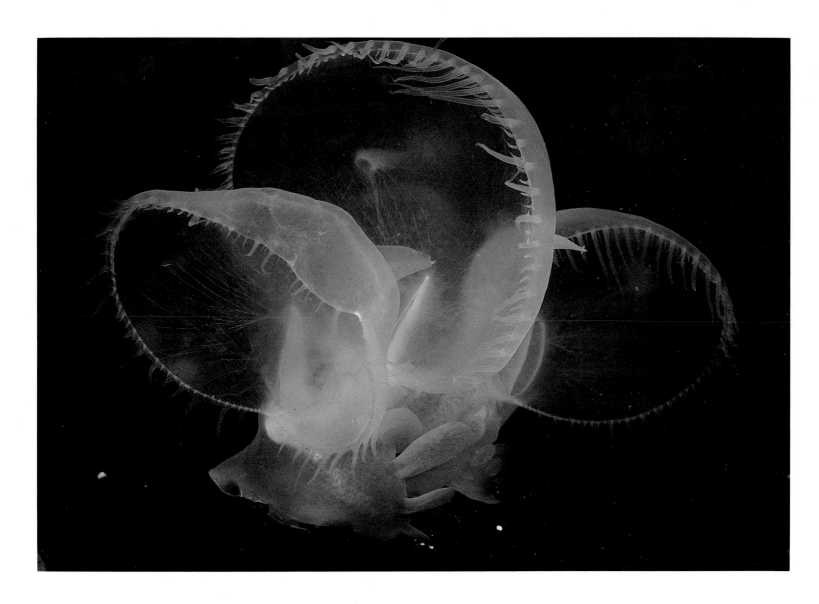

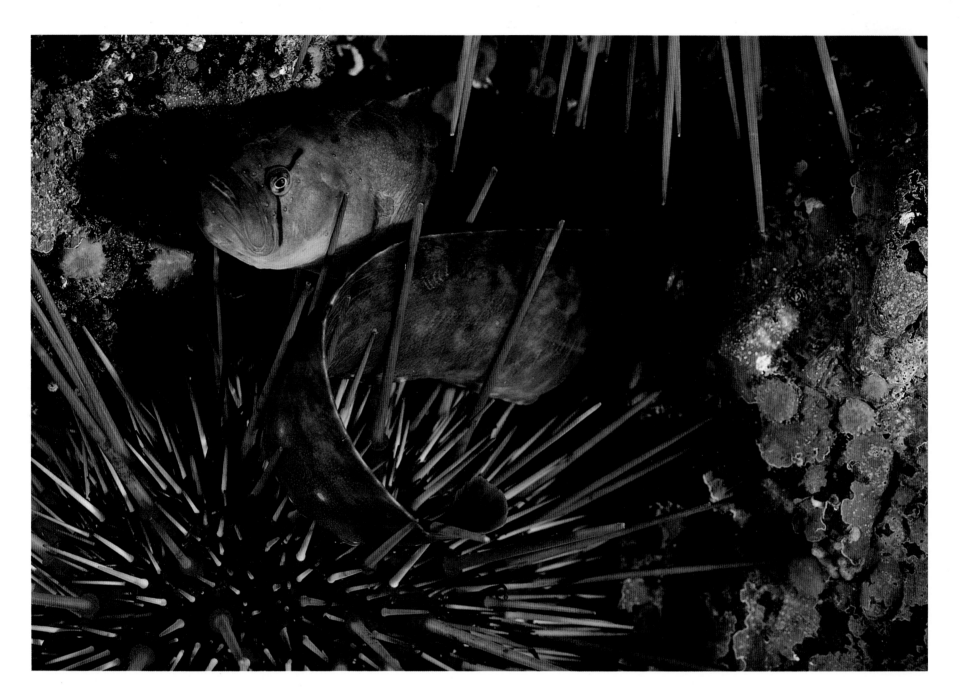

Penpoint gunnel in spines of

crimson sea urchin, Strait of

Georgia, British Columbia,

Canada.

APODICHTHYS FLAVIDUS;
STRONGYLOCENTROTUS
FRANCISCANUS

Orange sea star on rock covered

with purple sea stars, Strait of

Georgia, British Columbia,

Canada.

SOLASTER DAWSONI;
PISASTER OCHRASEUS

Bottle-nosed dolphin,

Kaneohe Bay, Oahu, Hawaii.

TURSIOPS TRUNCATUS

Potato cod and jacks, Cod

Hole, Ribbon Reefs,

Queensland, Australia.

EPINEPHELUS TUKULA;
CARANX SPECIOSUS

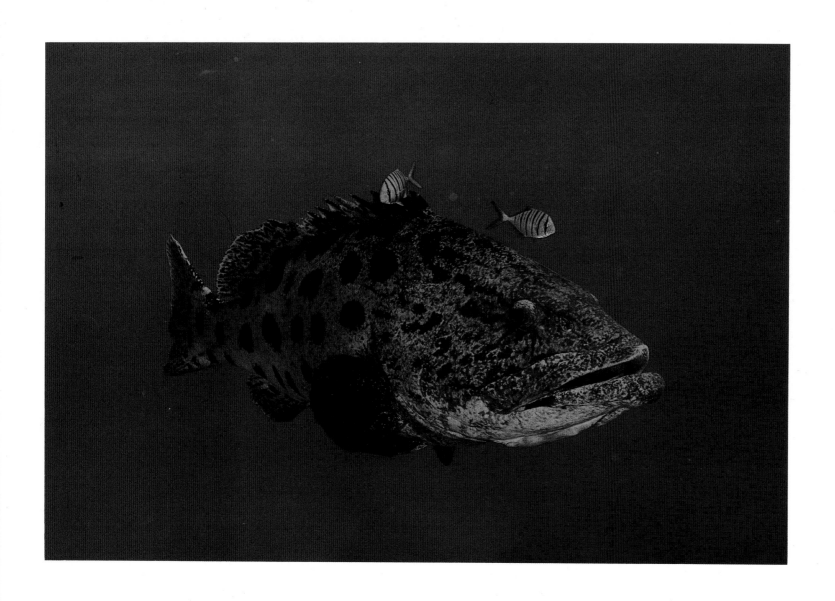

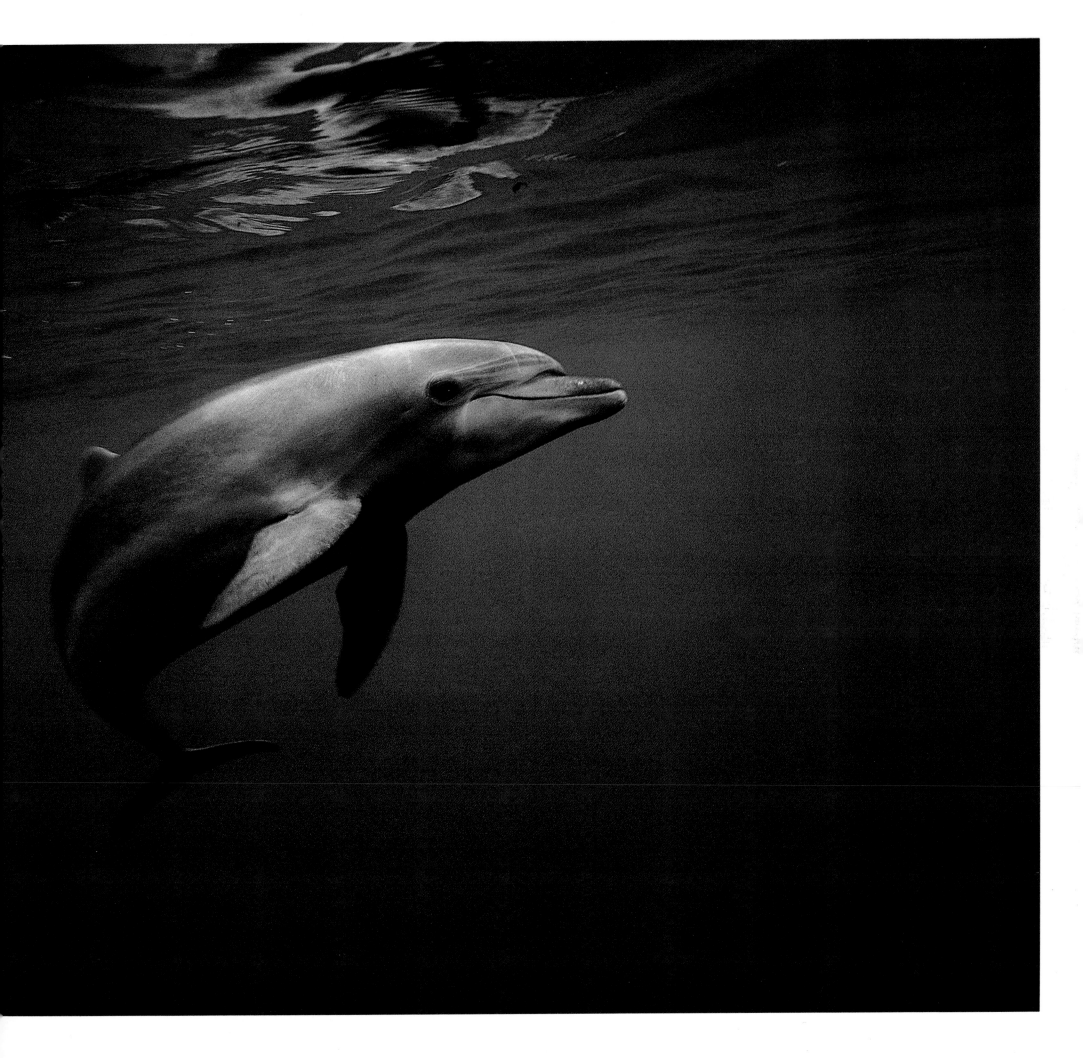

IZU

In spring, as winds from Siberia cease blowing across the slopes of Mount Fuji, warm rains come to the Izu Peninsula and bathe its cliffs and pine trees in mist. Cherry trees blossom on land; kelp and coral bloom beneath the waves.

Izu's steep, rocky coast emerges near one of the world's great tectonic joints, where the Eurasian, Philippine, and Pacific crustal plates meet. Fifty miles north, Fuji rises two and a half miles; one hundred and fifty miles east, the Izu trench sinks over six miles. Diving at Izu, photographer Koji Nakamura once saw an underwater earthquake. "The seabed jumped," he later told me. "Great boulders leaped like marbles. Fish flew about like leaves in a windstorm, but the most amazing thing was the sound. I didn't hear it, I felt it. It was so low and so loud it came through my stomach into my bones."

On Izu's windy cliffs, it can feel as if the entire Pacific is pushing against the rocks below. Sticking out into the ocean like a spatulate thumb, the peninsula hooks both warm and cold currents. The Kuroshio current, the "black stream," carries equatorial water north along Japan's coast, bringing coral-dwelling creatures from the south. Northern currents introduce temperate water creatures. Japan's coastal waters are too cold for reef-building corals, but sea fans, soft corals, and sponges flourish.

On a cloudy spring morning in 1982, Dr. Eugenie Clark, my wife Anne, and I joined Koji Nakamura and his diving partners Tadahiko Matsui and Yasumasa Kobayashi on the dock at Futo, a tiny fishing port on Izu's east coast. Koji, a wondrous photographer, grew up here. He learned to dive and photograph at the Izu Kaiyo-Koen Diving Center near Futo. Izu is his source, his studio; although he travels the world making pictures and films, he always returns.

Evening near Futo,
Izu Peninsula, Japan.

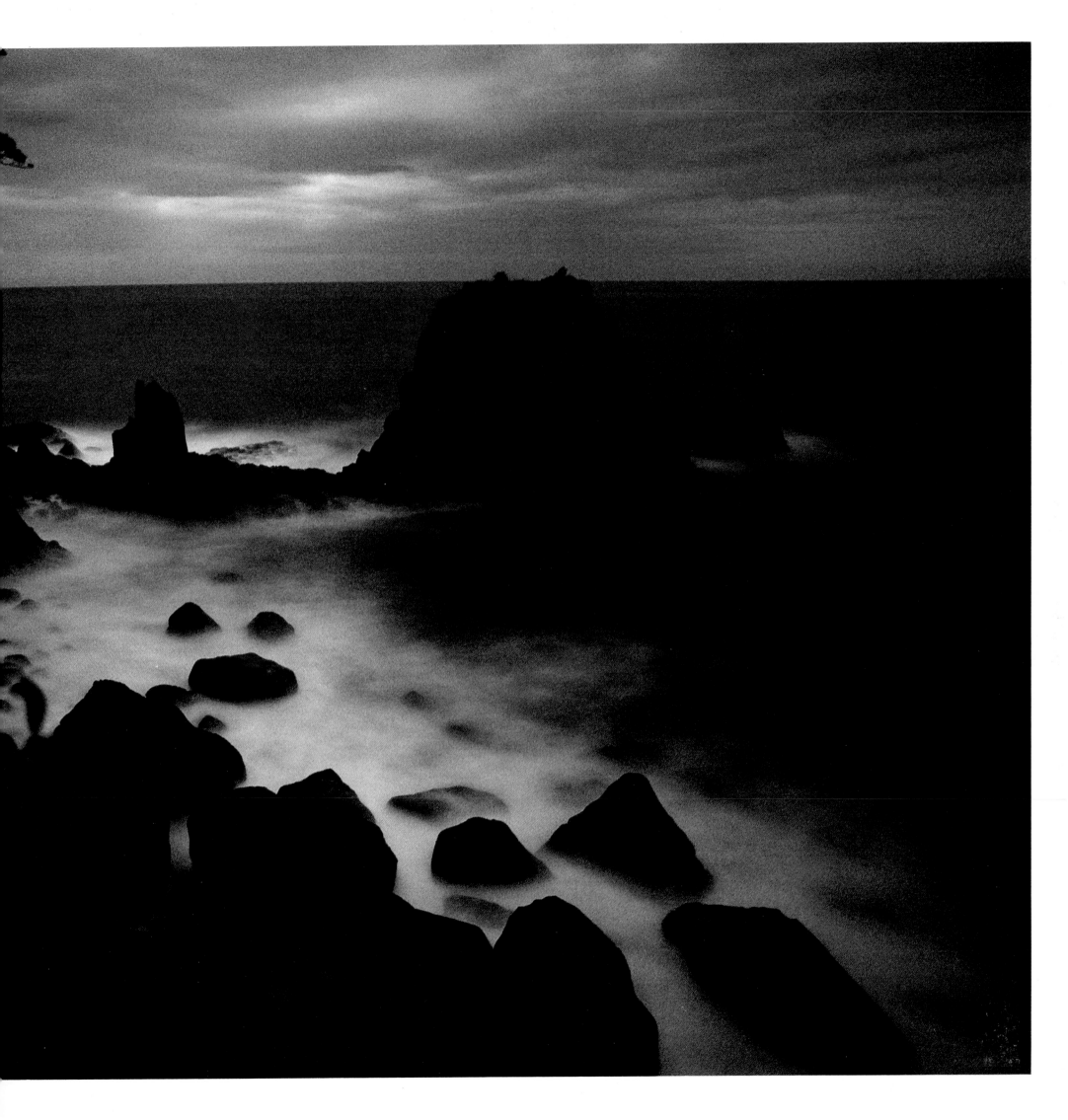

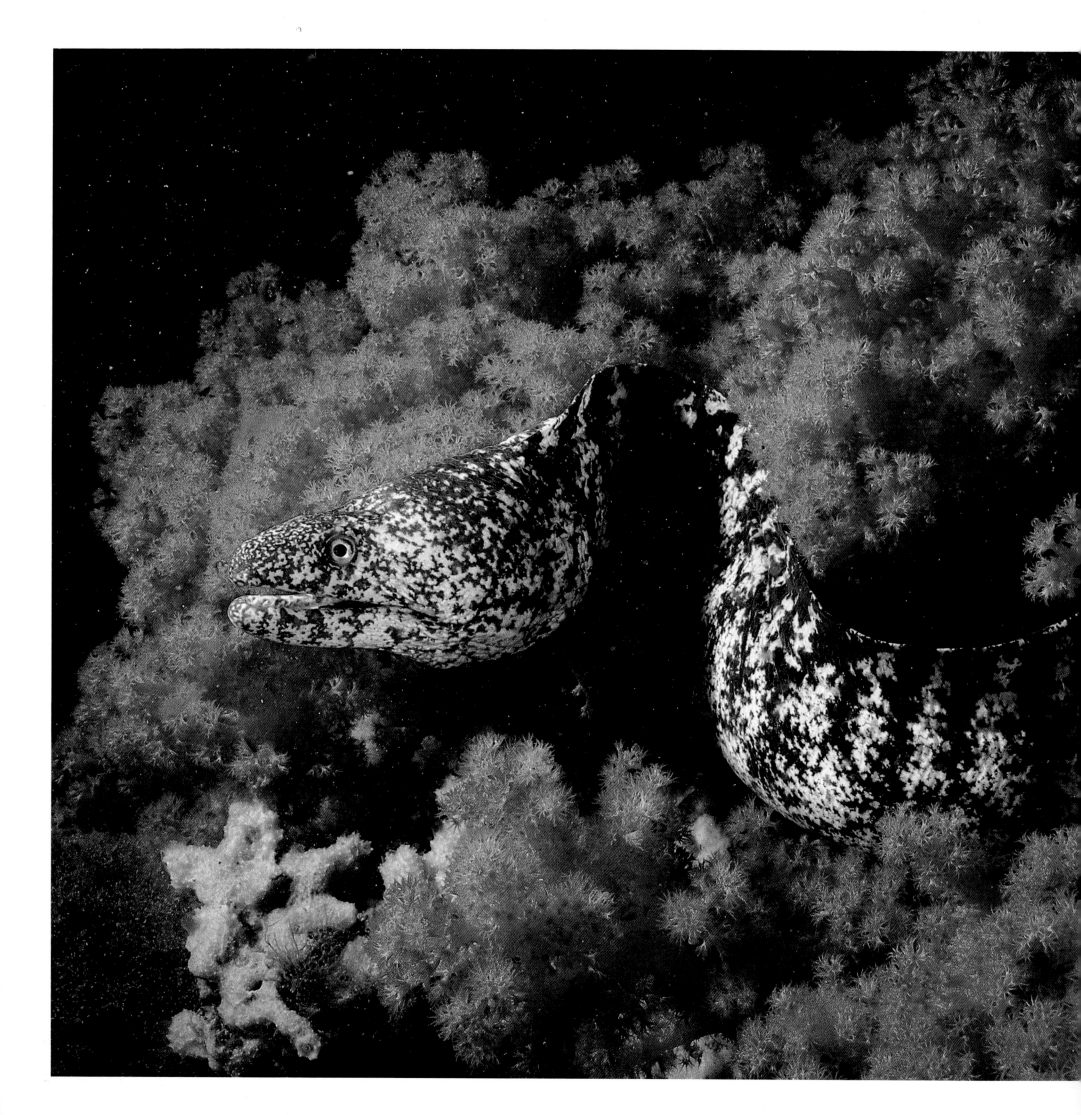

Izu diving is deep diving; within 100 yards of the rocky shore, the underwater cliffs, composed of huge black boulders, plummet 1,000 feet. Anchoring our boat off Futo Point, half a mile from the village, we planned to dive to 180 feet, and would have to return to the surface gradually, decompressing slowly, to avoid the bends. On a normal two-hour dive, you have only 20 minutes at 180 feet before you need to head upward. To give ourselves more deepwater time, we each took down an extra set of double tanks, a single tank, and their attendant regulators, stockpiling them near the boat's anchor. This gave us 40 minutes in deep water and over three hours in shallow water, where we continued to photograph as we decompressed. The system was safe, but there were two drawbacks: the water was very cold, and we couldn't bring lunch.

About lunch, we could do nothing, but for the cold we had 1950s-style all-rubber wetsuits without zippers or nylon inner linings. We used talcum powder and water to wriggle into them. For extra warmth, we also wore thin rubber T-shirts and Bermuda-length shorts underneath. In our rubber underwear, Koji and I looked like twin Humpty-Dumptys.

In spring, blooming plankton clouds Izu's warm top layers of water. Deeper down, the temperature is lower and the water clears. Between the warm and cold zones is the thermocline, the boundary layer where the temperature changes. On my first Izu dive, I thought the thermocline would be at a depth of 10 or 20 feet. Koji smiled enigmatically, took a vast coil of white rope, and jumped overboard. We followed. The water was murky, with about five feet of visibility. I poked my head above the surface. Koji said, "Miso soup," then disappeared.

Moray eel in soft coral,
Izu Peninsula, Japan.
GYMNOTHORAX KIDAKO

We dropped our extra tanks and cameras at the anchor. Koji tied one end of his rope to a rock; playing it out behind him, he crossed the boulder-filled shallows, then dropped over the cliff and began to descend with the rest of us behind him. The rope was our lifeline, our way back to the air tanks. Looking back, I could barely see the end of my flippers. We were in the open sea, but we might as well have been in a cave.

At 50 feet, still in murky water, I nearly stuck my knee into a giant fire urchin. It looked like a space ship, red and yellow and lit from inside. Touching one of its poison-tipped spines could make you sick for a week. The horrible thing waved its spines at me, then laid some eggs.

At 75 feet, Matsui turned on a big movie light he was carrying. Like bright headlights in a blizzard, it made matters worse. Where was the thermocline? At 120 feet, the old oppressive "why am I here?" feeling came over me. Suddenly, around 135 feet, we dropped out of broth into perfectly still, perfectly clear water. The rocky bottom sloped downward. Cold seeped into my wetsuit. In the silence and darkness, I thought of starlight slipping through a cathedral window. We had gone through the looking glass to a secret place in the sea.

Our surroundings looked as ordered and clean as a Japanese garden. Sea fans, sponges, and soft alcyonarian corals stood out in sharp patterns among the black boulders whose tops they covered. As Matsui played the movie light on the corals, colors bloomed, richer and more rare than I had ever seen on a tropical reef. A spectral forest of soft corals six feet tall dotted the lower slopes, receding into total darkness.

Koji found a blue-eyed white and gray moray eel threading its way through a bed of orange soft corals. A mottled Japanese swell shark cruised past with emerald eyes and a grim expression. Small groups of anthias hovered above the coral gardens. In the low light, all the corals' polyps were extended, the tiny mouths open and feeding.

Mullet, Izu Peninsula, Japan.

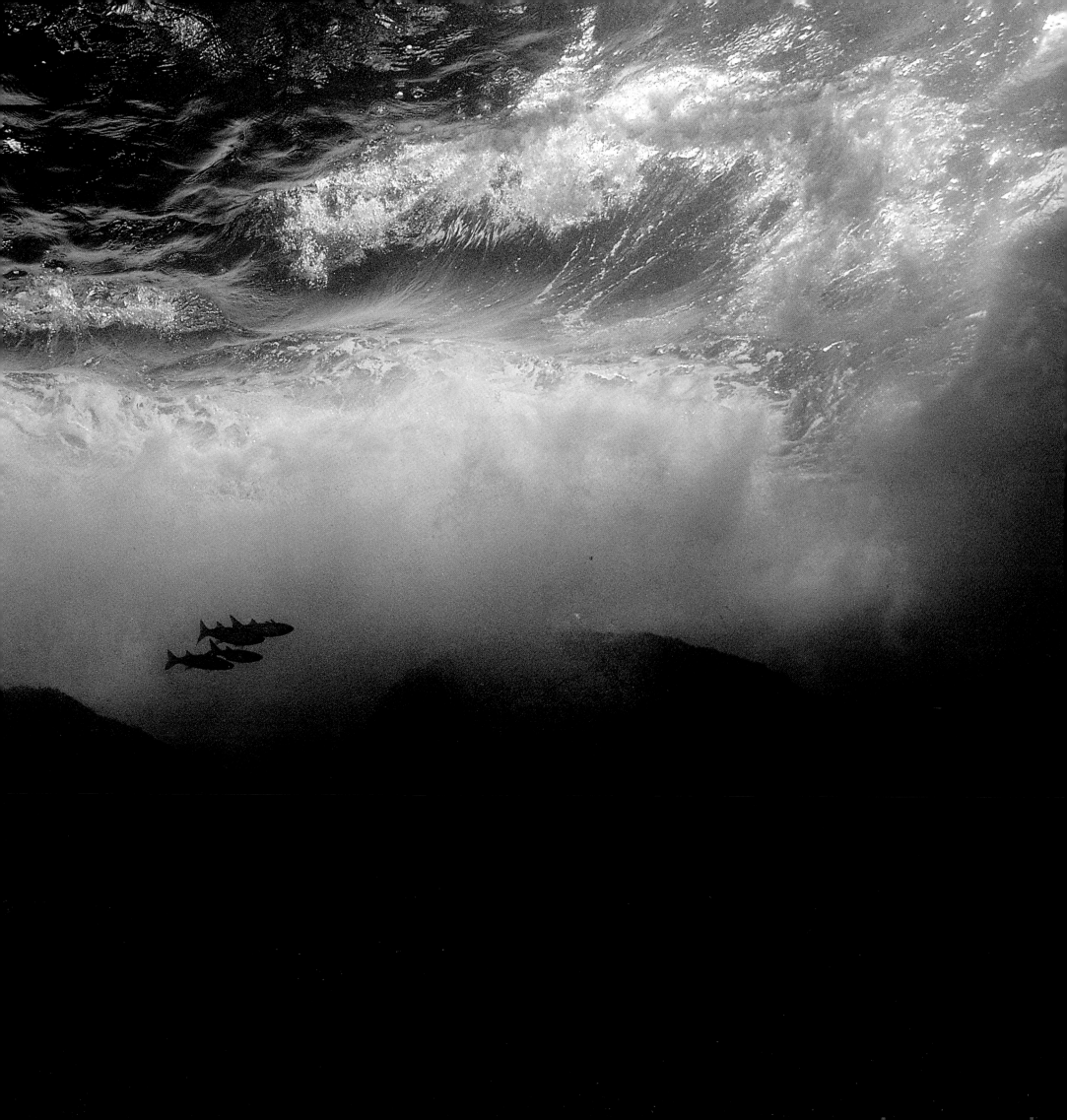

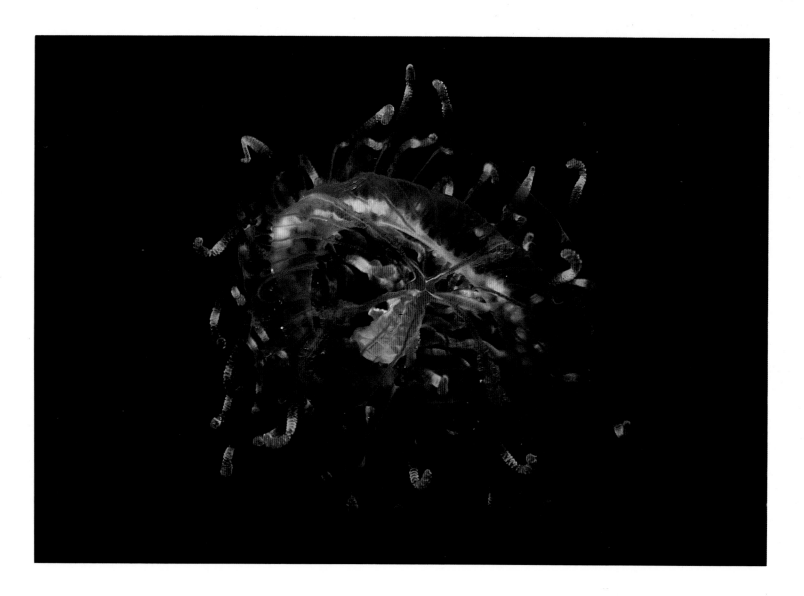

It seemed that only moments had passed before Anne swam up, took my arm, and pointed to her watch, depth gauge, and decompression meter. I looked up at the green glow of the distant surface. We found the end of the safety line and followed it toward the light. The dreamscape vanished; we swam again in planktonic murk.

In the evening, Koji and I stood in the pine grove at a nearby Buddhist temple, watching squid boats chugging out of Futo's tiny harbor. In the blue light of dusk, the line between sea and sky disappeared. When the boats switched on the powerful lights they use to attract squid, they became galaxies on the face of a darkening sea.

Jellyfish with stinging tentacles
extended, Izu Peninsula, Japan.
(Anne L. Doubilet)
OLINDIAS FORMOSA

Baby sharpnose pufferfish in gorgonian coral, Izu Peninsula, Japan.

*Soft-coral goby in alcyonarian
coral, Izu Peninsula, Japan.*
PLEUROSICYA BOLDINGHI

The nets of the lobstermen were already spread across the rocky shallows to capture lobsters as they crawled out to feed in the evening. During the day, Ama divers had scoured the shallows for seaweed, kelp, abalones, sea urchins, and sea slugs. In the past, these women divers wore white cotton robes; now they dive in wetsuits with yellow heart-shaped patches glued over their breasts and face masks with long orange hoses running up to the surface. Their husbands tend the hoses from boats while the women search the bottom like great bubbling rubber crabs, harvesting the fields of the sea.

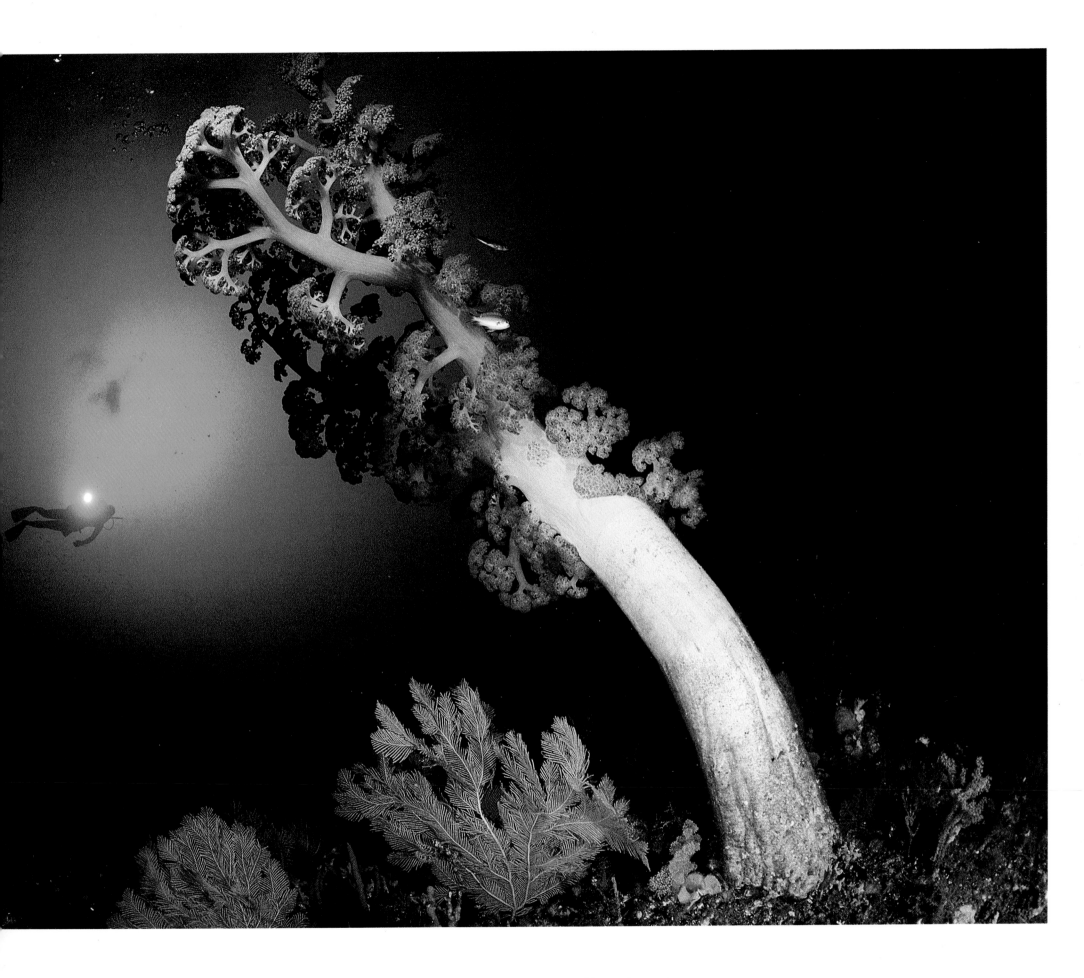

Alcyonarian coral,

Izu Peninsula, Japan.

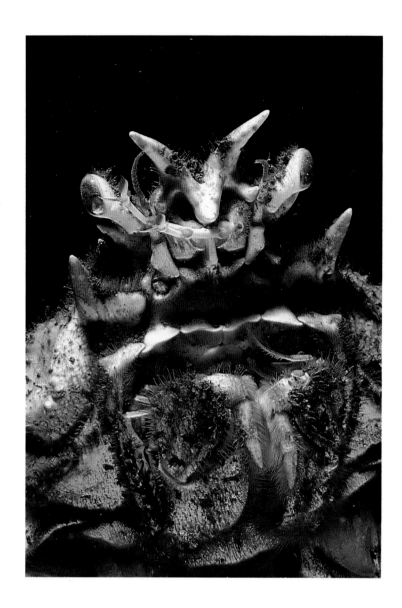

Giant Japanese spider crab,
member of world's largest
crustacean species; some have a
claw span of 11 feet.
Izu Peninsula, Japan.
MACROCHEIRA KAEMPFERI

We returned to Izu in late fall, when chill winds from Siberia had cleared the water. White-capped Pacific rollers mashed against the cliffs. Sunlight lanced through pines into the shallows boiling with foam clouds.

In the crystalline sea, light flooded the deep garden. A blue plain dotted with coral trees rolled away into the depths. We found tiny gobies living like birds in the branches of these trees. The gobies crawled up and down the trunks, eating detritus.

In a cave coated with yellow and red sponges, I came across a boldly striped tiger moray eel whose skin pattern continued inside its mouth. Anne photographed a jellyfish with purple and green tentacles projecting outward like pipecleaners. Turning over a sea star, I found two inch-long shrimp wandering like tourists between the columns of its tube feet. The shrimps' minute legs were as clear as glass.

We struggled with cold on our four-hour dives. For the first hour, our suits felt toasty warm. In the second, they grew chilly. By the last, they were unbearable. To stay warm, we swam, covering large amounts of undersea territory in looping circles.

If I timed it correctly, I would shoot the last frame of film on the last breath of air. As I took the last pictures, trying not to shiver while I pressed the trigger, everyone else transferred cameras and empty tanks from the seabed to the rocking boat.

Once on shore, with our tons of equipment loaded in the back of the van and the heater blasting, an amazing sensation hit us: hunger. Vast, uncontrollable hunger. The hunger of wolves loping across the tundra. Tyrannosaurus Rex hunger. We leaped out of the van at a small supermarket and attacked. Food flew off the shelves: rice balls, lunch boxes with sushi, potato chips, sweet potato sticks, dried squid, sandwiches, eclairs, chocolate bars, ice cream bars, and a strange kind of potato pancake. The checkout ladies looked bleakly down the aisles. Everywhere our rubber-clad horde went, it left huge puddles in their jewel-like supermarket.

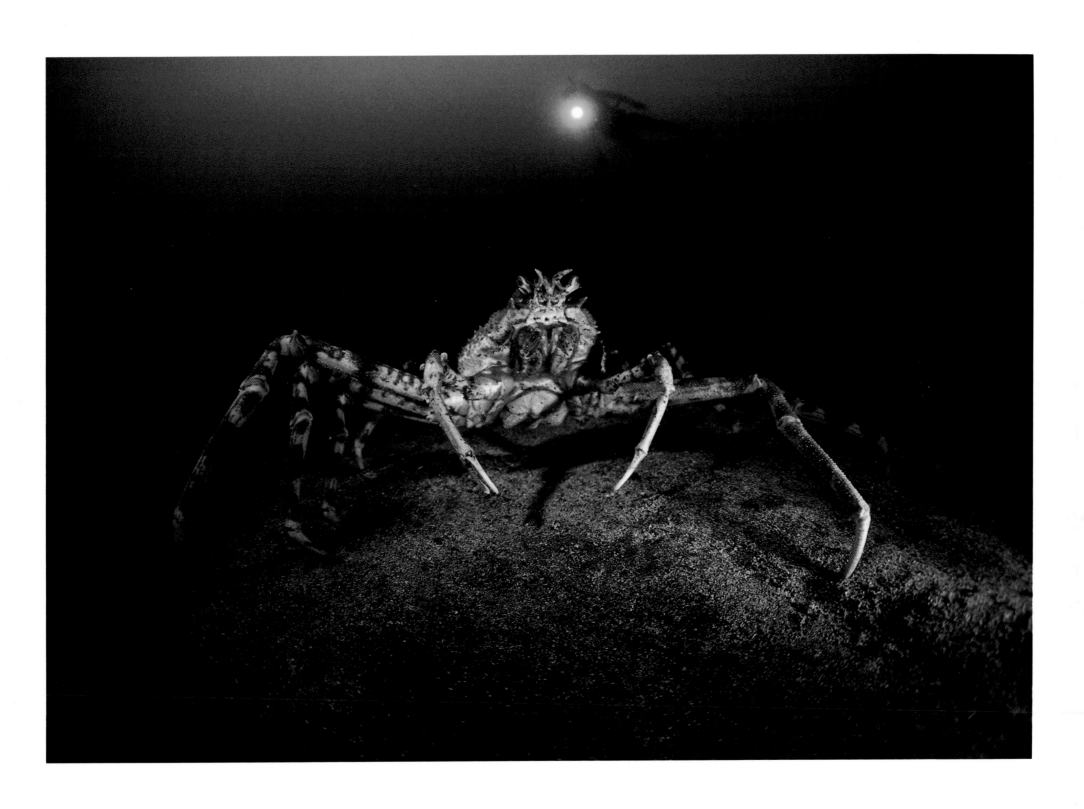

Giant Japanese spider crab,

possibly 50 years old, with an

eight-foot claw span,

Izu Peninsula, Japan.

MACROCHEIRA KAEMPFERI

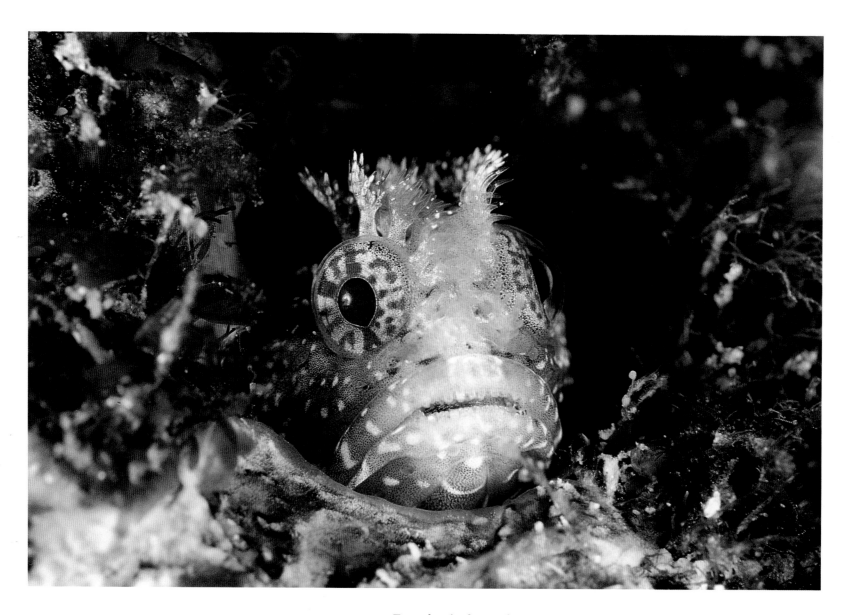

*Two-inch-long fringe-headed
blenny in rock burrow,
Izu Peninsula, Japan.*
NEOCLINUS BRYOPE

Every day, the dream of our supermarket feeding frenzy powered me
through the dive's last, freezing hours. Our pillage, however, was only a snack.
After a shower and a soak in the hot tub, we often drove up into the mountains
to a place that specialized in *tonkatsu* pork, lightly breaded and fried, and very
large shrimp in a dark, sweet sauce.

We were always exhausted; the cold of the sea pulled all of the energy
out of our bodies. Of one such evening, I remember only two things. We
ordered. Then, seemingly only seconds later, I was awakened by the sound of
soft giggling. The entire restaurant staff stood at the door of our tatami alcove.
We had all fallen asleep. Anne and I slumped together, head to head. Genie
was curled up like a cat. Matsui and Kobayashi had their heads on the low
table like students after a massive exam. Koji lay on his back like a walrus,
snoring gently and dreaming of giant white coral trees and green-eyed sharks.

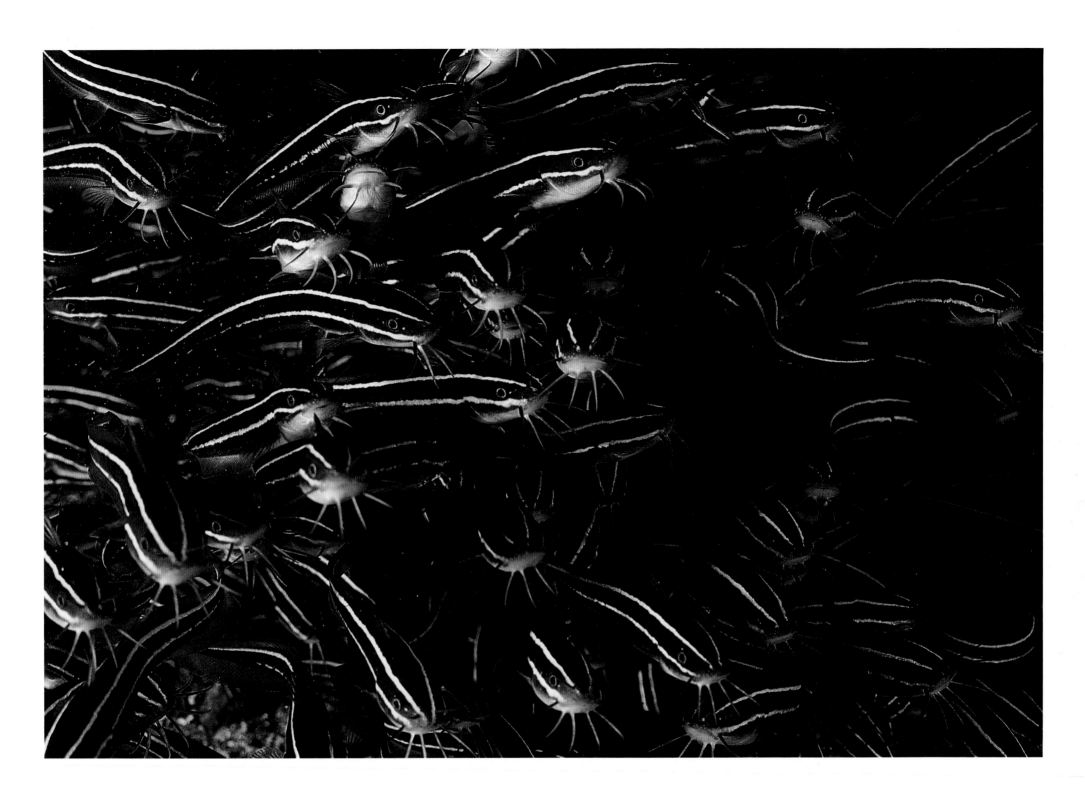

Gonzui dama, *or "catfish ball," of*
venomous catfish, whose sting can
be fatal, Izu Peninsula, Japan.
PLOTOSUS LINEATUS

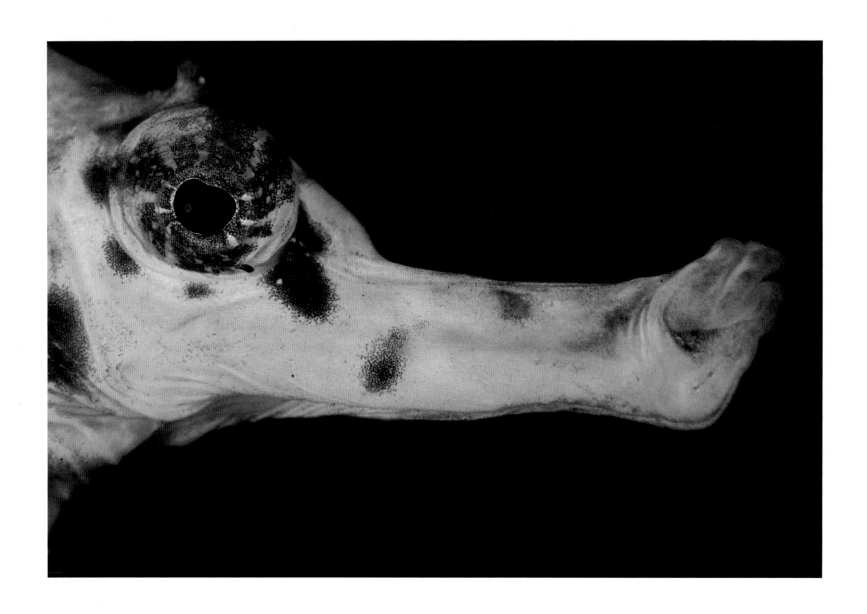

Yellow sea horse,

Izu Peninsula, Japan.

HIPPOCAMPUS KUDA

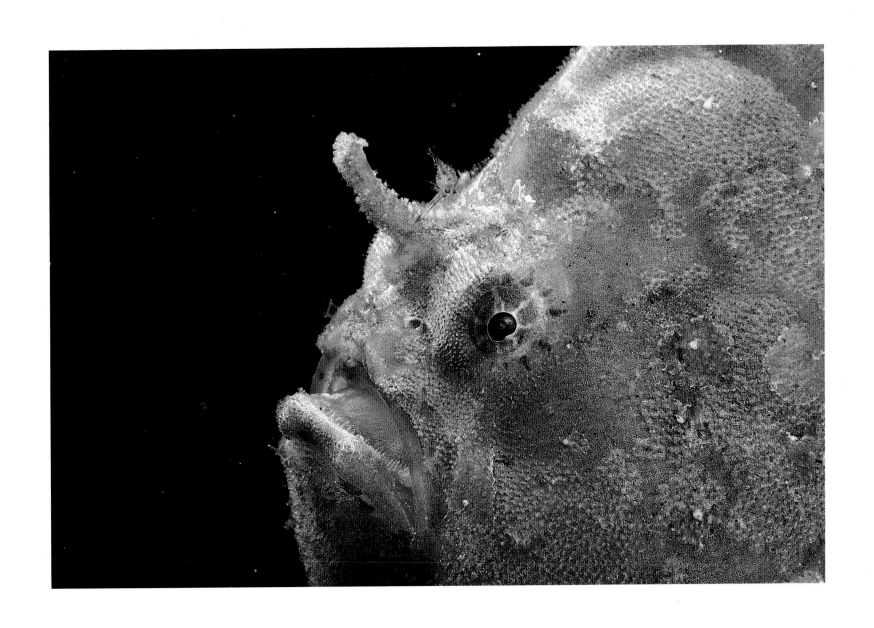

Japanese anglerfish,

Izu Peninsula, Japan.

ANTENNARIUS MOLUCCENSIS

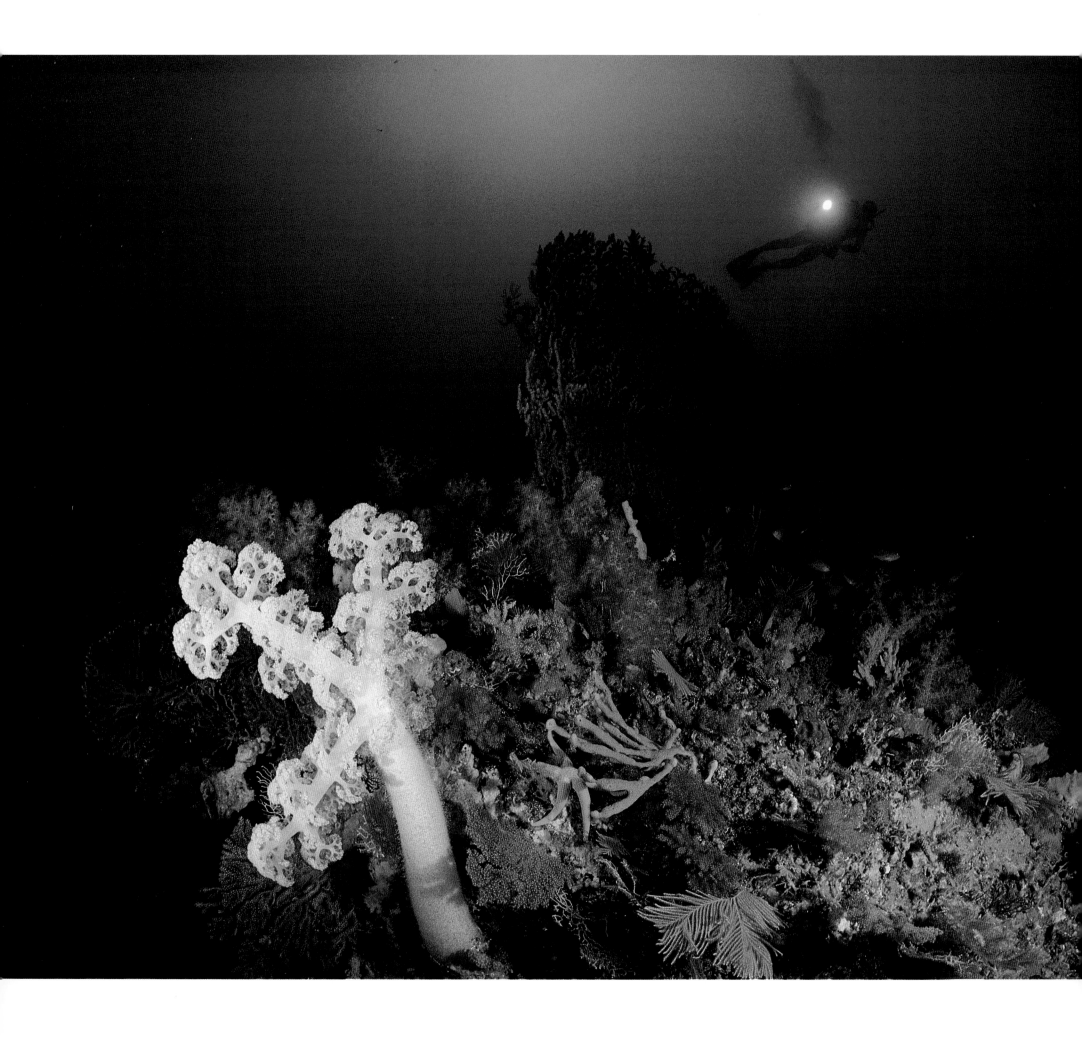

Alcyonarian, gorgonian,
and other corals at 160 feet,
Izu Peninsula, Japan.

Cleaner wrasse washes
striped morwong's eye,
Izu Peninsula, Japan.

LABROIDES DIMIDIATUS;
GONISTIUS ZONATUS.

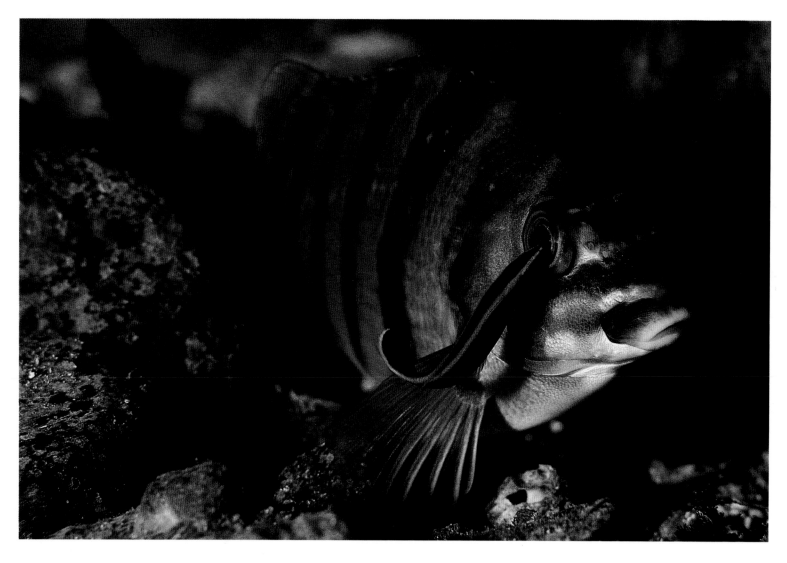

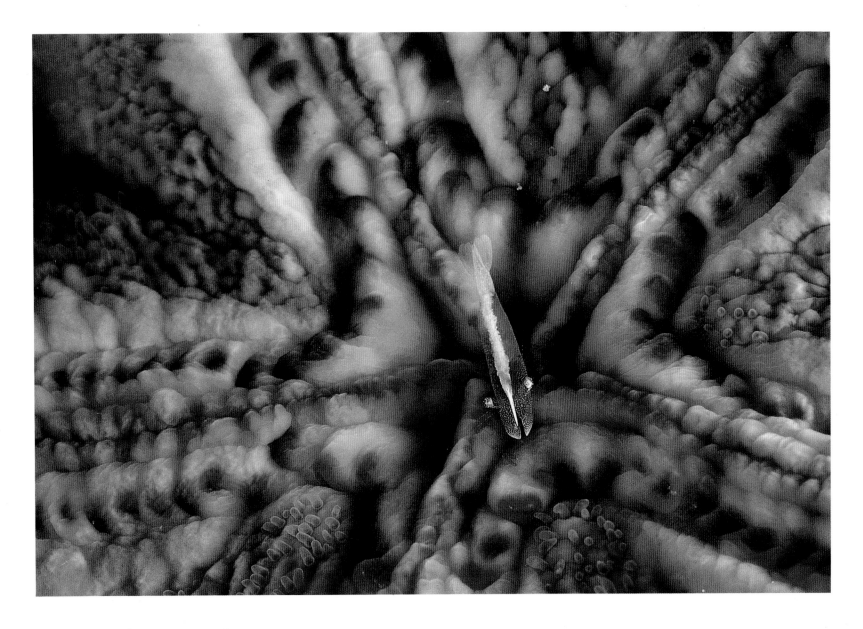

Shrimp near sea star's

mouth, Izu Peninsula, Japan.

PERICLIMENES SP.

Two-foot-wide sea star,

Izu Peninsula, Japan.

LEIASTER LEACHII

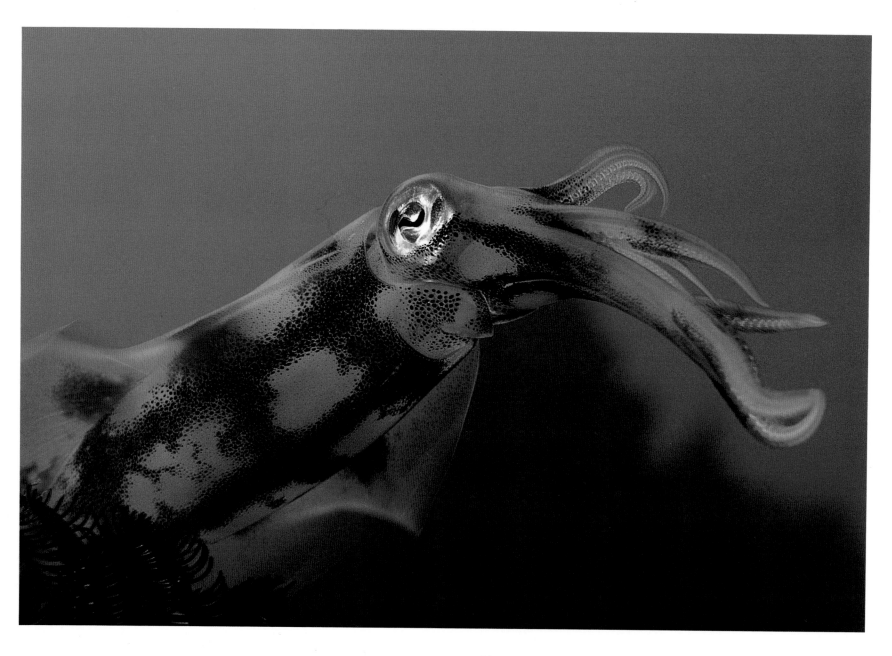

(Above and facing) Big fin reef

squid, Izu Peninsula, Japan.

SEPIOTEUTHIS LESSONIANA

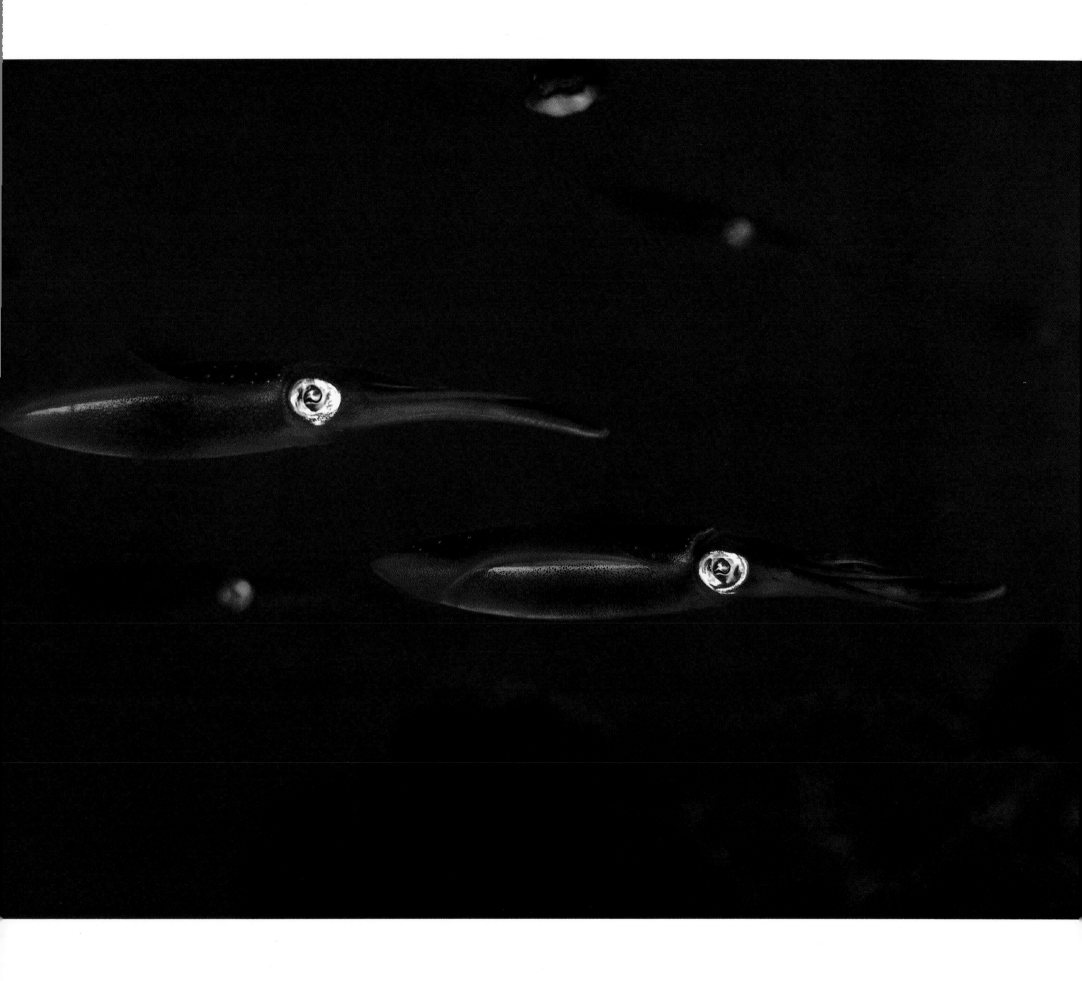

Tiger moray eel,

Izu Peninsula, Japan.

MURAENA PARDALIS

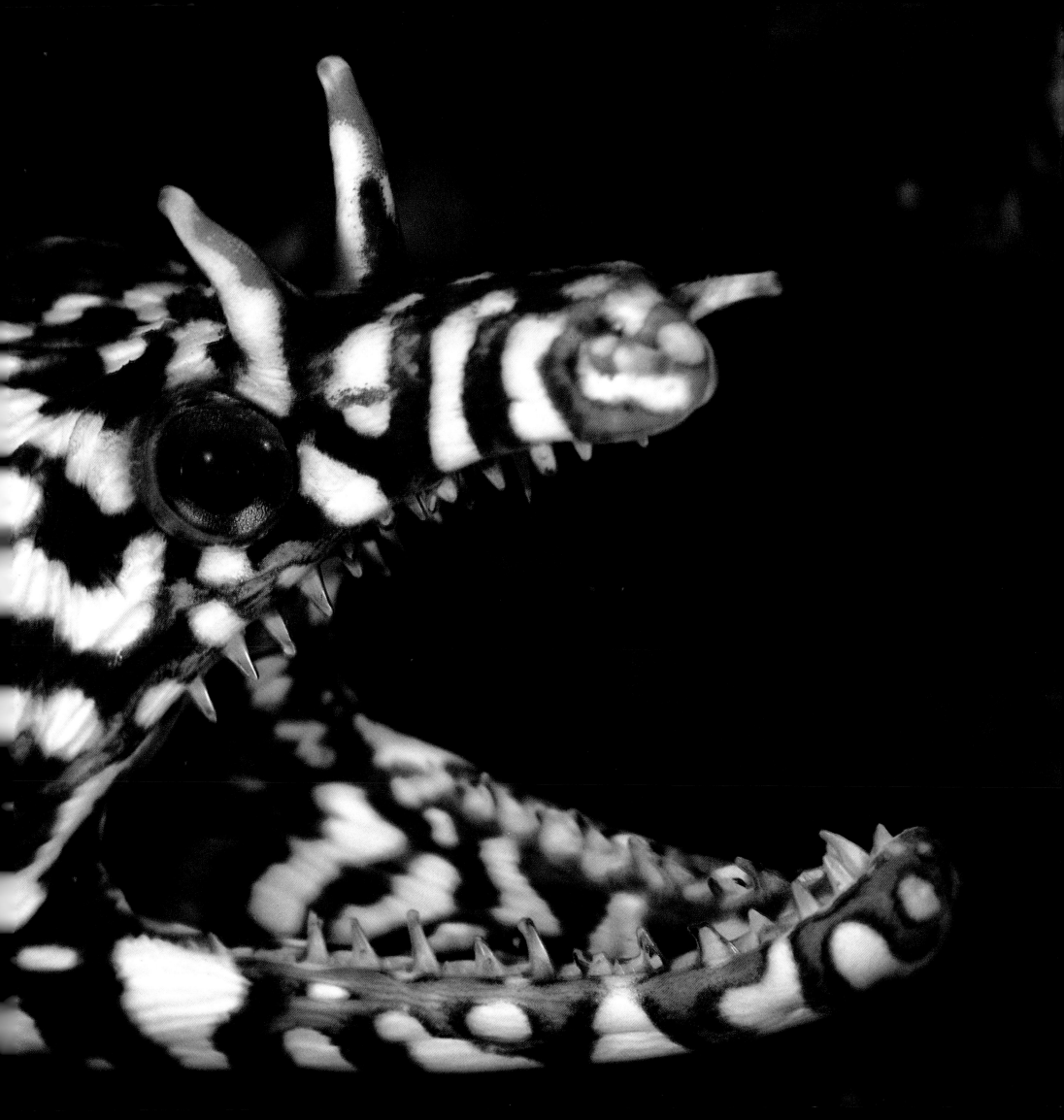

THE
SOUTHWEST PACIFIC

The dive boat *Telita,* owned by Bob and Dinah Halstead, was anchored bow and stern off the village of Boga Boga at the tip of Cape Vogel in eastern New Guinea. A strong current racing between the Coral and Solomon Seas made the anchor ropes vibrate like bass fiddle strings.

Dinah Halstead slipped on her blue flippers and dropped over the side. With one deft motion, she caught the stern anchor rope, instantly streaming out behind it in the current, which formed little whirlpools around her and nearly tore off her face mask. After I jumped in, Bob handed down the cameras, and somehow Dinah and I managed to take them without losing our grip on the rope.

The rope bellied out as we descended hand over hand, breath by breath, to a coral ridge where the anchor had hooked 150 feet down. We paused for a moment, and I glanced at Dinah. She seemed to be relaxed and happy. I was not; it's dangerous to be panting at 150 feet.

We crawled up the ridge and peered over the crest. Dinah gasped. Stretched out before us on the white sand seafloor was a B-17F bomber. In the clear water, we could see the entire ghostly plane—motionless, at peace, on a silent flight to nowhere.

Thousands of planes crashed in the Southwest Pacific in World War II, but intact wrecks are scarce. Downed aircraft usually disappeared in deep water or broke up when they hit the sea's surface. We swam along the B-17's fuselage. Its right stabilizer had struck the ridge's edge. Its four great radial engines were half buried in the sand with the propellers bent back. The nose was crumpled. We peered into the cockpit; it was fully decorated in yellow sponge. Once a war machine full of fear and pain and burning oil, the bomber had become an underwater sculpture where cardinal fish swam

Morning fog over Duke of York Islands, Papua New Guinea.

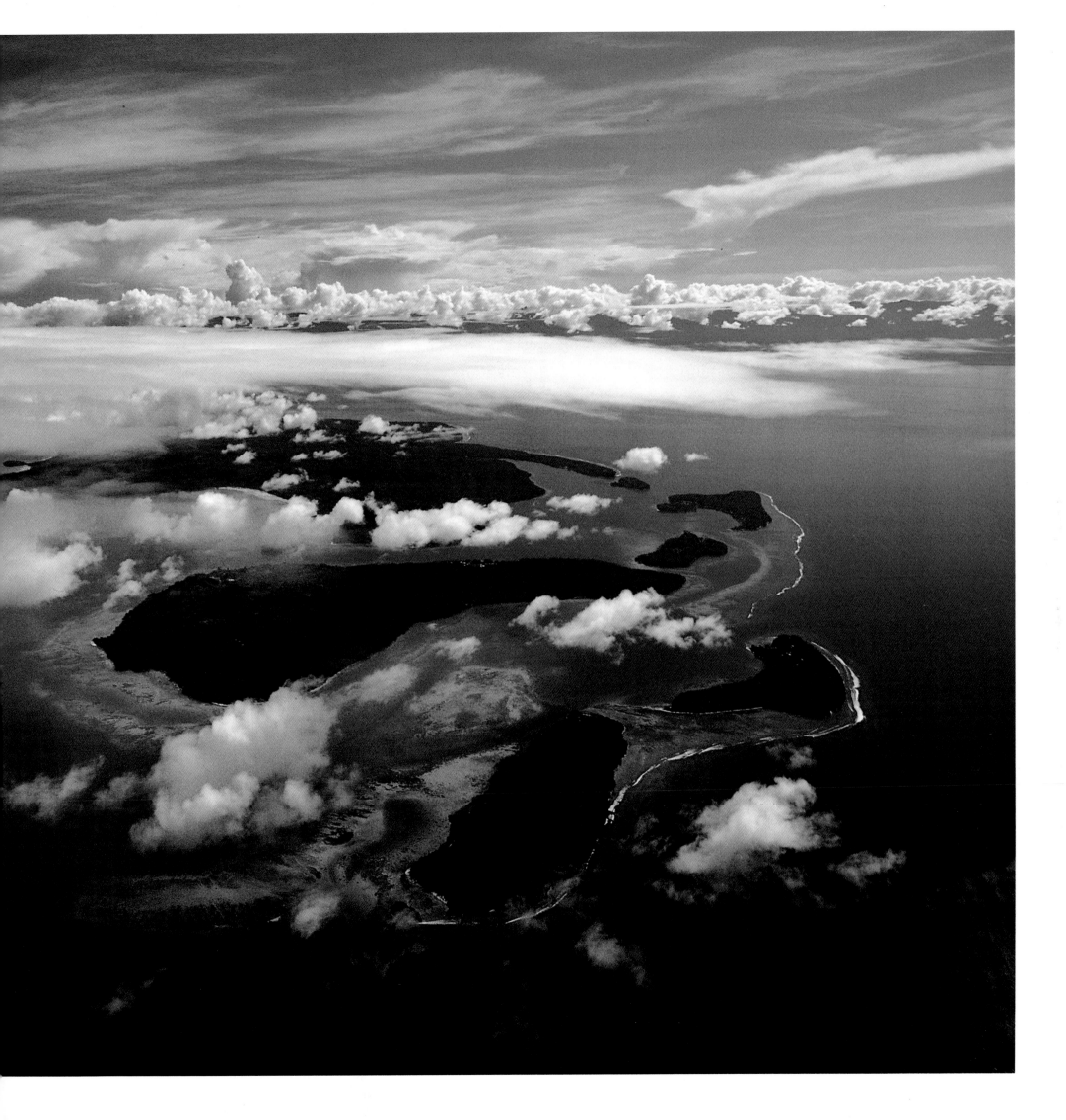

amid sponge-covered throttle handles and machine guns.

I thought I could hear voices. Maybe it was the exhaust from my regulator, made strange by the nitrogen narcosis of a dive to 150 feet. We pushed off the bottom, flew away from the sleeping B-17, and began our decompression, hanging onto the anchor line like palm fronds in a cyclone.

A few months later, with the help of aviation historian Steve Birdsall, of Sydney, Australia, I met Ralph DeLoach, the pilot of that B-17 when it went down. On the night of July 11, 1943, Ralph took off from Port Moresby, New Guinea with a scratch crew to bomb the Japanese bastion of Rabaul on the north tip of New Britain Island. Flying over the Owen Stanley Range, they hit "the blackest of black nights, the worst flying weather" Ralph had ever seen. Two of the four engines broke down, but the crew pushed on to Rabaul, dropped their bombs, and turned for home. At dawn, they found themselves over Cape Vogel, 300 miles east of Port Moresby. Ralph landed the plane on its belly in the water. All the crew escaped alive, and the B-17 settled quietly to the bottom.

It was a gentle ending for an illustrious plane. Named *Black Jack,* it played a fascinating part in the battle for the Bismarck Sea. A year after I met Ralph, I heard more from Harry Staley, another former B-17 pilot, at an air show in Geneseo, New York. Harry said, "*Black Jack* was *my* plane. Ralph just borrowed it one night."

Harry often flew missions in *Black Jack* between September 1942 and April 1943. At first, he was copilot for Ken McCullar, a brilliant flyer and "the all-time heavy bombardment hero of New Guinea," who regarded *Black Jack* as a magically protected plane. But early on, bombing Japanese ships from altitudes of 6,000 to 8,000 feet, "we weren't getting a lot of results," Harry told me. Then General George Kenney, commander of American air forces in the Southwest Pacific, sent Major William Benn to Port Moresby with an idea called skip-bombing, which would bring the B-17 closer to its target. Benn chose McCullar and his crew to test and refine the technique in *Black Jack* on a wreck near Port Moresby.

At several thousand feet, they'd cut the engines and drop until they were coming in at 250 mph about 200 feet above the wreck. When its waterline crossed a piece of black tape on the windscreen, the pilot released a 500-pound bomb, which hit the water, skipped up in the air, and bounced toward the wreck. Sitting in the ball turret, Harry timed the bounces with a stopwatch; they averaged five seconds. With five-second fuses, the bombs would explode just as they skipped up into a ship.

In October 1942, on a mission to Rabaul, six crews using the new technique made several impressive direct hits on Japanese vessels. Harry eventually became *Black Jack*'s pilot, and was credited with sinking seven ships. In March 1943, in the Battle of the Bismarck Sea, B-17s with Harry and *Black Jack* in the lead helped turn back a major Japanese naval advance from Rabaul to New Guinea.

I flew from Port Moresby to Rabaul on a hot, dark, greasy morning, following the course of Allied fighter and bomber pilots who flew hundreds of missions against the Japanese base at Simpson Harbor. Dawn came over the Bismarck Sea and the Owen Stanley Range, where high, silvery rain clouds gathered—playing fields for the Air Nui Guini jet. I thought of how murderous these skies had been to 20-year-old kids flying groaning piston-engine bombers in 1943. During the war for the Southwest Pacific, far more planes were lost to weather than to enemy guns.

In Simpson Harbor, I dove 160 feet to the 550-foot Japanese repair ship, the *Hakki Maru,* sunk by Marine dive bombers in 1944. Resting upright on the harbor bottom, the *Hakki Maru* appeared to be steaming through a green-blue fog. I found a scorpionfish living on an antiaircraft gun. Nearby, fish swarmed through the cockpit of a Japanese Mitsubishi A6M Zero. Along the wings of a reconnaissance biplane, a bonsai garden of pink soft coral trees flourished. For over two years, battles raged in the Southwest Pacific, consuming ships, planes, and men. Now jungles grow over the horror of man's endeavors and the sea works its changes on sunken implements of war.

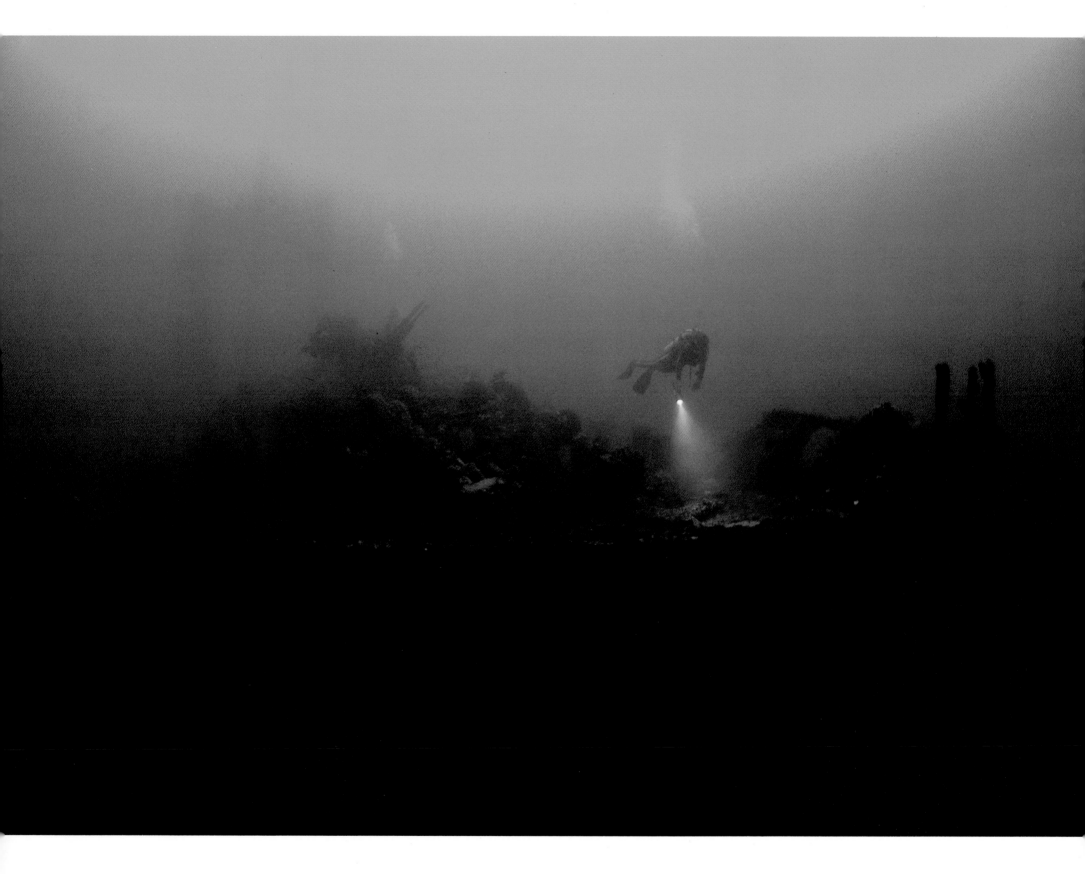

Japanese vessel Hakki Maru, *sunk by Marine dive bombers in 1944, Simpson Harbor, New Britain Island, Papua New Guinea.*

(Overleaf) B-17F Black Jack, *downed in storm after bombing mission, July 11, 1943, Boga Boga Island, near Cape Vogel, Papua New Guinea.*

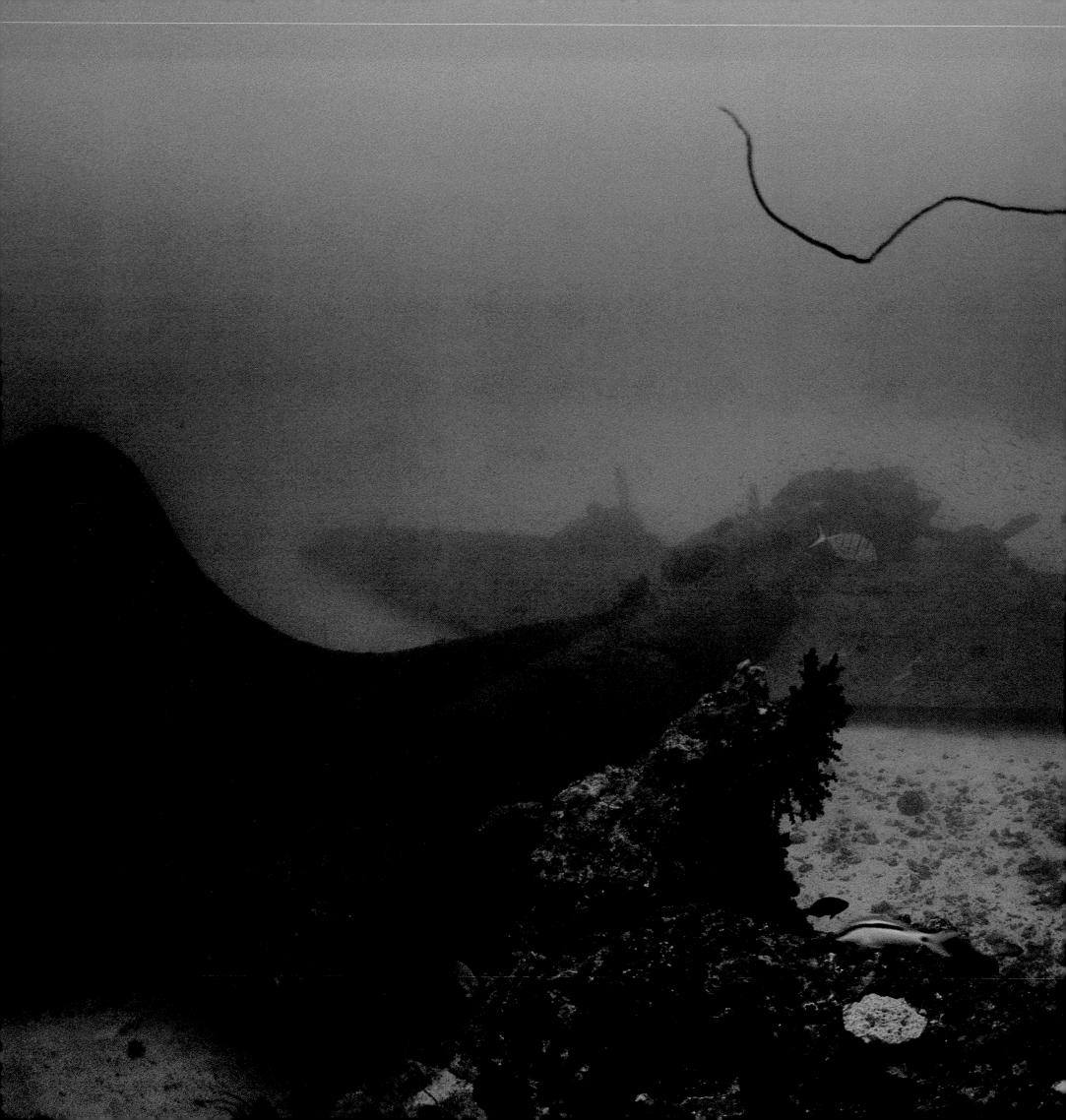

N ew Guinea and the archipelagos of the Southwest Pacific sit amid the richest coral seas on our planet—the navel of the coral kingdom, the Eden of coral. From these ancient coral gardens, reef life reaches north to Okinawa, northeast to Hawaii, south to the Great Barrier Reef, and west across the Indian Ocean and up the Red Sea to the Gulf of Aqaba, flourishing in shallow waters where nutrients abound. Bob and Dinah Halstead know the seas around New Guinea better than anyone, and with them Anne and I spent several weeks exploring remote reefs rarely visited by divers.

At a reef in Milne Bay, we tied *Telita* to tree branches reaching out from the jungle. As children from a nearby village paddled overhead in outriggers, we dove down the undercut bank. At 30 feet, gorgonian sea fans, which thrive in low light, grew to huge sizes in the shade cast by the jungle. Tiny gobies crawled up and down their branches. Nearby, whip corals as red as bursts of fireworks moved in the light undersea wind.

One late afternoon on a reef near New Ireland, Dinah and I swam into a school of Pacific barracuda. The barracuda began to circle Dinah. Instinctively, I dove for the bottom, 50 feet below, gripping my camera housing and mentally crossing my fingers. Once there, I rolled on my back, put the camera to my face, and looked up. The barracuda had made a perfect ring around Dinah. She was in the middle of a magical dance; evening light fell on the silvery skins of the circling fish. She pivoted and put her arm out in a gesture from a pas de deux. I held my breath, lest my rising bubbles disturb the dance, and a phrase from the Psalms came into my mind:

If I take the wings of the morning

and dwell in the uttermost parts of the sea,

even there thy hand shall lead me,

and thy right hand shall hold me...

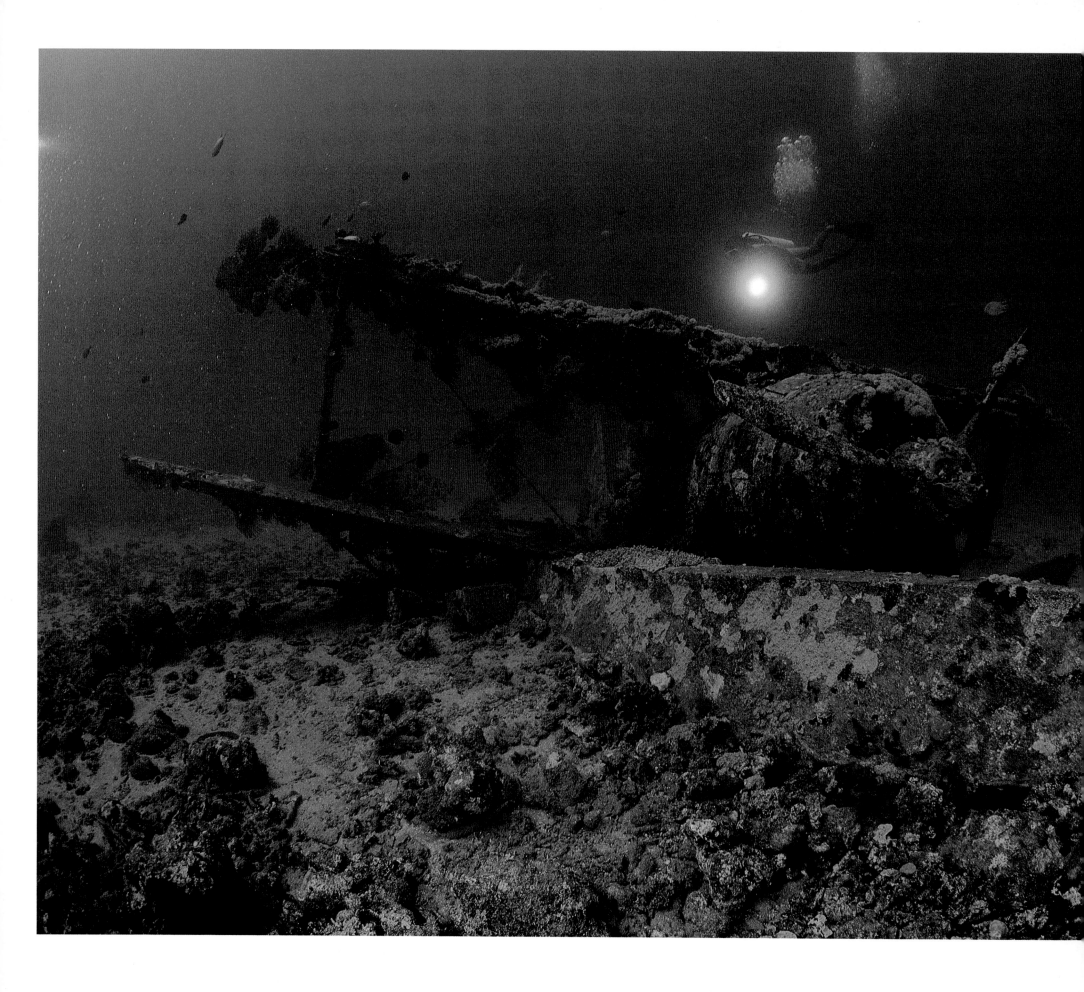

*Japanese World War II
reconnaissance biplane covered
with corals, near Simpson Harbor,
New Britain Island, Papua
New Guinea.*

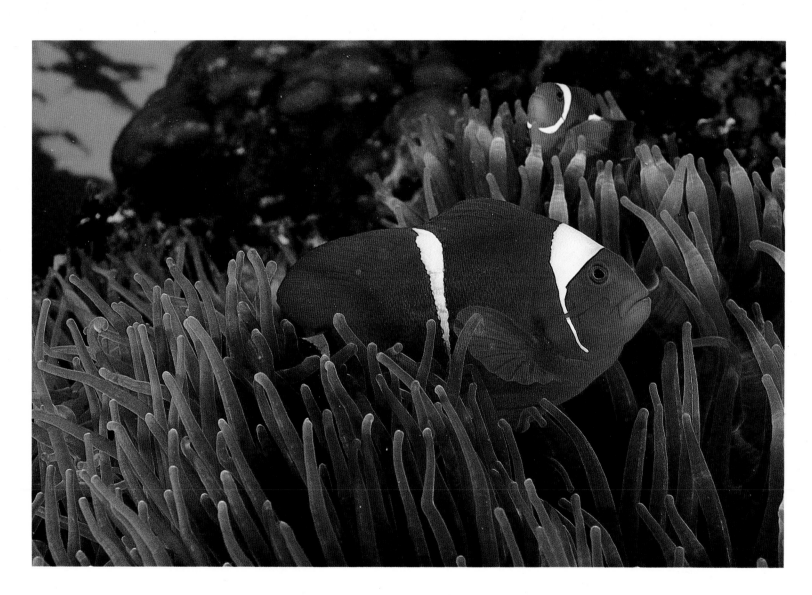

*Tomato clownfish among sea
anemones, Simpson Harbor, New
Britain Island, Papua New Guinea.*
PREMNAS BIACULEATUS

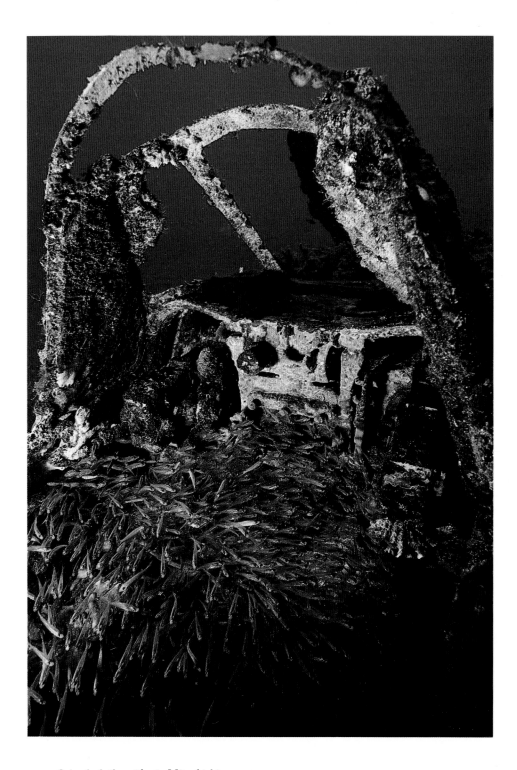

School of silversides in Mitsubishi
A6M Zero cockpit covered with
sponges and coralline algae,
Simpson Harbor, New Britain
Island, Papua New Guinea.

The Zero where it settled
on volcanic sand 100 feet down,
Simpson Harbor, New Britain
Island, Papua New Guinea.

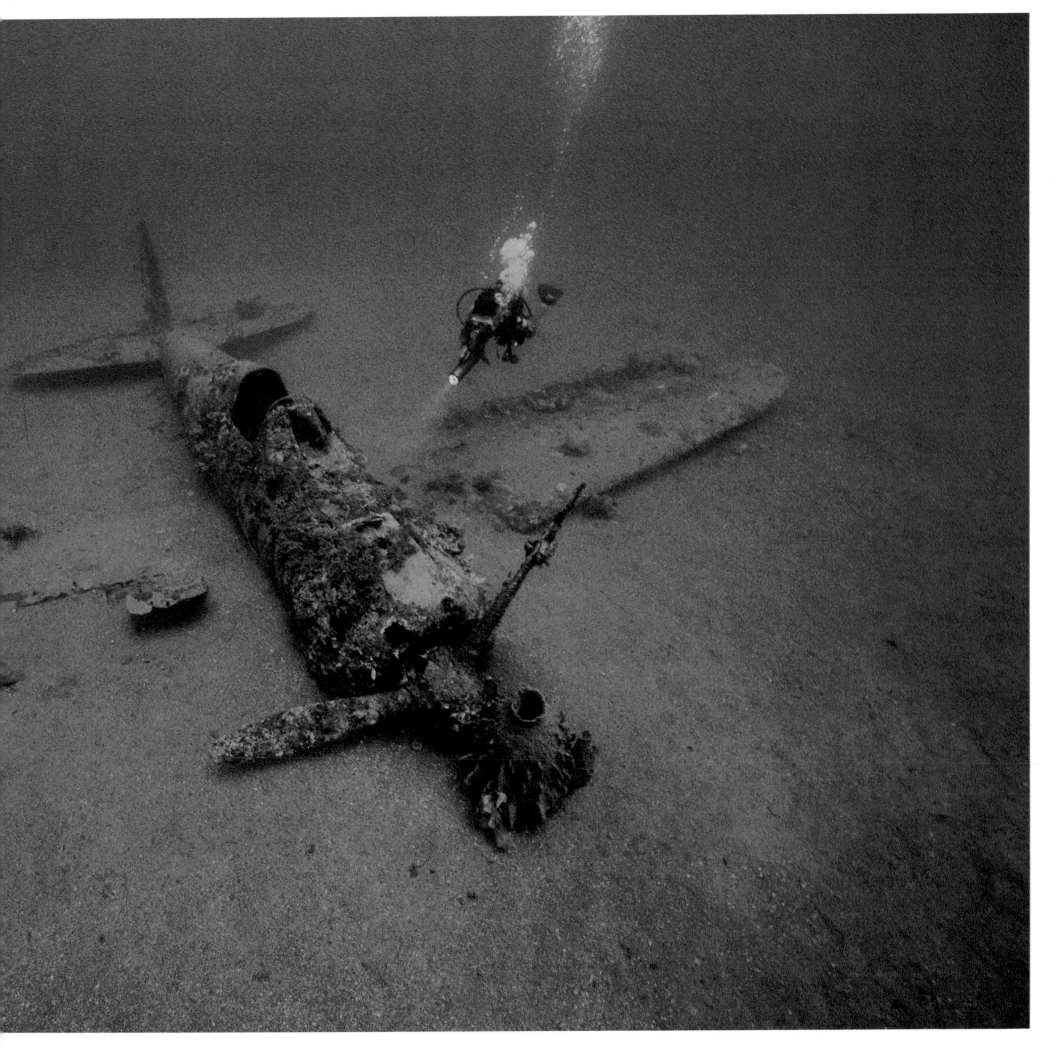

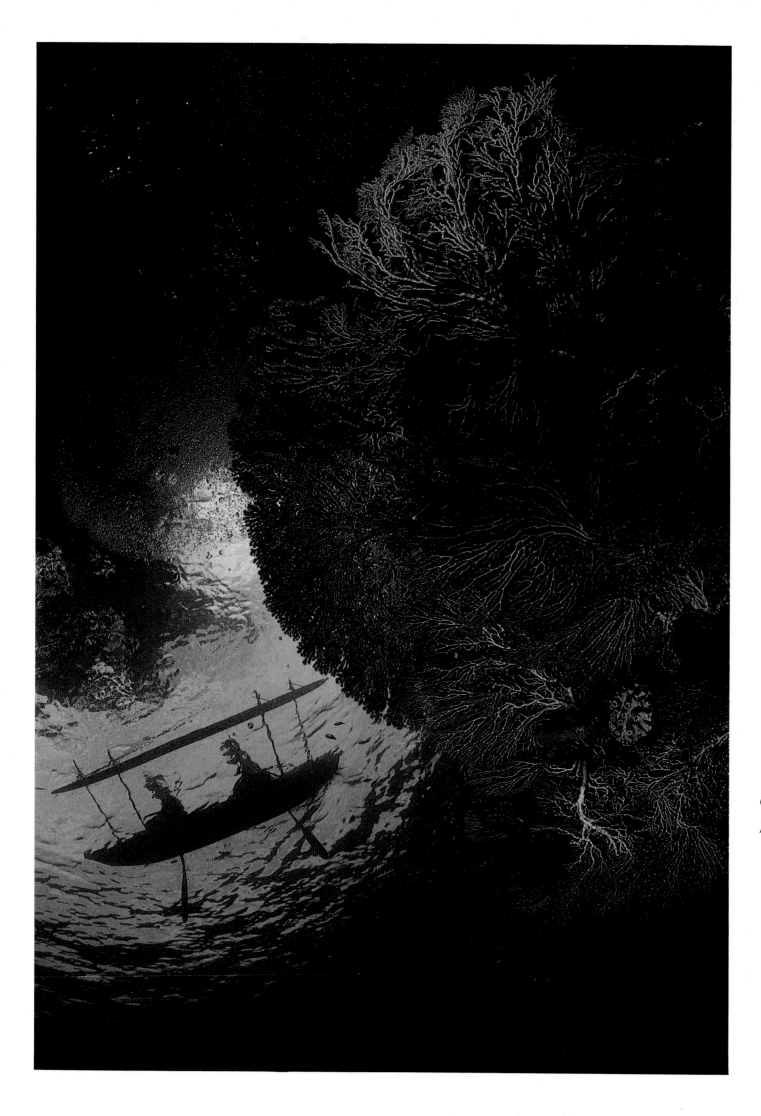

Outrigger over gorgonian coral,

Milne Bay, Papua New Guinea.

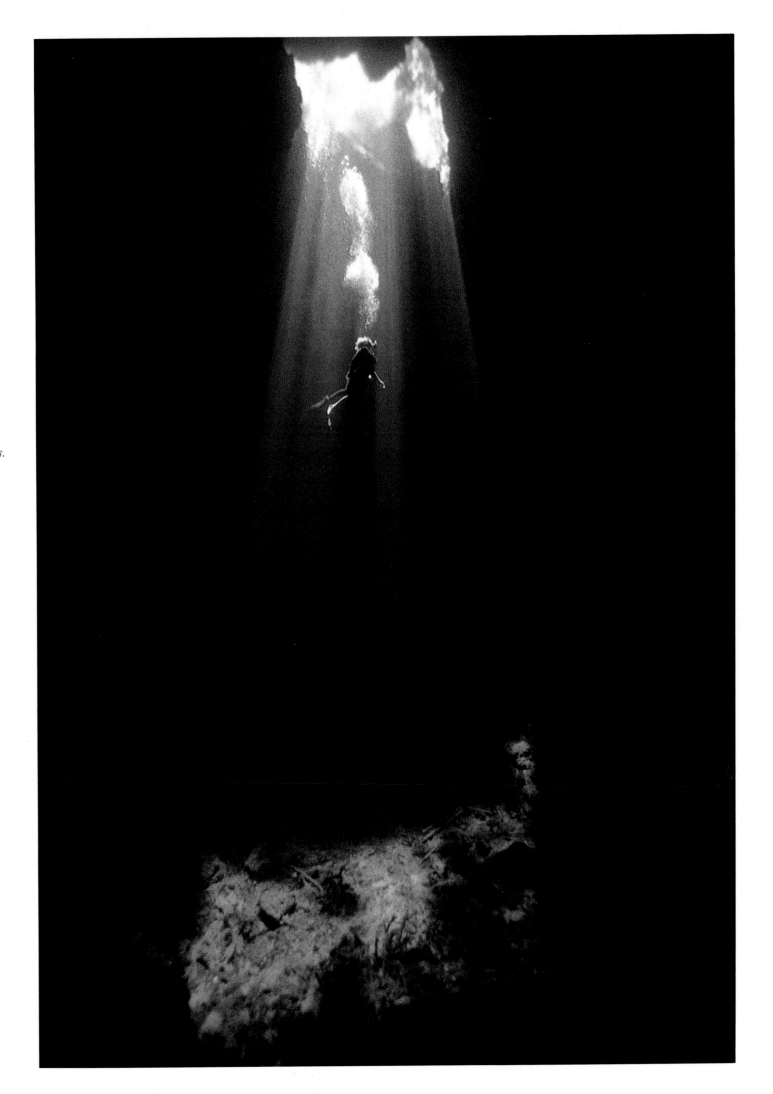

Diver Chris Deacon in sunlight which briefly enters this underwater cave each day, near Russell Islands, Solomon Islands.

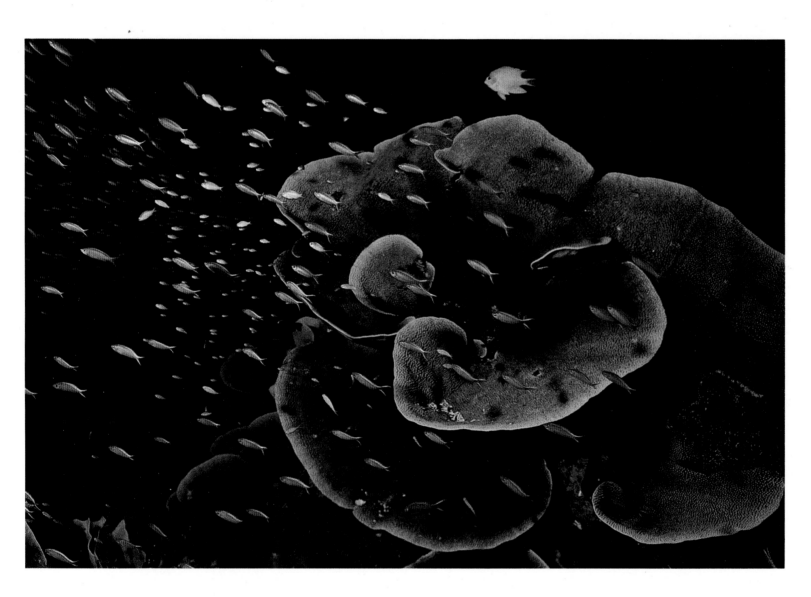

Purple anthias, yellow

damselfish, and chalice coral,

Milne Bay, Papua New Guinea.

ANTHIAS TUKA;
AMBLYGLYPHIDODON AUREUS

Cape Vogel, Papua

New Guinea.

Young anthias and gorgonian coral, Milne Bay, Papua New Guinea.
ANTHIAS SP.

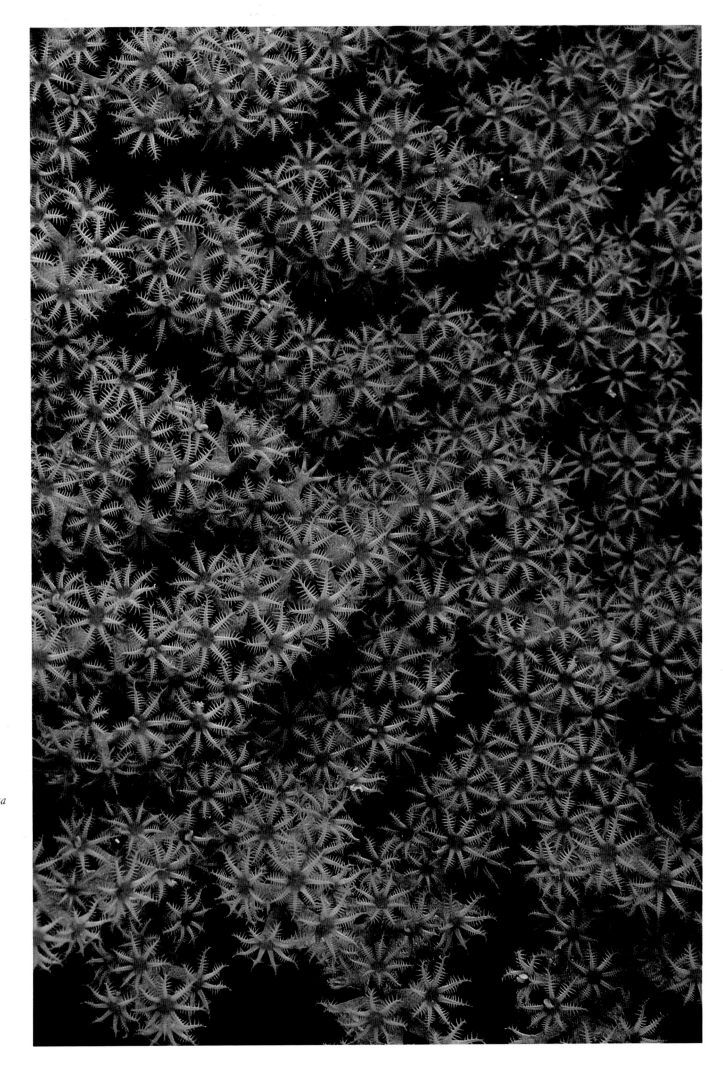

Gorgonian coral, Milne Bay, Papua New Guinea.

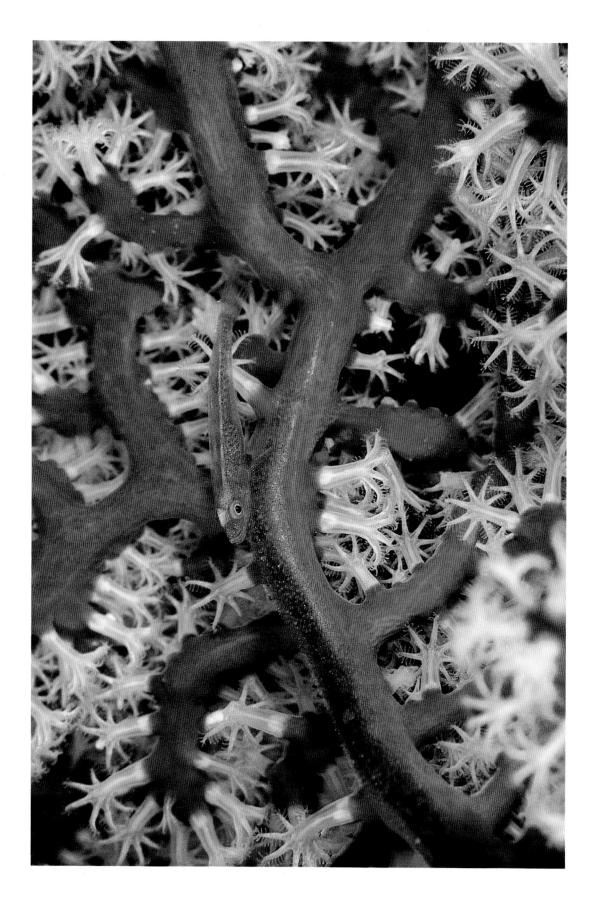

Seafan goby and gorgonian coral,

Milne Bay, Papua New Guinea.

BRYANINOPS LOKI

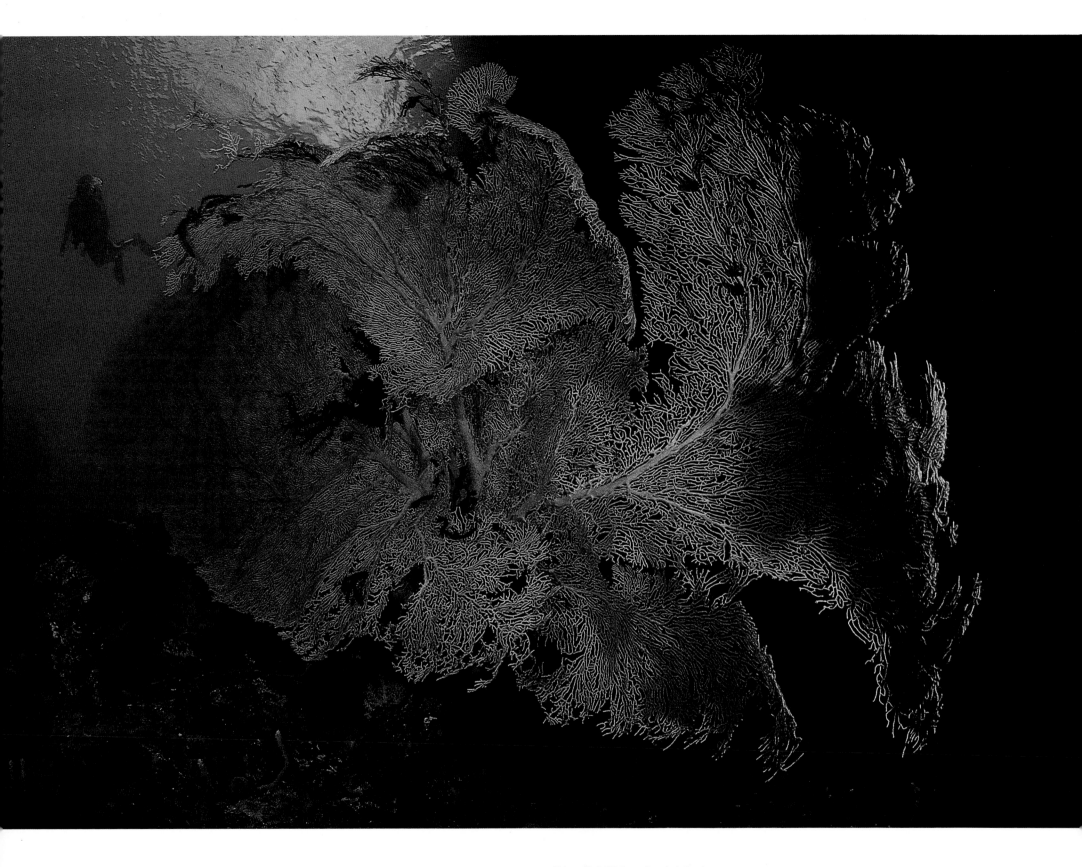

Diver Bob Halstead and eight-foot-wide gorgonian coral, Milne Bay, Papua New Guinea.

Fisherman and bottle-nosed dolphin, Milne Bay, Papua New Guinea.
TURSIOPS TRUNCATUS

School of yellow-striped goatfish, Milne Bay, Papua New Guinea.
MULLOIDES VANICOLENSIS

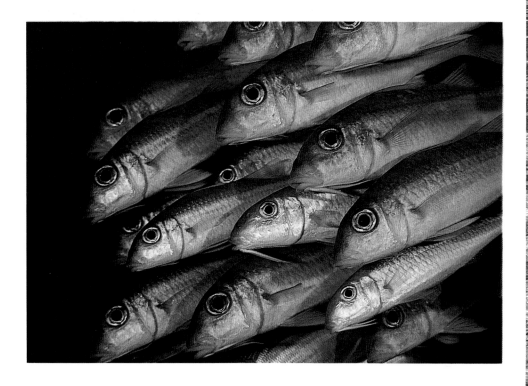

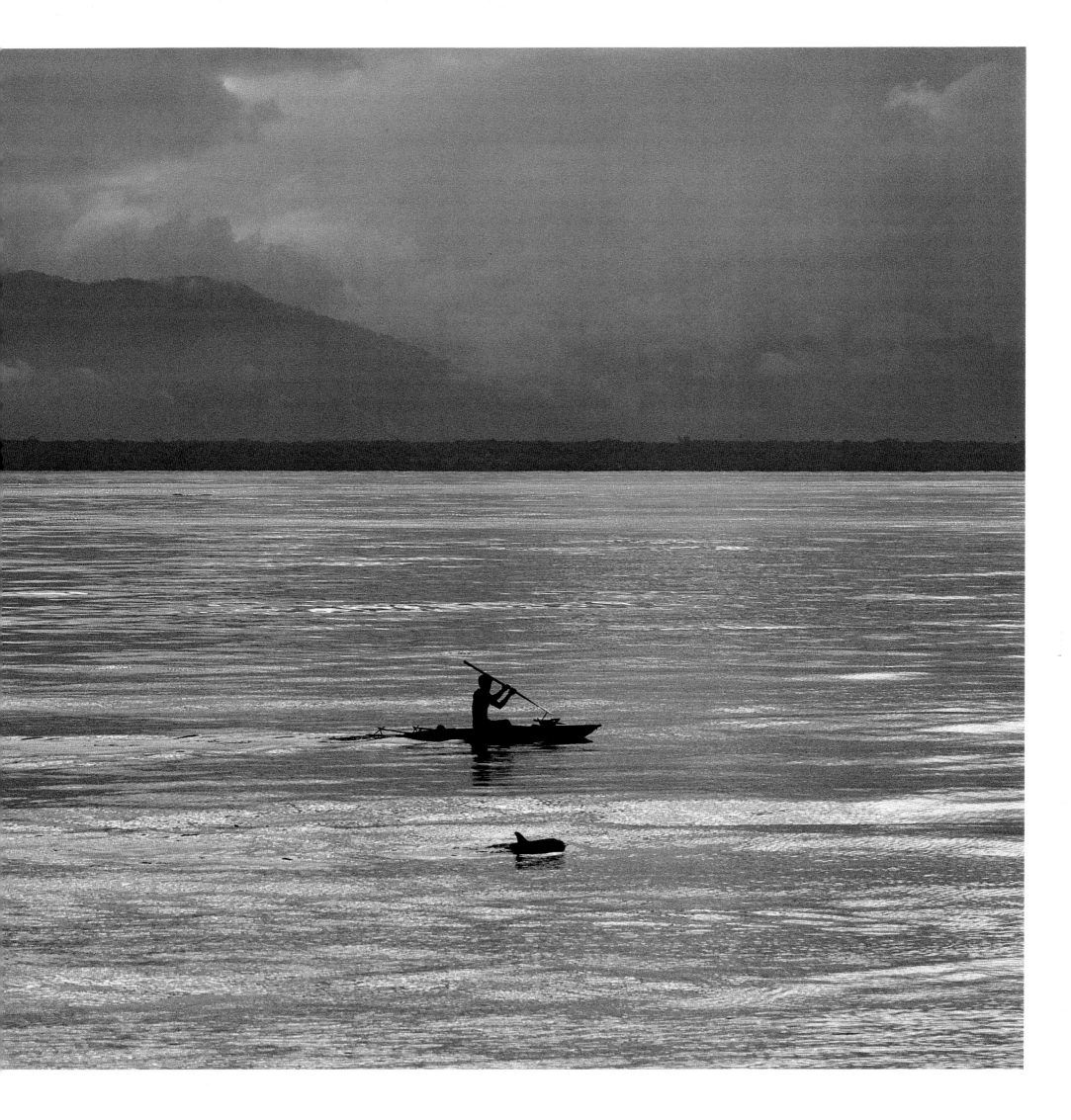

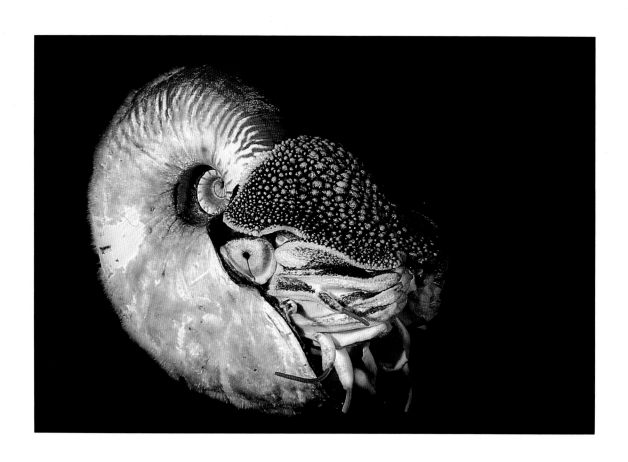

Chambered nautilus, eyes out and
tentacles moving, brought up from
a depth of 800 feet, near Manus
Island, Papua New Guinea.
NAUTILUS SCROBICULATUS

Coral reef and palm trees,
Russell Islands, Solomon Islands.

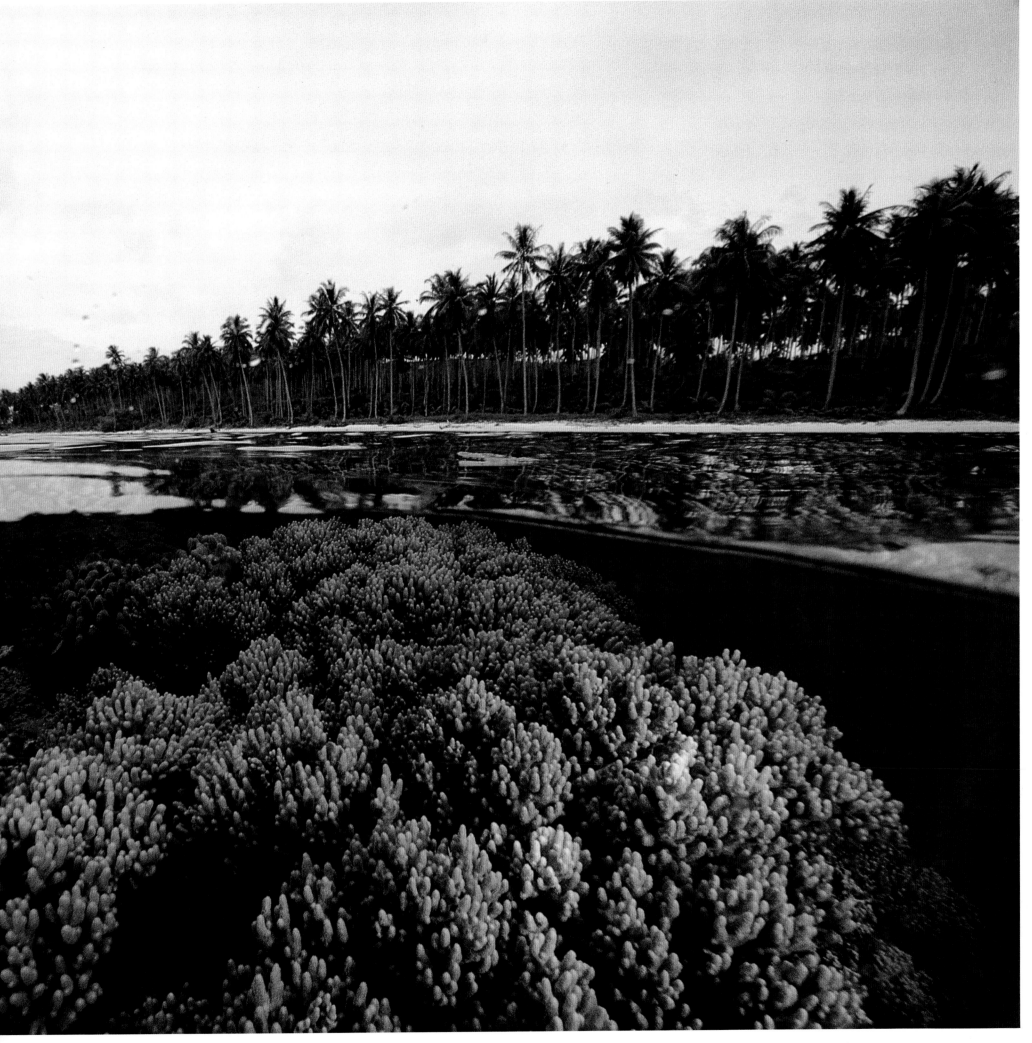

Boga Boga islander removes parrotfish from monofilament net, Cape Vogel, Papua New Guinea.

Needlefish just below surface, Milne Bay, Papua New Guinea.
ABLENNES HIANS

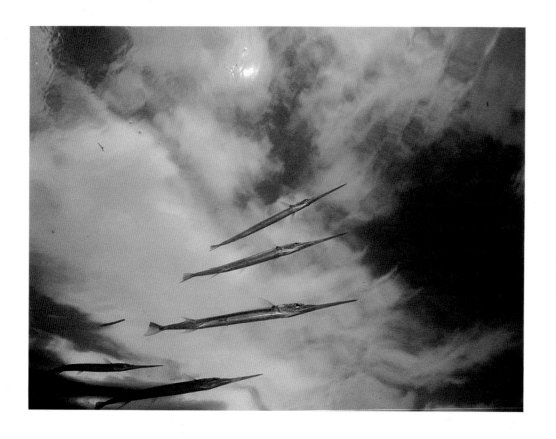

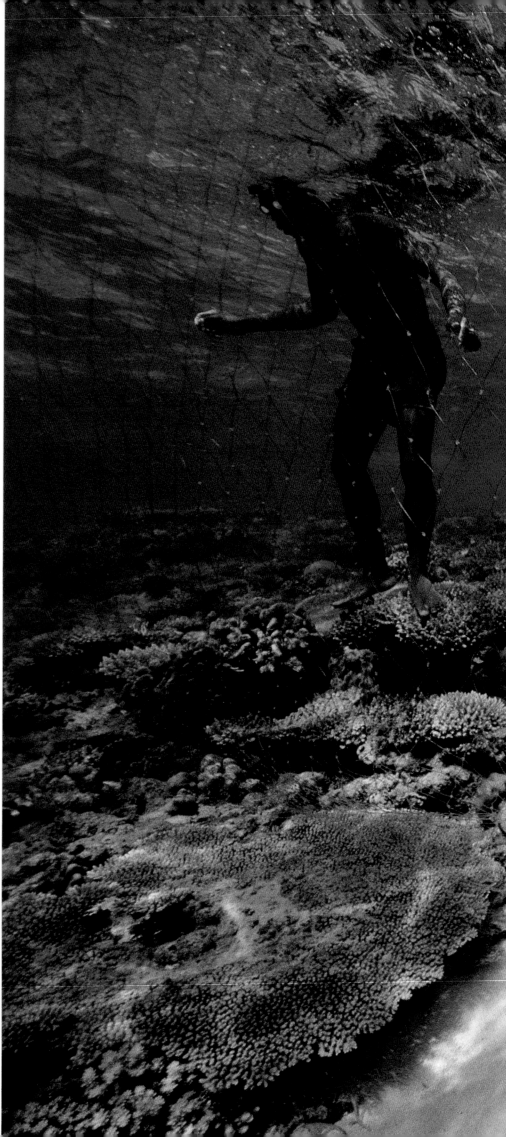

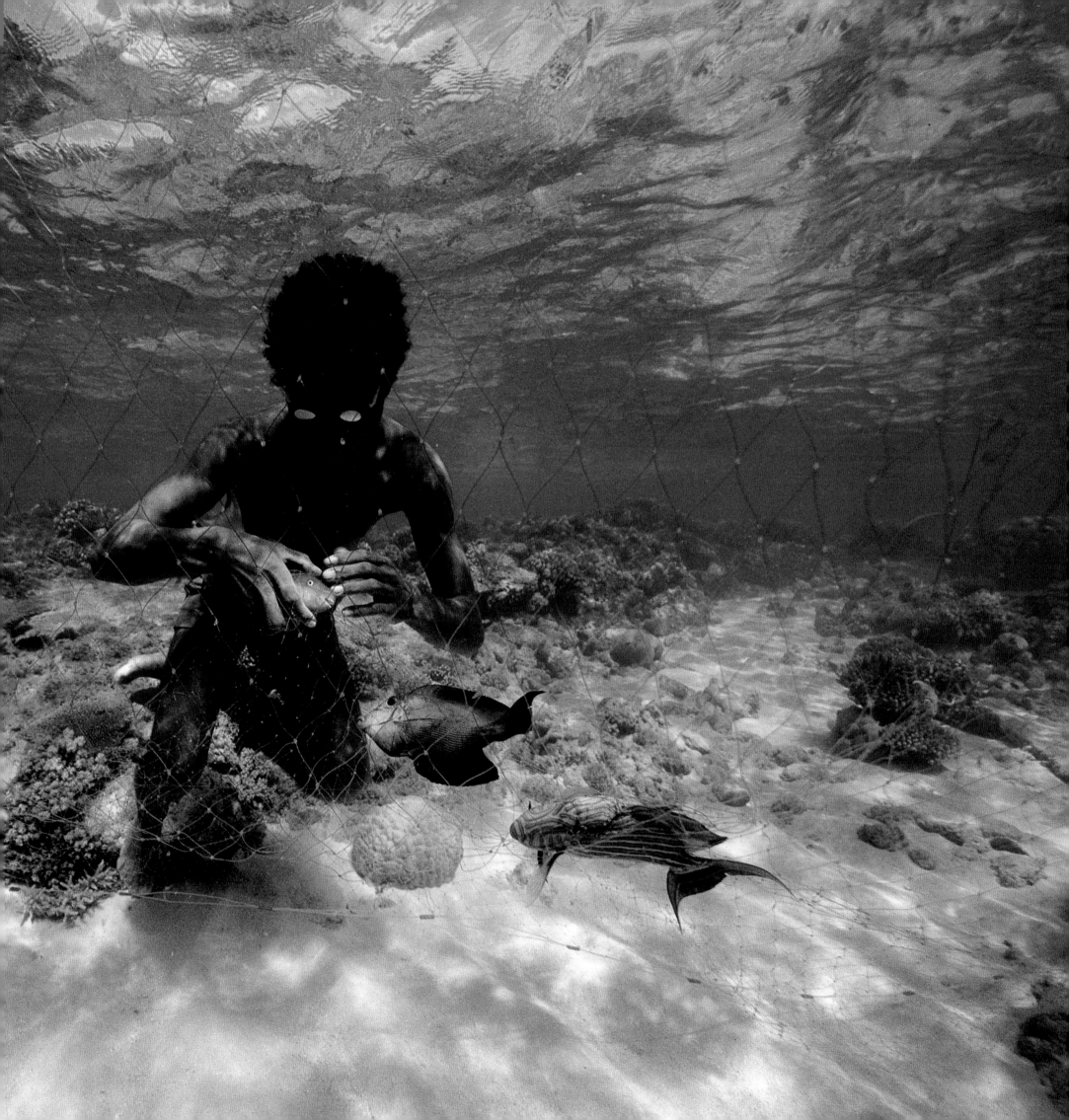

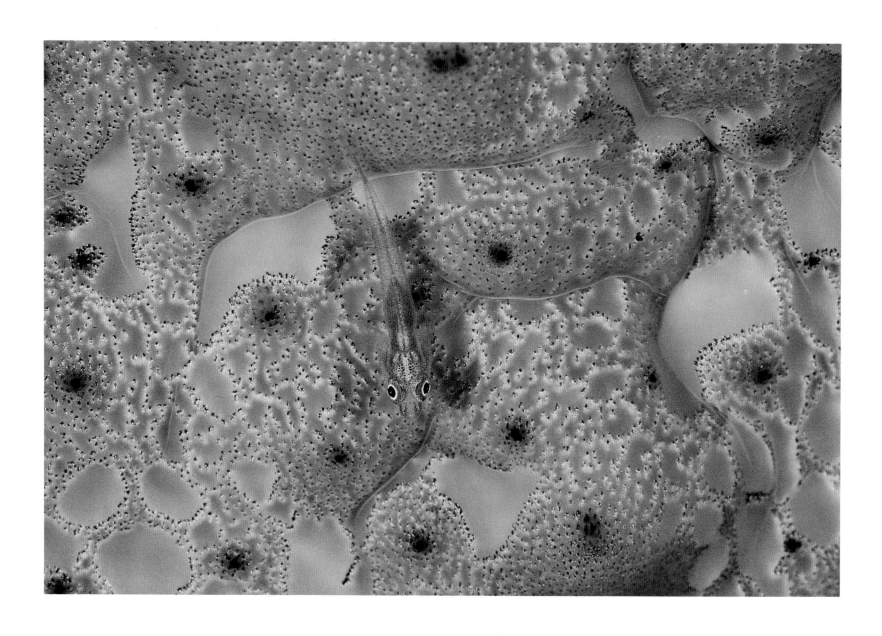

Soft-coral goby on giant clam,
where it eats plankton and its
host's mucus, Milne Bay, Papua
New Guinea.
PLEUROSICYA SP.

Seafan goby in branches of whip coral, Milne Bay, Papua New Guinea.
BRYANINOPS LOKI

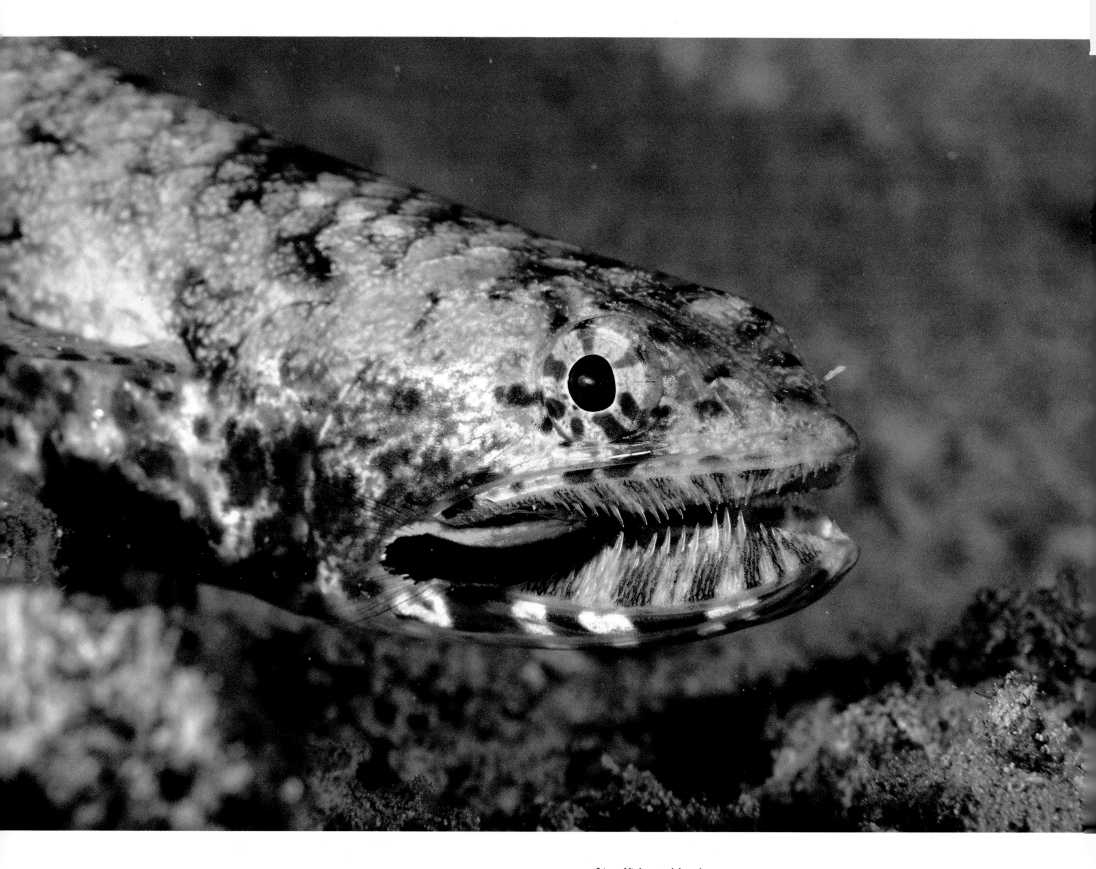

Lizardfish eats false cleaner or

sabertoothed blenny, near Espiritu

Santo, Vanuatu.

SAURIDA GRACILUS;
ASPIDONTUS TAENIATUS

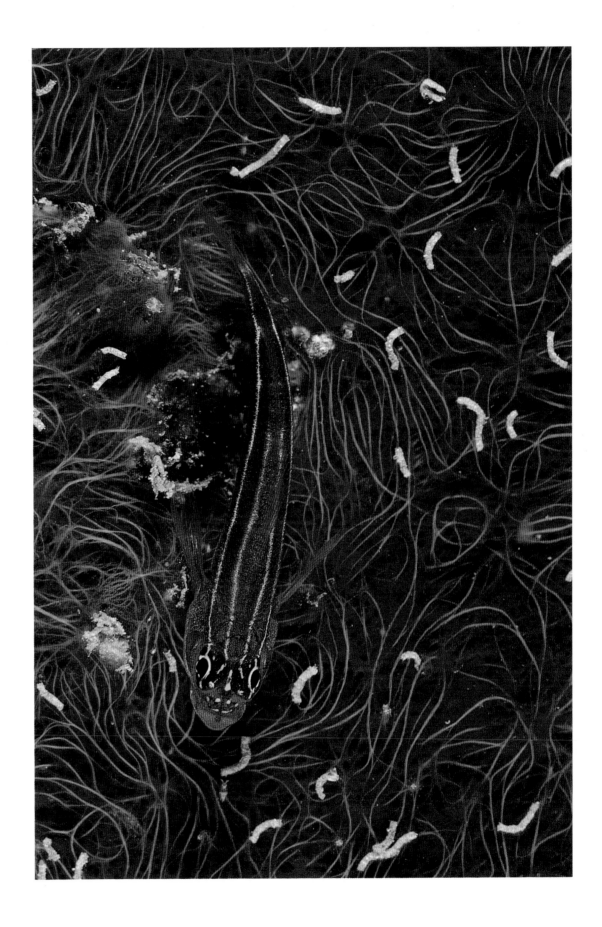

One-inch-long triplefin in sponge strands, Milne Bay, Papua New Guinea.

HELCOGRAMMA STRIATA

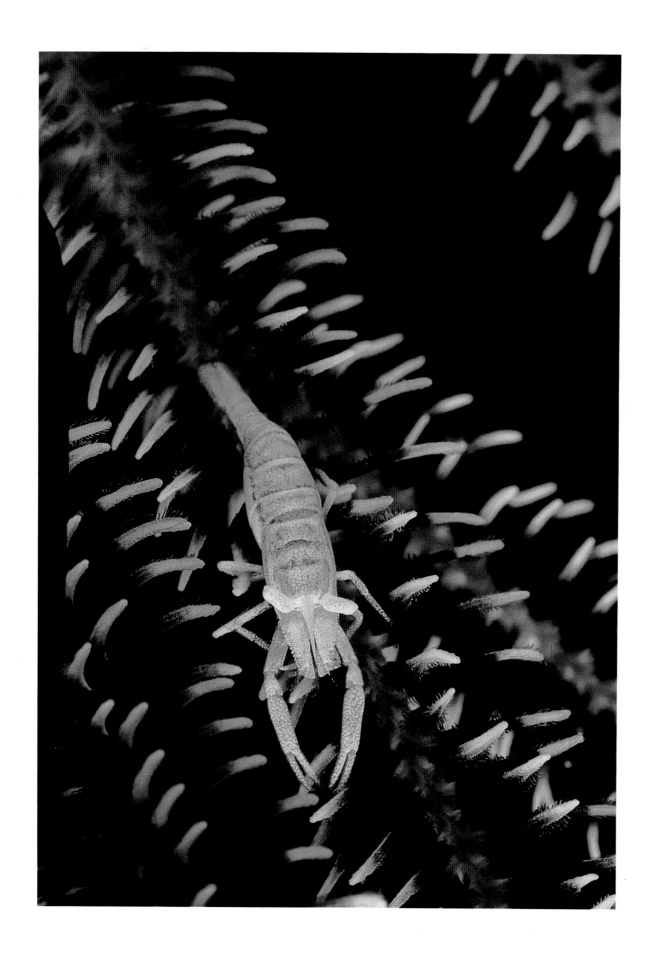

Shrimp in crinoid's arms, near
Crown Island, Papua New Guinea.

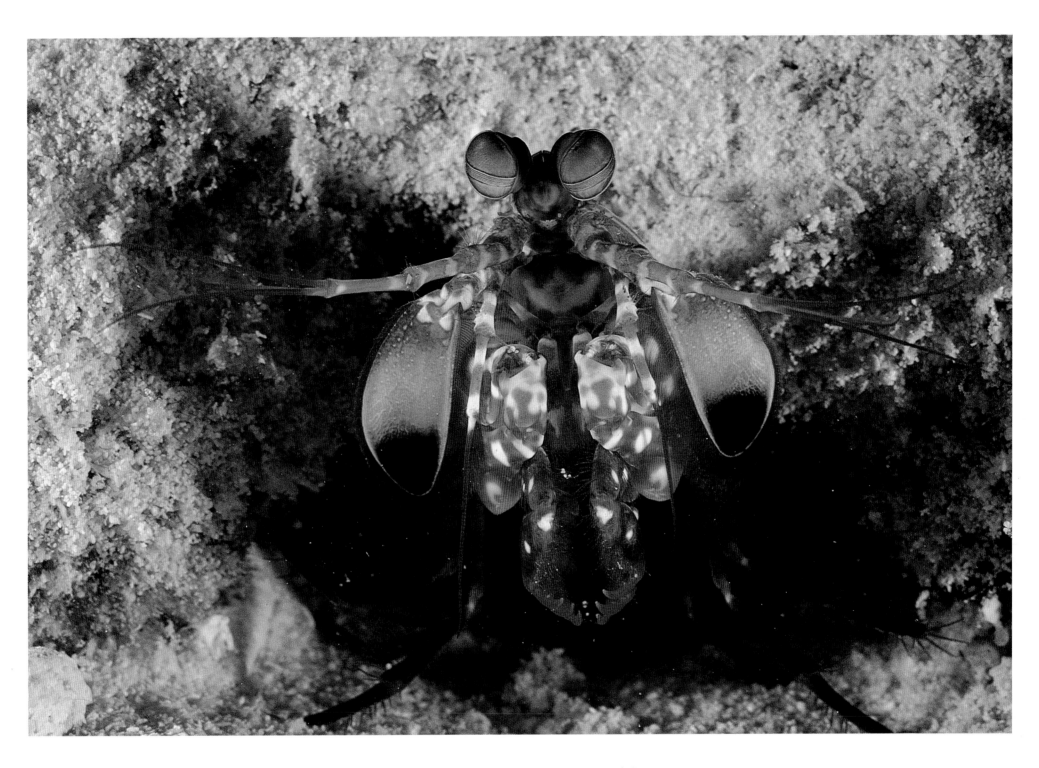

Mantis shrimp in sandy burrow,
near New Ireland Island, Papua
New Guinea.
ODONTODACTYLUS SCYLLARUS

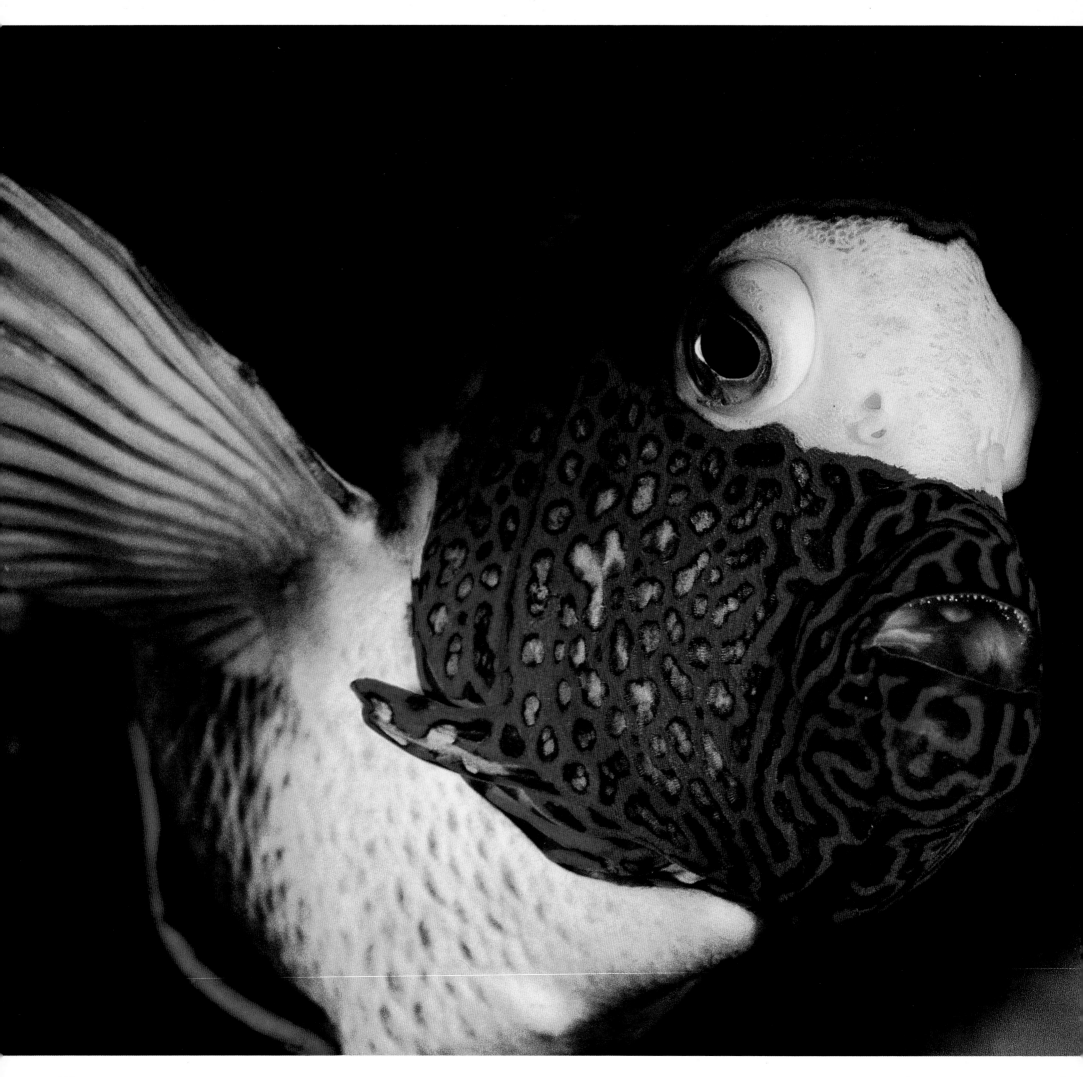

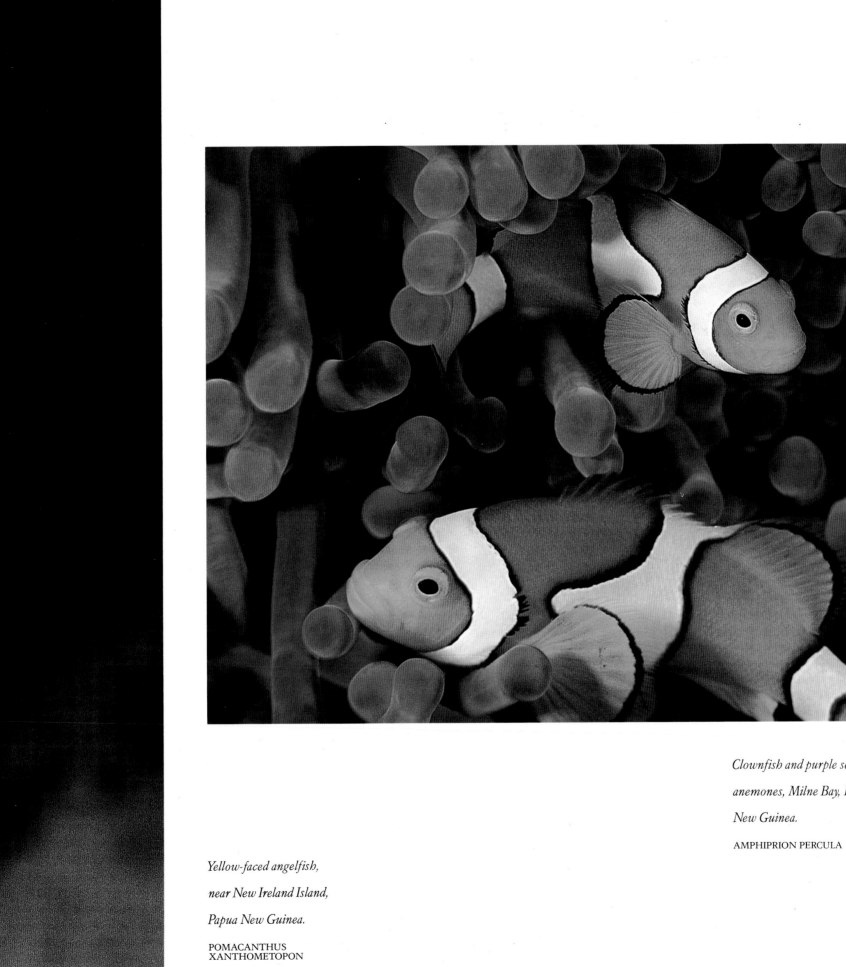

Clownfish and purple sea
anemones, Milne Bay, Papua
New Guinea.

AMPHIPRION PERCULA

Yellow-faced angelfish,
near New Ireland Island,
Papua New Guinea.

POMACANTHUS
XANTHOMETOPON

Diver Dinah Halstead swims amid
circling school of barracuda, near
New Hanover Island, Papua
New Guinea.
SPHYRAENA JELLO

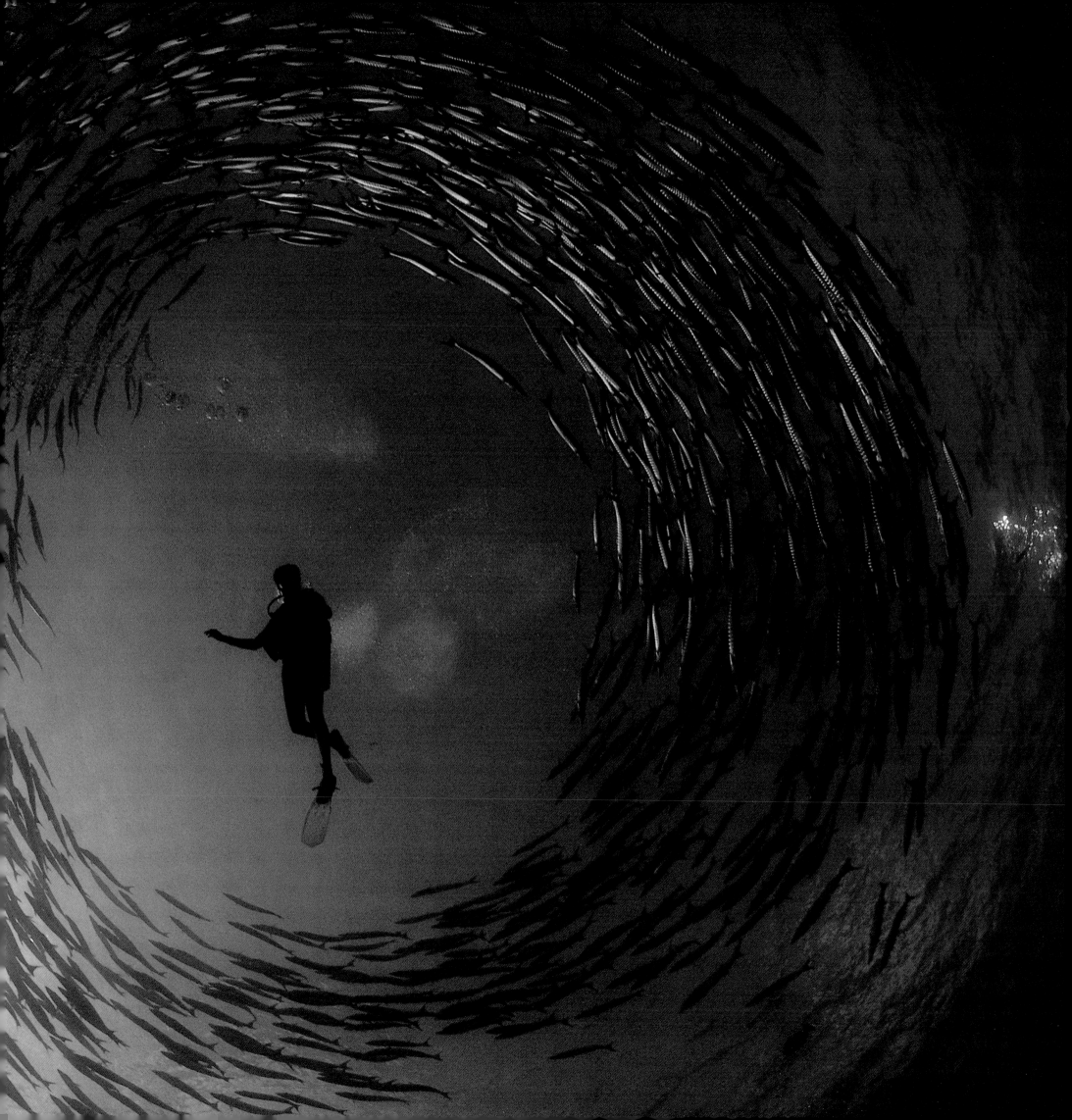

ACKNOWLEDGMENTS

Underwater photography depends on friendship. Without the help of these friends, none of my pictures would exist. Anne and I would like to thank the following:

In the Red Sea:
Howard and Sharon Rosenstein and family
David and Ariela Fridman and family
Dr. Yehuda Melamed
The staff of the Steinitz Marine Laboratory, Elat
The crew of the *Fantasea*
General Yatza
Yossi Kavashani
Former U.S. Ambassador Sam Lewis
 and Sally Lewis
Willy Halpert and Aquasport, Elat
Zvi and Ingrid Haggadi

Note: My photographs at Ras Muhammad, Ras Um Sid, Marsa Bareika, and Marsa el Muqabelah were taken when Israel governed the Sinai and protected these waters and their unique inhabitants.

In Australia:
Rodney and Kay Fox and family
Irvin and Trish Rockman
Ray Blizzard
Peter Thompson
The South Australian Fisheries
Don McBain and family
Kevin and Chris Beacon and Dive 2000
Adrian and Pat Cookson
Jane and Rain Doubilet Kramer
Gary Bell
Kim and Lianne Laufer

In Palau:
Bill and Peggy Hamner

In the Bahamas:
The entire extended Birch family

In the Cayman Islands:
Harry Ward
Alan Bloomrosen
Jay Ireland
Ron Kipp
Penny Pritchett Hatch
Lisa Truitt
Meg Kerr

In Japan:
Koji and Miyuki Nakamura
Duke Matsui
Prince Kobayashi
Mr. Matsuda
The staff of Izu Oceanic Park
Kunio Kadawaki

In Papua New Guinea:
Bob and Dinah Halstead
Bob and Diane Pierce
The crew of the *Telita*
Peter and Henrietta Miller

In the Strait of Georgia:
Warran Buck
Phil Nuytten
Jim and Jeanie Cosgrove
Frank White, Jr.

In Washington, D.C.:
Sam and Sue Edwards

In Los Angeles:
Baerwald West
Geoffrey Stern

In Boulder, Colorado:
Ann Doubilet

In Elberon, New Jersey:
Mrs. Bobby Doubilet

At National Geographic I received the most valuable gift of all—time in the sea. For this precious time and faith in me, I would like to thank Bill Garrett, Bob Gilka, Gil Grosvenor, Mary Smith, Al Royce, Bob Patton, Dave Arnold, Susan Welchman, Bill Allen, Bill Graves, and Charles McCarry.

My thanks also to Tom Kennedy, Kent Kobersteen, and Rich Clarkson, the chiefs of photography; Charlene Valeri, Lillian Davidson, Susan Smith, Thelma Altemus, and Marisa Domeyko of the administrative staff; George Von Kantor, Mary Simone, and the entire photo equipment shop; Bob Allnutt and the duplicating crew; Al Yee of color labs; Bob Madden and Connie Phelps, who laid out many of my stories; and Kathy Moran and Maria Stenzel of film review.

Jennifer Angle somehow read my writing and typed much of the manuscript.

Owen Andrews was a wonderfully patient, understanding, and sheltering editor.

Megan Youngquist laid out the book.

Finally, we would like to thank our colleagues: Bill Curtsinger, the family Nicklin, Jim Stanfield, Luis Marden, Jay Maisel, Doc and Cici White, Stanton Waterman and family, Dr. Joe MacInnis, Peter and Wendy Benchley, Richard Ellis, Jerry Greenberg, Doc Edgerton, Emory Kristof, Hillary Hauser, and especially Dr. Eugenie Clark for all that time under the sea.

David Doubilet, Anne Doubilet, Emily Doubilet
New York City
January 20, 1989

EQUIPMENT

Outdoor photographers can go into the field with a camera bag containing three camera bodies, half-a-dozen lenses, and a lighting kit with a few strobes, some umbrellas, and a tripod. To achieve the same flexibility, an underwater photographer needs a virtual mountain of equipment. The reason is simple: underwater, you can't change film or switch lenses, no matter how fast you are.

Underwater conditions make certain lenses essential. Many marine creatures are very small and very shy. Advanced macro and tele-macro lenses help photographers find them and keep their distance. Even the clearest water is not as clear as air, and photographs of larger subjects must be taken at fairly close range. Wide-angle and extreme wide-angle lenses bring the subject completely into the picture.

All of the images in this book were made with 35mm cameras. From 1970 to 1983, I used the OceanEye aluminum underwater housing, built for the Nikon F camera and F-36 motor drive. Developed by Gomer MacNeill and Bates Littlehales, the Ocean-Eye was the first to use a plexiglass dome that corrects wide-angle lenses underwater. It was manufactured for only three years.

I used the OceanEye with 13mm, 15mm, and 16mm fisheye Nikon wide-angle lenses. Aptly named, the fisheye is a natural for underwater photography. It bends the corners of the image inward, creating a field of view of 180 degrees. On land, the result is considerable distortion. Underwater, there are no straight lines, and you can close in to photograph a large object in dirty water or pull back for a wide-angle seascape.

I also use 18mm, 20mm, and 24mm lenses. My workhorse lens is a 55mm f2.8 macro lens, which makes pictures at any distance from infinity to six inches. The 105mm f2.8 macro lens and 200mm f4 macro lens let me photograph less approachable subjects.

In 1983, I switched from the OceanEye to the Aquavision Aquatica IIIC aluminum housing, which I use with these lenses and Canon F-1 cameras. For extreme closeup work, I use the Zeiss 60mm f2.8 Planar macro lens and the remarkable Zeiss 100mm f2.8 Planar lens, built for the Contax camera. Plexiglass housings for these lenses and Contax cameras were made in Tokyo by the mysterious Mr. Kudo. In 1987, Joe Stancampiano of National Geographic did the impossible: he converted the two Zeiss lenses to fit Canon camera mounts. I can now use these lenses in the Aquatica IIIC housing, which is also adapted for the 200mm Canon macro lens.

I house my Nikons in the Aquavision Aquatica IIIN, designed by Val Ranetkins of Montreal, Canada with the assistance of Alvin Chandler of the Geographic. In addition, I use Nikonos II and V cameras with 15mm and 20mm wide-angle lenses.

Al, a former submariner, is responsible for much of National Geographic's success in underwater photography. He turns dreams sketched on cocktail napkins into realities made of aluminum, stainless steel, plexiglass, and titanium. His work has been aided and abetted by Keith Moorehead. Keith is not only a brilliant machinist and camera expert, but a diver who understands the problems of underwater photography. In essence, every underwater assignment is like a war beneath the waves. Equipment comes home battered and damaged. Keith keeps tried and true gear working and is always ready to put something new together.

In the days of the Ocean Eye housings, my Nikon Fs were maintained at Marty Forscher's camera repair shop in New York. Now, Kenji Yamaguchi at National Geographic keeps the Nikon F3s and all the lenses in running order.

Kodachrome 64 is my standard film. I use Kodachrome 25 for much of the close-up macro work. Recently, I have used the new Kodachrome 200 in low-light, low-contrast situations.

Almost every exposure underwater must be lit. I use Subsea Mark 150 strobes and Sea and Sea YF 150 and YF 200 strobes. I also use the Sonic Research SR 2000 miniature slave flash unit. Larry Kinney and Nelson Brown maintain the strobe equipment, and Larry makes special connectors and photo eyes to trigger the flash.

The entire crew of the National Geographic photo equipment shop has supported me and helped to make these photographs. In a sense, they are with me on every dive.

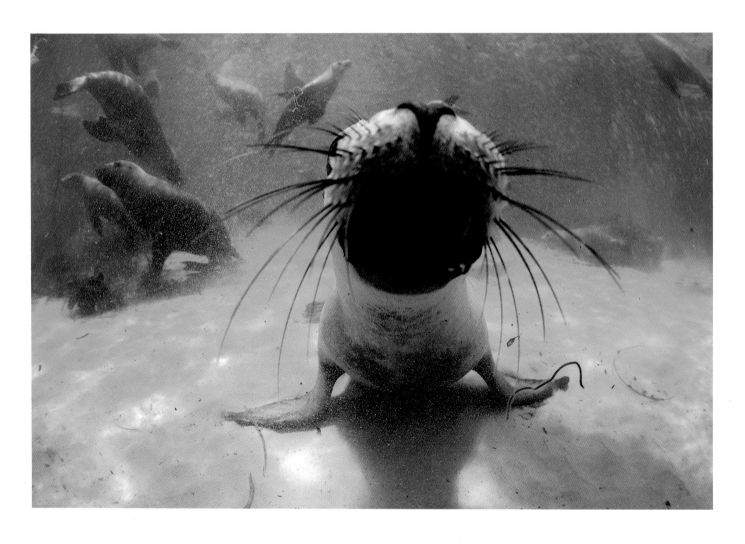

Australian sea lions, Hopkins Island,

South Australia.

NEOPHOCA CINEREA